CHARLOTTE COTTON is a curator and writer. She has held positions including Head of the Wallis Annenberg Photography Department at the Los Angeles County Museum of Art, Head of Programming at the Photographers' Gallery, London, Creative Director at the National Media Museum, UK and Curator of Photography at the Victoria & Albert Museum, London. Cotton has curated a number of exhibitions on contemporary photography and her publications include *Imperfect Beauty*, *Then Things Went Quiet* and *Guy Bourdin*. She is also the founder of wordswithoutpictures.org and EitherAnd.org.wordswithoutpictures.org and EitherAnd.org.

Thames & Hudson world of art

This famous series provides the widest available range of illustrated books on art in all its aspects

To find out about all our publica
World of Art series, please visit

D1041019

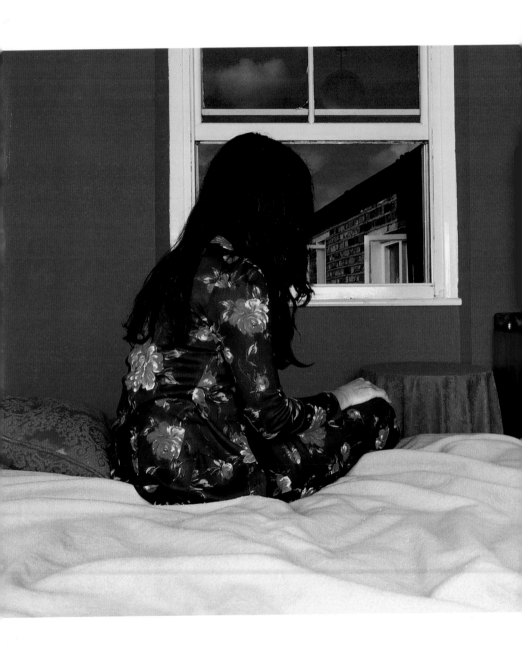

Charlotte Cotton

The Photograph as Contemporary Art

Third Edition

249 illustrations, 212 in color

Thames & Hudson world of art

For Issi, mum and dad

Thank you to all the photographers and galleries who contributed images, information and thoughts to this book. Thanks to Andrew Brown, Melanie Lenz, Anna Perotti, Jo Walton and everyone at Thames & Hudson who helped shape and produce the first version of this book. Special thanks to Jacky Klein, Flora Spiegel, Nick Jakins and Raffaella Morini for their help and advice in preparing this edition.

First published in 2004 in paperback in the United States of America by Thames & Hudson Inc., 500 Fifth Avenue, New York, New York 10110

thamesandhudsonusa.com

Second edition 2009
This third edition 2014

Library of Congress Catalog Card Number 2013945204

ISBN 978-0-500-20418-4

Printed and bound in Hong Kong through Asia Pacific Offset Ltd

Frontispiece:
1. **Sarah Jones**,
The Bedroom (I), **2002**.

Contents

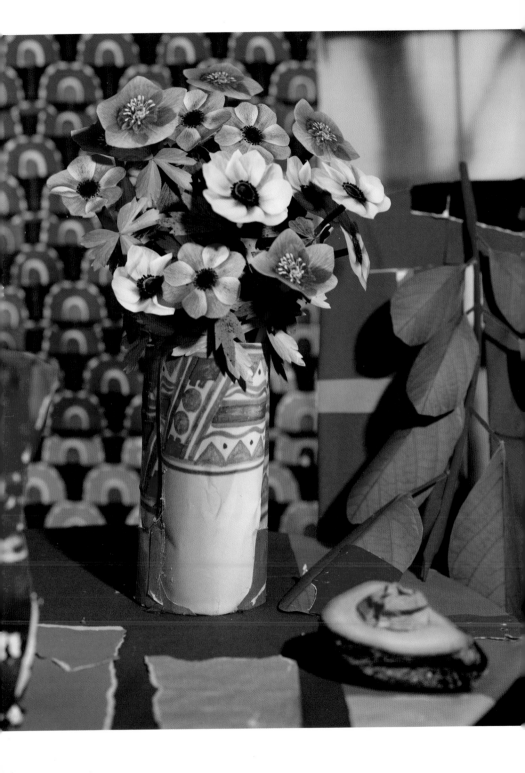

Introduction

Nearly two centuries after the technology was first invented in the 1830s, photography has come of age as a contemporary art form. In the 21st century the art world has fully embraced the photograph as a legitimate medium, equal in status to painting and sculpture, and photographers frequently display their work in art galleries and illustrated fine-art monographs. In light of these exciting developments, this book is intended to provide an introduction to and overview of the field of photography as contemporary art, with the aim of defining it as a subject and identifying its characteristic features and themes.

If there is a single, overarching idea of contemporary photography in this book, it is the wonderful pluralism of this creative field. The selection of nearly 250 photographers whose work is illustrated in these pages aims to convey a sense of the broad and intelligent scope of contemporary photography. While it includes the handful of well-known photographers who hold permanent residence in the pantheon of contemporary art, it intentionally treats contemporary art photography as fundamentally diverse in both form and intent, involving the cumulative efforts of many independent practitioners, most of whom are not well known outside their immediate spheres of practice. Every photographer represented here shares a commitment to making their own contribution to the physical and intellectual space of culture. In its most literal interpretation, this means that all of the photographers in this book create work that is intended to be displayed on gallery walls and in the pages of art books. It is important to bear in mind that most of the photographers are represented only by a single image, invariably selected to stand for their entire body of work. The pinpointing of one project from a photographer's oeuvre belies the full range of his or her expressions and underplays the plural possibilities that photography offers its makers, but it is a necessary simplification in the context of this book.

2. **Daniel Gordon,**
Anemone Flowers and Avocado, 2012.

The majority of contemporary art photographers working today have undertaken undergraduate and graduate art-school education and, like other fine artists, are crafting work primarily for an audience of art viewers, supported by an international web of commercial and non-profit galleries, museums, publishing houses, festivals, fairs and biennials. In the wake of this increase in professional infrastructure for photography as contemporary art in the twenty-first-century, it is no surprise that critical discussion now tends to centre on the consolidation and qualification of the field, rather than on rethinking it conceptually. While the idea of photography as a necessary and expected aspect of contemporary art practice has strengthened significantly in the new millennium, however, the issues that influence the subject of photography as contemporary art are increasingly those of image-making at large. They include the ways in which we use purely image-based communication in our daily interactions, in social media and photo-sharing platforms, for instance; the opportunities for amateurs to self-publish photobooks following the revolution in digital printing in the early twenty-first century; the rise of citizen photography in journalism, particularly for online publications; new camera technologies, such as the ability to fuse still- and moving-image capture; and the evolution and application of computer coding in data visualization. These new facets of image-making impact not only on the visual languages and the modes of dissemination for photography as contemporary art, but also push us to become more specific about what qualifies as artistic photographic practice in light of the new ubiquity of photography in everyday life. In this context, it becomes more evident that contemporary art photography is driven by the astute and active choices of its makers, whose works maintain the brilliantly dialogical nature of an art form within the ever-shifting wider photographic landscape.

The chapters of the book divide contemporary art photography into eight categories. These categories, or themes, were chosen to avoid giving the impression that it is either style or choice of subject matter that predominantly determines the salient characteristics of current art photography. Naturally, there are stylistic aspects that connect some of the works shown in this book, and there are subjects that have been especially prevalent in the photography of recent years, but the themes of the chapters are more concerned with grouping photographers who share common ground in their motivations and working practices. Such a structure foregrounds the ideas that underpin

contemporary art photography before going on to consider their visual outcomes.

Chapter 1, 'If This Is Art', considers how photographers have devised strategies, performances and happenings specially for the camera. It is given its place at the beginning of the book because it challenges a traditional stereotype of photography: the idea of the lone photographer scavenging from daily life, looking for the moment when a picture of great visual charge or intrigue appears in the photographic frame. Attention is paid here to the degree to which the focus has been preconceived by the photographer, a strategy designed not only to alter the way we think about our physical and social world but also to take that world into extraordinary dimensions. This area of contemporary photography grew, in part, out of the documentary photographs of conceptual art performances in the 1960s and 1970s, but with an important difference. Although some of the photographs that appear in this chapter play off their potential status as casual records of temporary artistic acts, they are, crucially, destined to be the final outcome of these events: the object chosen and presented as the work of art, not merely a document, trace or by-product of an action that has now passed.

Chapter 2, 'Once Upon a Time', concentrates on storytelling in art photography. Its focus is in fact more specific, for it looks at the prevalence of 'tableau' photography in contemporary practice: work in which narrative has been distilled into a single image. Its characteristics relate most directly to the pre-photographic era of eighteenth- and nineteenth-century Western figurative painting. This is not because of any nostalgic revivalism on the part of the photographer, but because in such painting an established and effective way of creating narrative content through the composition of props, gestures and the style of the work of art can be found. Tableau photography is sometimes also described as 'constructed' or 'staged' photography because the elements depicted and even the precise camera angle are worked out in advance and drawn together to articulate a preconceived idea for the creation of the image.

Chapter 3 gives the greatest consideration to the idea of a photographic aesthetic. 'Deadpan' relates to a type of art photography that has a distinct lack of visual drama or hyperbole. Flattened out, formally and dramatically, these images seem to be products of an objective gaze in which the subject, rather than the photographer's perspective on it, is paramount. The works represented in this chapter are those that suffer the most from

a reduction in size and print quality when presented as book illustrations, for it is in their dazzling clarity (all of the photographs are made with either medium- or large-format cameras) and large print size that their impact is felt. The theatricality of human action and dramatic light qualities seen in many of the works in Chapter 2 are markedly absent here; instead, these photographs have a visual command that comes from their expansive nature and scale.

While Chapter 3 engages with a neutral aesthetic of photography, Chapter 4 concentrates on subject matter, but at its most oblique. 'Something and Nothing' looks at how contemporary photographers have pushed the boundaries of what might be considered a credible visual subject. In recent years, there has been a trend to include objects and spaces that we might ordinarily ignore or pass by. The photographs shown in this chapter maintain the 'thing-ness' of what they describe, such as street litter, abandoned rooms or dirty laundry, but are conceptually altered because of the visual impact they gain by the act of being photographed and presented as art. In this respect, contemporary artists have determined that through a sensitized and subjective point of view, everything in the real world is a potential subject. What is significant in this chapter is photography's enduring capacity to transform even the slightest subject into an imaginative trigger of great import.

In Chapter 5, 'Intimate Life', we concentrate on emotional and personal relationships as a collective diary of human intimacy. Some of the photographs have a distinctly casual and amateur style, many resembling family snaps taken with Instamatic cameras with the familiar colouration of machine-made prints. But this chapter also considers what contemporary photographers add to this vernacular style, such as their construction of dynamic sequences and their focus on unexpected moments in everyday life, events that are distinctly different from those the average person would ordinarily capture. It also looks at other seemingly less casual and more considered approaches to representing the most familiar and emotionally resonant of subjects for a photographer.

Chapter 6, 'Moments in History', covers a large amount of ground in highlighting the use of the documentary capacity of photography in art. It starts with what is arguably the most counter-photojournalistic approach, one that is loosely termed 'aftermath photography'. This is work by photographers who arrive at sites of social and ecological disaster after they have been decimated. In the literal scarification of the places depicted,

3. William Eggleston,
Untitled, 1970.
Eggleston's influence on contemporary art photography has become recognized as central, not least because of his early validation of the use of colour in the 1960s and 1970s. Considered the 'photographer's photographer', he continues to publish and exhibit internationally, his repertoire being constantly re-evaluated in the light of art photography's increasing profile over the past thirty years.

contemporary art photography presents allegories of the consequences of political and individual upheaval. The chapter also investigates some of the visual records of isolated communities (whether isolated by geography or by social exclusion) that have been shown in art books and galleries. At a time when support for intensive documentary projects destined for the editorial pages of magazines and newspapers has waned, the gallery has become the showplace for such documentations of human life. This chapter also touches upon bodies of work in which either the choice of subject or the photographic approach counters or aggravates our perception of the boundaries of documentary-led photographic conventions.

Chapter 7, 'Revived and Remade', explores a range of recent photographic practice that centres on and exploits our pre-existing knowledge of imagery. This includes the remaking of well-known photographs and the mimicking of generic types of imagery such as magazine advertising, film stills or surveillance and scientific photography. By recognizing these familiar kinds of imagery, we are made conscious of what we see, how we see and how images trigger our emotions and shape our understanding of the world. The implicit critique of originality, authorship and photographic veracity that is brought to the fore here has been

4. **Stephen Shore**,
Untitled (28a), 1972.

a perennial discourse in photographic practice and one that has had especial prominence in photography of the last forty years. This chapter also looks at instances in which photographers have either revived historical photographic techniques or created archives of photographs. These examples invigorate our understanding of past events or cultures, as well as enriching our sense of parallels and continuities between contemporary and historical ways of seeing.

The final chapter, 'Physical and Material', focuses upon photography in which the very nature of the medium is part of the narrative of the work. With digital photography now a ubiquitous aspect of daily experience and communication, a number of contemporary art photographers have made conscious decisions to highlight the physical and material properties of photography and how they currently operate within the rarefied spaces of galleries and museums. Other artists are imaginatively responding to the changing modes of photographic dissemination that proliferate in our digital epoch. The photographs illustrated in this chapter draw attention to the many choices that a photographer must make when creating an artwork. For some the main choice has been to use analogue technologies (that is, older film-based and light-sensitive chemical processes) rather than the digital image-capture and post-production techniques that are now

standard, while others are using photography as just one element of their practice: for instance, as components of installation and sculptural work. Chapter 8 concludes by considering innovative ways in which contemporary art photographers are creating images designed to be viewed on internet platforms and handheld screens, *alongside* their other works of art intended exclusively for art galleries. Some are also capitalizing on the increased opportunities for self-publishing that have emerged in the wake of the digital revolution. These versatile photographers epitomize the newly flourishing creativity of photography as contemporary art.

Photography as contemporary art in the twenty-first century is strongly influenced by the momentum of the contemporary art market and by the impact of digital technologies on both the production and dissemination of images. Yet at the same time contemporary art photographers are also inspired by the nineteenth- and twentieth-century history of their medium, frequently utilizing it as an imaginative prompt for their work, in particular the experimentalism of European avant-garde photography of the early twentieth century and the 'photography of the everyday' reenvisioned by American art photographers in the mid-1970s.

The use of colour photography, rather than black-and-white, has dominated contemporary art photographic expression since the mid-1990s. It was not until the 1970s that art photographers who used vibrant colour – which previously had been the preserve of commercial and vernacular photography – found a modest degree of critical support, and not until the 1990s that the use of colour became standard practice. Most prominent among the many twentieth-century photographers who contributed to this shift were the Americans William Eggleston (b. 1939) and Stephen Shore (b. 1947). Eggleston began to create colour photographs in the mid-1960s, and in the late 1960s started to work with colour transparency film (colour slide film) of the same kind typically used for photographing family holidays, advertising and magazine imagery. At that time, his adoption of the colour range of commonplace photography put him outside the established realms of fine art photography. In 1976, however, a selection of photographs he had created between 1969 and 1971 was exhibited at the Museum of Modern Art in New York, comprising the first solo show of a photographer working predominantly in colour [3]. It is an oversimplification to argue that one exhibition (albeit at MoMA) could singlehandedly change

5. Alec Soth,
Sugar's, Davenport, IA, 2002.
Alec Soth photographs cross the pictorial genres of landscape, portrait and still life. In his images, he uses the neutral aesthetic so dominant in photographic practices of recent years, while also referencing the heritage of the use of colour in art photography since the 1970s, especially in the faded interiors he depicts.

the direction of art photography, yet the show was an early and timely indicator of the force that Eggleston's alternative approach would have.

In 1971, Shore photographed the main buildings and sites of public interest in Amarillo, Texas. To underscore his subtle portrayal of Amarillo as a generic American town, Shore had the photographs printed as ordinary postcards. When he did not sell many of the 5,600 cards he had printed, he put them in existing postcard racks in all the places he visited (some were sent back to him in the mail by friends and acquaintances who had spotted them). Shore's fascination with and simulation of photography's everyday styles and functions continued in 1972, when he exhibited 220 photographs, made with a 35mm Instamatic camera and shown in grids, of day-to-day events and ordinary objects cropped and casually depicted [4]. Shore's early explorations of colour photography as an artistic medium were not well known or

widely accessible until his book *American Surfaces* was published in 1999 and went on to have great influence on the next generation of contemporary art photographers.

Eggleston and Shore's greatest contribution has been in opening up a space within art photography to allow a more liberated approach to image-making. Younger artists have followed in their footsteps, including the American photographer Alec Soth (b. 1969) [5]. His series made on journeys along the Mississippi River, depicting the people and places he encountered along the way, is clearly part of Eggleston's legacy. (Soth visited Eggleston as part of his exploration of the American South.) That said, Soth's photographs also contain elements of the 'deadpan' aesthetic discussed in Chapter 3, as well as the conventions of nineteenth- and early twentieth-century portraiture, demonstrating that contemporary art photography draws on a range of traditions, both artistic and vernacular, and reconfigures them.

The exhibition 'New Topographics: Photographs of a man-altered landscape', curated by William Jenkins and first shown at George Eastman House in Rochester, New York, in 1975, is now recognized as an early survey of some of the most critically important and influential photography of the late twentieth century. The exhibition included the work of German duo Bernd (1931–2007) and Hilla Becher (b. 1934) [6], who worked together

6. **Bernd and Hilla Becher**, *Twelve Water Towers*, 1978–85. Through their sustained documentation of vernacular architecture and their tutelage of some of today's most prominent art photographers, the Bechers have had a resounding impact on contemporary ideas and practice. Their typologies of buildings have most often been shown on a modest scale and in grids, emphasizing the variety and specificity of the structure types they represent.

from the mid-1950s onwards. Their austere grids of black-and-white photographs, specifically those depicting American architectural structures such as gas tanks, water towers and blast furnaces, have deeply informed the aesthetics and conceptual approaches of contemporary art photography. The Bechers' black-and-white images may appear to stand in stark contrast with the colour work of Eggleston and Shore (who was also included in the original 'New Topographics' exhibition), but there is also an important connection: like Eggleston and Shore, the Bechers have been instrumental in adapting vernacular photography to function as part of a considered artistic strategy, with the intent of infusing art photography with visual connections to history and everyday life. Their photographs serve a dual function: they are unromantic documents of historic structures, yet their unpretentious and systematic recording of architecture recalls the use of taxonomies in conceptual art of the 1960s and 1970s. The Bechers have also played an important role as teachers at the Kunstakademie Düsseldorf, where their students have included future leading practitioners such as Andreas Gursky, Thomas Struth, Thomas Demand and Candida Höfer, whose work can be found later in this book.

7. **Lewis Baltz**,
Southwest Wall, Vollrath, 2424 McGaw, Irvine, from *The New Industrial Parks near Irvine, California,* 1974.

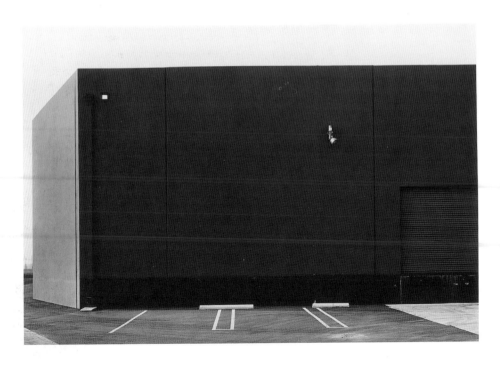

The 'New Topographics' exhibition brought together a range of work that represented the diverse concepts, technologies and formal approaches at play within the pioneering contemporary landscape photography of the 1970s. Lewis Baltz's portrayal of the near-obliteration of the Californian landscape in his photographs of the construction of a sprawling industrial park in Irvine, California, was perhaps the most wry and double-edged out of all of the selected artists' work [7]. Using a 35mm camera, Baltz masterfully created a series of austere photographs of the anonymous pre-fabricated industrial structures, purposely invoking what by the early 1970s were the pared-down formalist clichés of Minimalist sculpture and painting. With similar resonance, Robert Adams (b. 1937) captured intense observations of the encroachment of tract housing, shopping malls and light industry onto the monumental landscapes of Colorado that offered an epic narrative of the American West and the impact of post-war capitalism.

The inclusion of most of the aforementioned photographers in the canon of late twentieth-century masters has come about only relatively recently as a result of the wider availability of their work through new publications and exhibitions, in conjunction with the ongoing reassessment of photography by the art world. The twenty-first century has also been an era for the reappraisal of other histories of photography: geographical surveys of photographic practice from the Southern hemisphere, for instance, as well as imaginative presentations of anonymous and vernacular photography from the nineteenth and early twentieth centuries have cumulatively created a much more rounded understanding of the historical richness of photography.

The influence of the history of art upon present-day contemporary art photographers also reflects the current fascination in wider contemporary art with early twentieth-century avant-garde practices, which have encouraged the trend for reassessing the language and ambitions of modernist art. This interest in avant-garde experimentation has made László Moholy-Nagy (1895–1946) an especially important figure. Moholy-Nagy's artistic practice encompassed painting, sculpture, film, design and experimental photography in the spirit of European art movements such as Dadaism and Russian Constructivism, and epitomized the pluralistic practices associated with the German Bauhaus School. Among the works most often cited by contemporary art photographers are Moholy-Nagy's black-and-white photographic darkroom

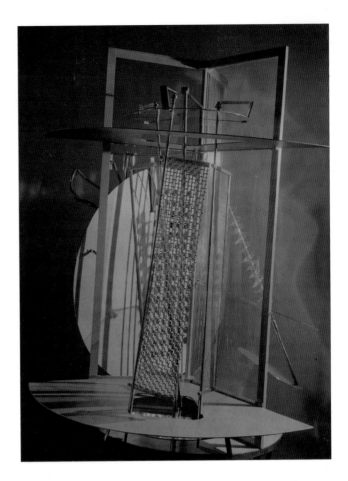

8. **Lázló Moholy-Nagy,**
Lightplay: Black/White/Gray, c. 1926.

experiments, in which he created visions that did not simulate human optical perspectives, and his mobile construction of the 1930s, posthumously entitled the Light-Space Modulator [8], which generated kinetic patterns of light and shade. Moholy-Nagy's work with photographic and light abstraction was the forerunner to the 21st-century abundance of both abstract photography and artwork that fuses photography with sculpture (see Chapter 8).

The influence of Marcel Duchamp (1887–1968), the originator of Dadaism, over modern and contemporary art remains pervasive in the twenty-first century, and his collaborations with photographers such as Alfred Stieglitz (1864–1946) and Man Ray (1890–1976) [9] resonate strongly within the field of contemporary art photography. In essence, Duchamp and his collaborators used the photograph as a device to generate a visual charge and

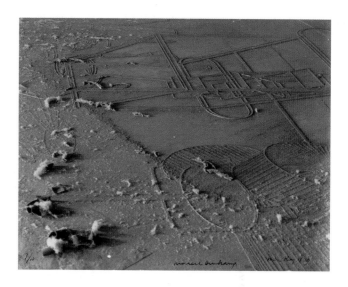

9. **Man Ray and Marcel Duchamp**, *Dust Breeding*, 1920.

automatically assign artistic meaning to its subjects. Photography in this context operates very much as the tool of the Duchampian readymade: it creates a default, manufactured object borrowed directly from daily life. At a point in the history of art when the idea of photography as a conceptually valid contemporary art medium has been accepted beyond any shadow of a doubt, it is perhaps not surprising that there has been a revival of interest in work from an earlier time when photography was a liberated artistic economy of means.

While the expanding and rethinking of the history of photography continues to influence contemporary art photography, the second decade of the twenty-first century has ushered in an era of incredible confidence and experimentation within this field of artistic practice. It is distinctly different from the late twentieth-century process of validating photography as a widely recognized, independent art form through its stylistic and critical alignment with traditional art forms, especially painting. Now that photography's identity as contemporary art has been accepted as fact, the stage is set for new and exciting turns in its development.

Chapter 1 If This Is Art

The photographers in this chapter collectively make one of the most confident declarations about how central photography has become within contemporary art practice, and how far removed it is from traditional notions of the way a photographer creates his or her work. All of the photographs here evolve from a strategy or happening orchestrated by the photographers for the sole purpose of creating an image. Although making an observation – framing a moment from an unfolding sequence of events – remains part of the process for many here, the central artistic act is one of directing an event specially for the camera. This approach means that the act of artistic creation begins long before the camera is actually held in position and an image fixed, starting instead with the planning of the idea. Many of the works here share the corporeal nature of performance and body art, but the viewer does not witness the physical act directly, as one does in performance, being presented instead with a photographic image as the work of art.

The roots of such an approach lie in the conceptual art of the mid-1960s and 1970s, when photography became central to the wider dissemination and communication of artists' performances and other temporary works of art. The motivations and style of such photography within conceptual art practice was markedly different from the established modes used in fine art photography of the time. Rather than offering an appreciation of virtuoso photographic practice or distinguishing key individuals as 'masters' of photography, conceptual art played down the importance of craft and authorship. It made an asset of photography's unshakable and everyday capacity to depict things: it took on a distinctly 'non-art', 'deskilled' and 'unauthored' look and emphasized that it was the act depicted in the photograph that was of artistic importance. The style of mid-twentieth-century photojournalism – a snap-happy, shoot-from-the-hip response to unfolding events – was often adopted to invest the image with a sense of unpremeditated

10. **Philip-Lorca diCorcia**, *Head #7*, 2000. DiCorcia's *Head* series was made by placing flash lighting on construction scaffolding above a busy New York street, out of sight of the passers-by below. The movements of the pedestrians prompted diCorcia to activate the flash, at which moment he photographed the illuminated stranger with a long-lens camera. The resulting images show people who do not know that they are being photographed and so do not compose themselves for their 'portraits'.

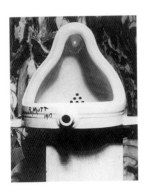

11. Alfred Stieglitz,
Fountain, 1917, by Marcel Duchamp,
1917.

photographic action, counterbalancing the level of preconceptualization of the idea or act that the photograph seemingly casually represented. At the same time, the image acknowledged the spontaneous forms that performance could take. Conceptual art used photography as a means of conveying ephemeral artistic ideas or actions, standing in for the art object in the gallery or on the pages of artists' books and magazines. This versatility of photography's status as both document and evidence of art had an intellectual vitality and ambiguity that has been well used in contemporary art photography. Just as this form of photograph subverted conventional standards of what was considered to be an artistic act, it also demonstrated a more pedestrian mode of art-making. Art was revealed to be a process of delegation to ordinary and everyday objects, and photography became the tool by which to circumvent the need to create a 'good' picture.

The precedents for conceptual artists of the 1960s and 1970s were created in the early twentieth century by French artist Marcel Duchamp (1887–1968). In 1917, the father of conceptual art – as he is often called – submitted a factory-made urinal to the Armory Show in New York on the basis that art could be anything the artist designated it to be. The labour on Duchamp's part was minimal: he simply rotated the urinal from its functional, vertical position to the horizontal and signed the piece with the fictional signature 'R Mutt, 1917', a pun on the manufacturer's name and the popular comic strip 'Mutt and Jeff'. Today, only photographs remain of the original *Fountain,* taken by Alfred Stieglitz (1864–1946) in his 291 Gallery in New York, seven days after the work was rejected by the judges of the Armory Show [11]. (Multiple copies of the sculpture have since been made, thereby further questioning the idea of an 'original' work of art that Duchamp intended to challenge.) The raw and confrontational nature of the *Fountain* is pronounced in Stieglitz's photographs, as is the mystical symbolism of the piece, its formal relations to a Madonna figure or seated Buddha made apparent by the photographs' compositions.

To cite these historical moments in art practice is not to say that the same dynamic between avant-garde art and photography is still at play today. Rather, it is to suggest that the ambiguity with which photography has positioned itself within art, as both the document of an artistic gesture and a work of art, is the heritage that some contemporary practitioners have used imaginatively. French artist Sophie Calle's (b. 1953) blending of artistic strategy

with daily life is one of the most compelling realizations of conceptually led photography. Her celebrated *Suite Vénitienne* (1980) began when she accidentally came across a stranger twice in one day in Paris. On the second sighting, Calle had a brief conversation with the man, known as Henri B., and learned that he was soon to travel to Venice. She decided to follow him to Italy and through the Venetian streets without his knowledge and to document the unexpected journey he unwittingly took her on with photographs and notes. In a work from the following year, *The Hotel*, Calle took a job as a chambermaid in a hotel in Venice. During her daily cleaning of the bedrooms, she photographed the personal items of their temporary inhabitants, discovering and imagining who they might be. She opened suitcases, read diaries and paperwork, inspected laundry and rubbish bins, systematically photographing each intrusion and making notes that were then published and exhibited. Calle's art works conflate fact and fiction, exhibitionism and voyeurism, and performance and spectatorship. She creates scenarios that consume her, border on being out of control, fail, remain unfinished or take unexpected turns. The importance of a script for her art was highlighted when Calle collaborated with the writer Paul Auster (b. 1947). In his novel *Leviathan* (1992), Auster created a character called Maria who was based on Calle. Calle intertwined the novel's character with the

12. **Sophie Calle**,
The Chromatic Diet, 1998. For six days, Calle ate a diet of food of a single colour. This combination of artistic strategy and daily life is the hallmark of the French artist's imaginative work.

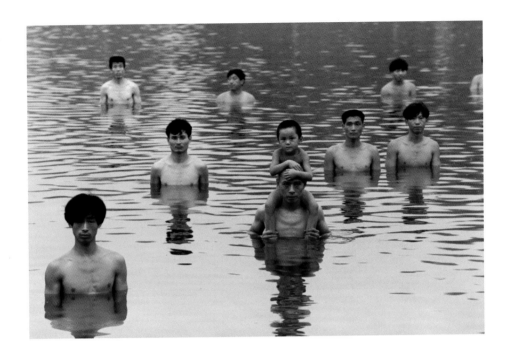

13. **Zhang Huan**,
*To Raise the Water Level
in a Fishpond*, 1997.
This group performance was
staged by Zhang Huan to be
photographed, the photograph
being the final outcome of the
artistic gesture. Along with
Ma Liuming and Rong Rong
(below), Huan was a member
of the Beijing East Village
community. The group always
used photography as an integral
part of their performance pieces.

14. **Rong Rong**,
*Number 46: Fen. Maliuming's Lunch,
East Village Beijing*, 1994.

artistic persona by correcting passages in the book that referred
to Maria. She also invited Auster to invent activities for her, while
undertaking the activities Auster had invented for Maria in the
novel. These included a week-long chromatic diet that consisted
of eating food of a single colour [12]. On the final day, Calle added
her own twist by inviting dinner guests to choose one of the
meals from the diet.

Performance played a major role in Chinese art in the 1980s
and 1990s. In a political climate in which avant-garde artistic
practice was outlawed, the temporary theatricality of
performance-based art, which is not reliant on the support of
art institutions, provided an opportunity and outlet for dissident
expression. Furthermore, the corporeal nature of performance
intrinsically challenged the cultural subordination of the self in
China, and hence became a critical dramatization of Chinese
politics. One of the best-known artists' groups was the short-lived
and politically persecuted Beijing East Village, which began in 1993.
Most of its members had trained as painters and used
performances that blurred life and theatre to present disturbing
manifestations that questioned, countered and responded to the
violent shifts in Chinese culture. These were staged to small
audiences in houses or out-of-the-way-places. In the extreme

performances of Zhang Huan (b. 1965), Ma Liuming (b. 1969) and Rong Rong (Lii Zhirong, b. 1968), the human body was tested to its limits, the artists enduring physical pain and psychological discomfort. Photography was always part of the performance, whether through its interpretation by art photographers or as the final work of art born out of the performance [13, 14].

The Ukrainian artist Oleg Kulik (b. 1961) has a parallel practice. Kulik stages animalistic protests and zoomorphic performances in an attempt to suggest that we are the alter egos of animals and animals are ours. There is a direct, politically confrontational element to Kulik's performances that have included acting like a savage dog and attacking the police and representatives of institutionalized power. His dedication to his concept of the 'artist-animal' is not just a persona he adopts for the length of his performances but also a way of life: he has even formed his own Animal Party to give his ideas a platform within the political arena. The influence of earlier conceptually minded artists is especially apparent in Kulik's work. In one two-week performance as a dog in New York, entitled *I Bite America and America Bites Me*, he paid homage to the heritage of performance as a politicized photo-opportunity by referencing German artist Joseph Beuys's (1921–86) protest against the Vietnam War, *I Like America and*

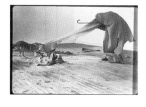

15. (above) **Joseph Beuys**,
I Like America and America Likes Me,
1974.

16. (right) **Oleg Kulik**,
Family of the Future, 1992–97.

America Likes Me [15], in which Beuys lived locked up with a coyote in a New York gallery and their strange cohabitation was photographed. Kulik's *Family of the Future* [16] is made up of photographs and drawings that ruminate on what the relationship between man and animals could be if the behaviour and attitudes of both were combined in one lifestyle. Kulik is shown naked with a dog, performing part-human, part-animal behaviour. The black-and-white photographs have been exhibited framed and printed small like family photographs, and installed in a room that contains furniture made smaller than normal so that one has to drop down on all fours like a dog in order to use it.

Photography's role in making and showing alternative realities has also been used in less specific but equally intriguing ways. Melanie Manchot's (b. 1966) series *Gestures of Demarcation* [17] shows the artist expressionless and static as a second figure pulls the elastic skin of her neck. There is an absurdist theatricality here that resonates back to the use of comedic and grotesque performance within conceptual art of the 1960s. However, this scene is not a performance being photographed but an act created for the express purpose of being photographed. Manchot has carefully selected the location, camera angle and fellow performer but has done these things so that the preconceived nature of the work is concealed beneath the seemingly spontaneous gesture. As a result, the image remains open-ended and the viewer must interpret it imaginatively.

17. **Melanie Manchot**, *Gestures of Demarcation VI*, 2001.

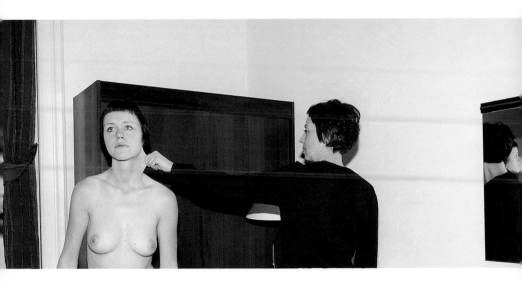

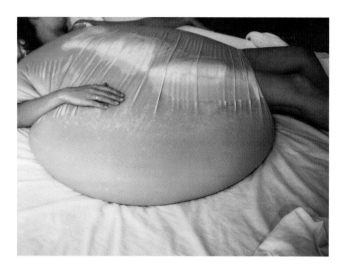

A similarly engaging corporeality is also evident in Jeanne Dunning's (b. 1960) photographs showing an organic mass dramatically abstracted to the point that the actual subject is lost in favour of its reference to bodily organs, both exterior and interior. In *The Blob 4* [18], a sack with the look of a huge silicon implant covers a woman's torso, the bulk sliding like swollen flesh towards the camera. The blob embodies the embarrassment and vulnerability of human physicality. In an accompanying video piece, a woman is shown trying to dress the blob in women's clothing, struggling as if with an unwieldy, bloated body. In both the photographs and the video, the blob carries psychological connotations of the human body as irrational and uncontrolled.

'Bread Man' is the performance persona of the Japanese artist Tatsumi Orimoto (b. 1946), who hides his face under a sculptural mass of bread and then performs normal everyday activities. His performances as this cartoonish character are not particularly dramatic. As he walks or cycles around a town, his strange but non-threatening appearance is usually politely ignored by passers-by; occasionally it engenders amused curiosity. But the photographs representing these absurdist interventions are dependent on people's willingness and resistance to break with their daily routines in order to interact and be photographed with the artist. Orimoto has also used his bread guise for double portraits of himself and his mother, who has Alzheimer's disease, a visual merging of her changed mental reality with his performance of physical difference [19].

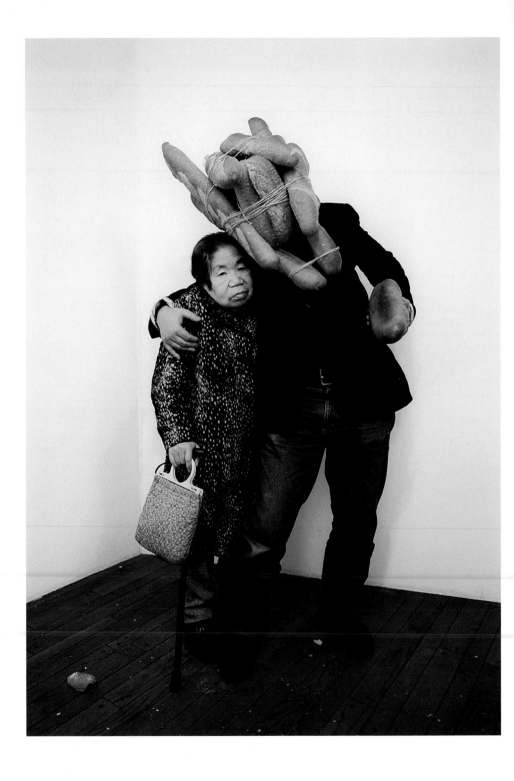

20. **Erwin Wurm**, *The bank manager in front of his bank*, 1999. Wurm photographs himself and the people who agree to collaborate with him in absurd sculptural poses, sometimes with the aid of props made from everyday objects. No special physical skills or equipment are required for these 'one-minute sculptures', which encourage people to turn themselves into works of art in their daily lives.

21. **Erwin Wurm**, *Outdoor Sculpture*, 1999.

19. **Tatsumi Orimoto**, *Bread Man Son and Alzheimer Mama, Tokyo*, 1996.

A similar kind of banal disruption of daily life is also present in the incongruent physical acts that Erwin Wurm (b. 1954) stages and then photographs [20, 21]. In his *One Minute Sculptures*, Wurm provides a manual of sketches, instructions and descriptions of potential performances that require no specialized physical skills, props or locations, such as wearing all your clothes at once and putting a bucket on your head while standing in another bucket. By extending the invitation to anyone willing to undertake these acts, Wurm suggests that the work of art is the idea, and the artist's own physical manifestation of it is more of an encouragement to others to participate than an act only he can perform. The models for Wurm's photographs include friends, visitors to his exhibitions and people who respond to his newspaper adverts. Occasionally,

Wurm appears in his photographs, but not in a way that distinguishes him as the authoritative body; instead, he is a tragic-comic spoof of an artistic persona.

The capacity of photoconceptualism to dislodge the surface of everyday life through simple acts occurs in British artist Gillian Wearing's (b. 1963) *Signs that say what you want them to say and not signs that say what someone else wants you to say* [22]. For this work, Wearing approached strangers on the streets of London and asked them to write something about themselves on a piece of white card; she then photographed them holding their texts. The resulting photographs revealed the emotional states and personal issues that were occupying the minds of those portrayed. Giving the control of self-determination to the subject challenges the

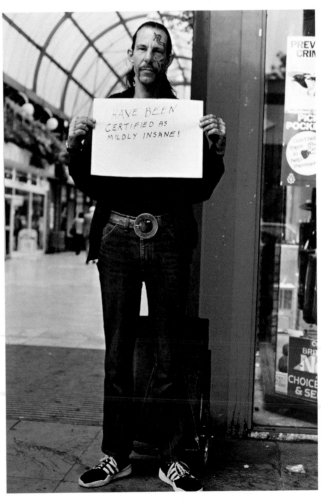

22. **Gillian Wearing.**
Signs that say what you want them to say and not signs that say what someone else wants you to say,
1992–93.

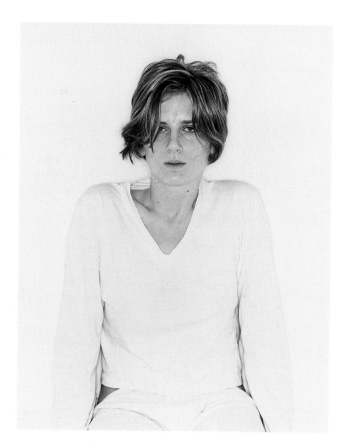

23. **Bettina von Zwehl**, #2, 1998.

notion of traditional documentary portraiture. By making the thoughts of her subjects the focus of the portraits, Wearing proposes that the capturing of the profundity and experience of everyday life is not intrinsic to the traditional styles or compositions of the documentary photograph, but is more effectively reached through artistic intervention and strategy.

This proposal has been an important one within contemporary art photography, and is especially evident when sitters are given instructions that disarm them and prompt less self-conscious gestures for the camera. An example is German artist Bettina von Zwehl's (b. 1971) three-part series that portrays subjects when their appearance is not controlled by them. For all three parts, von Zwehl asked a sitter to wear clothes of a certain colour and agree to undertake simple tasks. For the first part of the series, her subjects went to sleep wearing white clothes, were woken, and then photographed with the vestiges of slumber still clear on their faces. In the second part, the figures wore blue polo-neck sweaters

24. Shizuka Yokomizo,
Stranger (10), 1999.
Yokomiza sent letters to the
inhabitants of houses into which
she could photograph from street
level. She asked the strangers to
stand in front of their windows at
a certain time in the evening with
the lights on and the curtains open.
The photographs show the people
who followed the directions
posed in anticipation of being
photographed by an unknown
photographer.

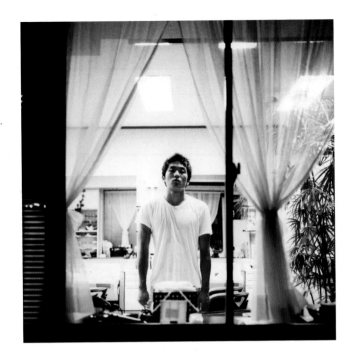

and exerted themselves physically before being photographed
trying to seem composed as their hearts raced and their faces
looked flushed. In the third part, the sitters appear strained. Von
Zwehl had positioned herself above them as they lay on her studio
floor and photographed them as they tried to hold their breath.

A similar complicity between photographer and subject is
required in Japanese artist Shizuka Yokomizo's (b. 1966) *Strangers*
[24]. This series consists of nineteen portraits of single figures
photographed through downstairs windows of houses at night.
Yokomizo selected windows that she could observe from street
level and sent letters to the inhabitants of the houses asking if they
would stand facing the window with the curtains open at a
designated time. We are looking at the strangers looking at
themselves in these photographs, for the windows act as mirrors
as they anticipate the moment they will be photographed. The
title of the series refers not only to the status of the sitters as
strangers to the artist and to us but also to the photographing of
that curious self-recognition, or misrecognition, we have when we
catch a glance of ourselves unexpectedly.

Dutch artist Hellen van Meene (b. 1972) photographs girls and
young women. It is unclear whether we are looking at knowingly
constructed or awkwardly struck spontaneous poses, whether

these girls are dressed up for the occasion or caught in unselfconscious play [25]. There is a tantalizing ambiguity as to whether these are portrayals of enigmatic, other-worldly female protagonists or fictions orchestrated to create subtle allegories of femininity. This uncertainty stems from van Meene's coupling of a conscious sense of what she wants to capture with a deliberate putting aside of her prepared 'script' and her photographing of what then spontaneously unfolds. Strategy here is about constructing an environment that draws the subject out, first through the photographer's choreography and then through the responses of the individual sitter.

25. **Hellen van Meene,** *Untitled #99*, 2000.

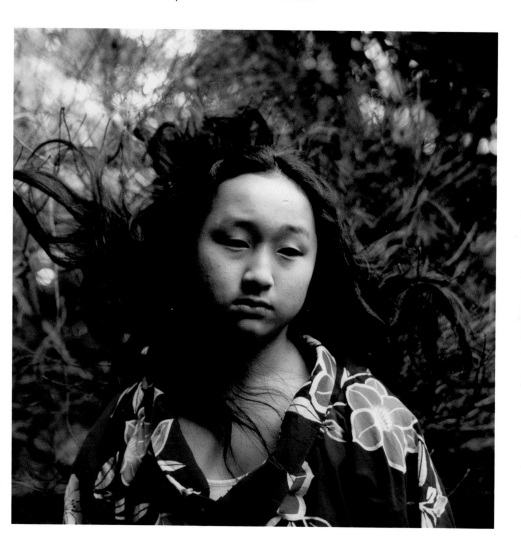

26. Ni Haifeng,
*Self-portrait as a Part of Porcelain
Export History (no. 1)*, 1999–2001.

27. Kenneth Lum,
Don't Be Silly, You're Not Ugly, 1993.

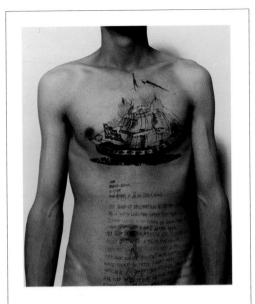

SELF PORTRAIT AS A PART OF THE
PORCELAIN EXPORT HISTORY

Ni Haifeng, 1999

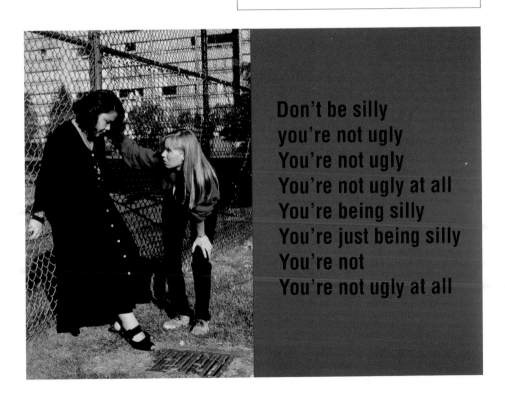

Don't be silly
you're not ugly
You're not ugly
You're not ugly at all
You're being silly
You're just being silly
You're not
You're not ugly at all

As we have seen earlier in this chapter, the inscribing of cultural and political meaning onto the human body has been reinvigorated by contemporary art photography. This has been done on a literal level by the Chinese artist Ni Haifeng (b. 1964). In the image shown here [26], the artist's torso is painted with motifs from eighteenth-century Chinese porcelain, designed by Dutch traders catering to the Western market for 'china'. The words on his body are written in the style of a museum label or a catalogue entry, suggestive of the language of the collector and the social implications of trade and colonialism. The equal prominence given to text and image in Kenneth Lum's (b. 1956) work [27] implies that a photograph needs a caption for it to elaborate its ideas or message fully. The image alone, even one that is staged by the artist, is shown to be problematic and ambiguous without the addition of text to help 'explain' the work's meaning. In *Don't Be Silly, You're Not Ugly*, Lum uses the words of the Caucasian woman's entreaty to her friend to highlight the ways in which social values of beauty and race are projected onto our daily lives.

In a reversal of this strategy, the Dutch artist Roy Villevoye (b. 1960) represented cultural difference in a purely visual way when he collaborated with the Asmati community of Irian Jaya as part of his ongoing artistic exploration of colour and race with particular reference to Dutch colonial history. In *Present (3 Asmati men, 3 T-shirts, 3 presents)* [28], Villevoye photographed the local men lined up, in a fashion reminiscent of nineteenth-century anthropological photographs, wearing T-shirts brought from Holland. Villevoye's strategy reflects the historical trading links between the two cultures and the implied zeal of Westerners to impose their tastes and sense of decorum onto colonized

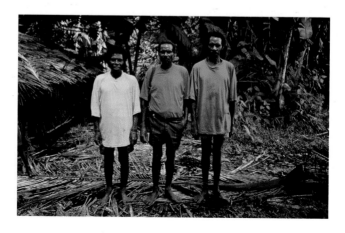

28. **Roy Villevoye**,
Presents (3 Asmat men, 3 T-shirts, 3 presents), 1994.
Villevoye has undertaken a long-term collaboration with the Asmati. The project takes many forms but often centres on the physical exchange, customization and reinterpretation of indigenous and Western goods and design.

indigenous people. Other photographs depict Asmati people wearing T-shirts after they have customized and fashioned them according to their own designs, suggesting that Asmati culture is neither fragile nor static in the face of Western dominance, but is able to transform outside influences for its own ends.

The customization of the natural world has been the playful signature of projects by the American artist Nina Katchadourian (b. 1968) since the mid-1990s. In her *Renovated Mushroom (Tip-Top Tire Rubber Patch Kit)* of 1998, she repaired cracks in mushroom caps with brightly coloured bicycle-tyre patches and then photographed them. In her *Mended Spiderweb* series [29], she patched up spiders' webs with starched coloured thread. An unplanned twist to her acts of handiwork was that, overnight, spiders would attempt to remove and rework her 'repairs'. Within the context of art, Katchadourian's small and consciously clumsy interventions into nature are a wry and feminized retort to the much grander engagements with nature made in land art of the 1960s and 1970s.

With wit and humour, Wim Delvoye's (b. 1965) sculptures and photographs are driven by visual punchlines. Just like his finely crafted, rococo-style wooden cement mixers, and intricate mosaics of sliced salami and sausages, his photographs offer an irreverent joining of the mundane and functional with the grand

29. **Nina Katchadourian**, *Mended Spiderweb #19 (Laundry Line)*, 1998.

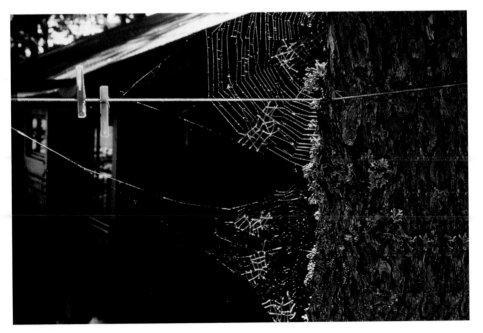

30. **Wim Delvoye,**
Out Walking the Dog, 2000.

31. **David Shrigley,**
Ignore This Building, 1998.

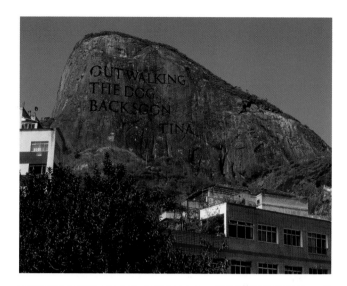

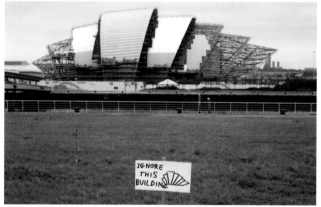

and decorative. Delvoye uses this device to create experiences that are aesthetically pleasurable and psychologically aberrant. He mixes civic typographies normally used for inscriptions on monuments and gravestones with the language of the quickly scribbled, casual note left on a doorstep or kitchen table [30]. The witty combination of the grandiloquent and the ordinary, public and private, carries the works' serious comments on our waste of natural resources and the nature of communications in contemporary life. Similarly, British artist David Shrigley's (b. 1968) photographs and sketches take the formulas of shock and visual puns, with a special nod towards surrealism, and, in a manic, schoolboyish way, debunk art's pretentiousness [31]. This anti-intellectual form of photoconceptualism relies on a fast

turnaround of ideas and, for the viewer, an immediate comprehension and enjoyment of their meaning. Shrigley's use of a consciously unsophisticated style of sketching and a perfunctory and unauthored photographic look is crucial in signalling to the viewer that we are not being asked to take the artist seriously, at least not on the level of dexterity or skill. Our enjoyment of the work has more in common with our daily experiences of toilet-wall jokes and schoolroom doodles.

A wry and dark playfulness has also been apparent in the work of British artist Sarah Lucas (b. 1962), who has often used photography in her consciously rough and ready art. *Get Off Your Horse and Drink Your Milk* [32] has a blunt and funny rudeness that, in its ad hoc staging, brings together the popular cartoon language of tabloid-newspaper photo-stories with the use of performance and the photographic grid in avant-garde art practice. Whereas we saw earlier in this chapter the naked body being used as a means of reaching and signalling sensitized experience, in Lucas's work it is the way the body is conventionally represented in the everyday imagery of magazines and newspapers that is important. In the work shown here, she enacts a reversal and subversion of received sexual roles and imagery, the body becoming more of a travesty than a desirable symbol.

32. **Sarah Lucas**,
Get Off Your Horse and Drink Your Milk, 1994.

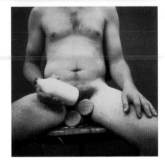

33. **Annika von Hausswolff**,
Everything is connected, he, he, he,
1999.

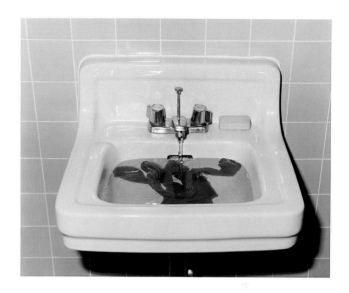

In Swedish artist Annika von Hausswolff's (b. 1967) *Everything is connected, he, he, he* [33], the photographer also plays with depictions of the sexualized body. Her photograph of a basin of soaking laundry can also be read as a sexual diagram in the phallic tap and the coiled washing. Von Hausswolff creates a visual game so that we see the actual subject of the bathroom sink and then the conceptualized subject of sex. This interplay between two pictorial registers relates to the hovering status of contemporary art photography, discussed earlier in the chapter, as being a device for documenting a performance, strategy or happening as well as a legible work of art in its own right. Photography is both a practical way to fix the observation but also the means by which that play between visual registers comes into force.

Such is the visual currency of Mona Hatoum's (b. 1952) *Van Gogh's Back* [34], where we jump mentally from the swirls of hair on the man's wet back to the starry skies of van Gogh's swirling paintwork. The enjoyment of such a photograph is based on our shift from registering a photographic image as a three-dimensional scene (something we respond to because of its presentation of a sculptural object or event that we trust once existed in the real world) and that of a two-dimensional, graphic representation of the swirls of wet hair that we connect, via van Gogh, to a patterned sky. The interplay of two- and three-dimensional spaces is one of the great pleasures of looking at photographs. The ability of the medium to depict solid plastic forms, fleeting events and combinations, and graphically reduce them to two dimensions, has

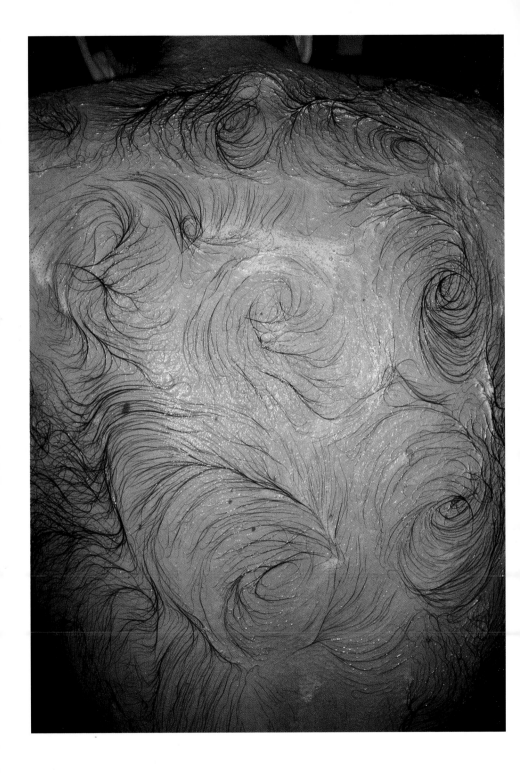

been an enduring fascination and challenge to photographers throughout its history. And in contemporary art photography, such questions about the essential nature of the medium not only have a bearing on the techniques employed by artists but can also often be the *subject* of entire bodies of work.

This has been the central theme of French artist Georges Rousse's (b. 1947) photographs. Rousse works in abandoned architectural spaces, transforming the sites by painting and plastering an area so that, when photographed from a certain position, a geometric, coloured shape such as a circle or chequerboard design seems to hover on the surface of the image [35]. At first glance, the process appears to involve the simple overlaying of the photograph with a geometric wash of colour, but in fact the shape comes from carefully constructing the scene and then positioning the camera so that the illusion is complete. Rousse's act is about making a discrete tableau within a physical space, crafting another dimension into the picture plane. British artist David Spero's (b. 1963) *Ball Photographs* depict modest locations into which he has placed colourful rubber balls, which, when photographed, make for comical but beautiful punctuations

35. **Georges Rousse**,
Mairet, 2000.

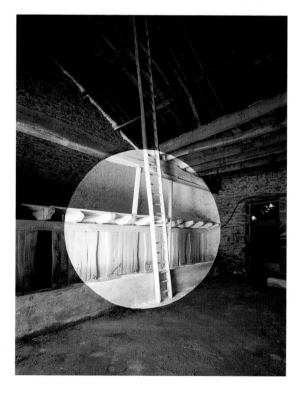

of the spaces [36]. They form homemade celestial planes, tilted through the floors, sills and surfaces of each scene. They draw our attention to the many still lifes within each photograph and the transformations of their contents into photographic subjects.

The remaining photographs in this chapter focus on repetition. This practice could be likened to fieldwork or a quasi-scientific testing of a hypothesis. Repeating turns speculation into a proposal, for the repetitive act seems to offer the proof of something. Often we are being asked to compare likeness and difference. The American photographer and poet Tim Davis's (b. 1970) series *Retail* [37] depicts the darkened windows of American suburban houses at night, with windows reflecting the neon signs from fast-food joints. The photographs reveal a subliminal imposition of contemporary consumer culture onto domestic life. To see just one of these photographs may alert us to Davis's unnerving social observation, but it is through the repetition of this night-time phenomenon that his idea becomes a theory of the contamination of our privacy and consciousness by commercialism. Russian artist Olga Chernysheva's (b. 1962) series

36. **David Spero**,
Lafayette Street, New York, 2003.

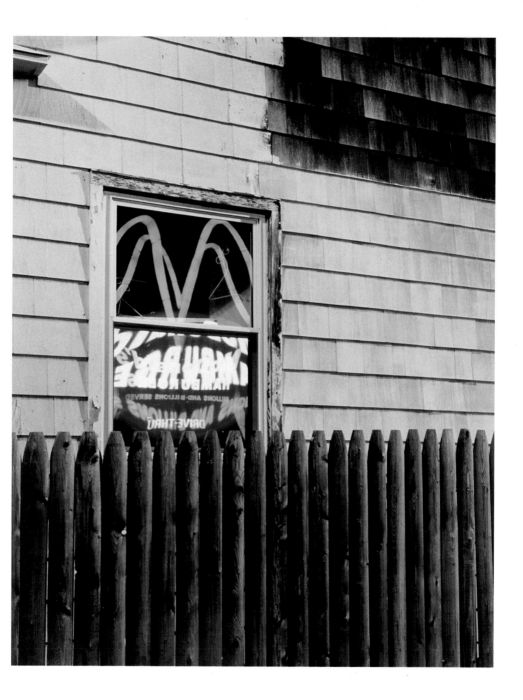

37. **Tim Davis**,
McDonalds 2, Blue Fence, 2001.

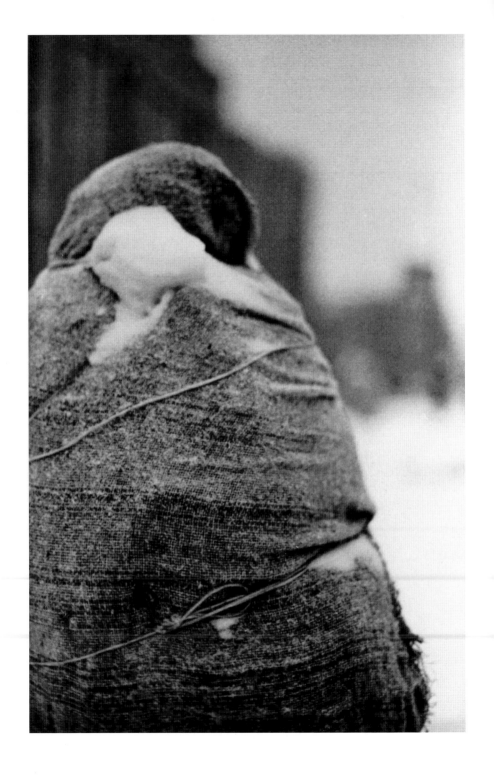

38. Olga Chernysheva,
Anabiosis (Fisherman; Plants), 2000.

39. Rachel Harrison,
Untitled (Perth Amboy), 2001.

of mutely toned photographs entitled *Anabiosis (Fishermen; Plants)* [38] pairs images of plants with those of Russian fishermen wrapped in lengths of cloth to protect themselves against the deadly cold on snow-covered ice floes. Motionless and looking like plant shoots breaking through the snow, the fishermen are barely recognizable as the human figures mentioned in the work's title, which also alludes to the way they appear to be cocooned in a state of suspended animation. By singling out the figures and representing them in a series, Chernysheva accentuates the uncanny appearance of these solitary workers.

In *Perth Amboy* [39], American artist Rachel Harrison (b. 1966) observes a strange and obscure form of human gesture. The photographs show the window of a house in New Jersey, where, it was claimed, there had been a visitation from the Virgin Mary on the windowpane. Guests to the house place their hands on either

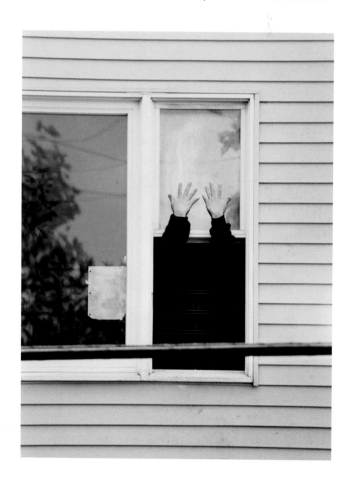

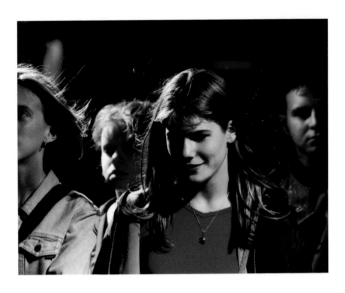

side of the window in an attempt to comprehend the phenomenon through the sensory experience of touch. On one level, the repetition of people's responses to the site makes Harrison's *Perth Amboy* a sustained contemplation of human attitudes to the paranormal; on another, the repeated gesture remains visually unfathomable to us and we wonder what it means, mirroring the pilgrims' desire for comprehension.

The inclusion of American photographer Philip-Lorca diCorcia's (b. 1953) work here may be unexpected, as his influence has been so strongly felt in the emergence of the staged photographic image that is the subject of the next chapter. But his *Heads* series [10, 40] offers an extreme use of a pre-planned artistic strategy. For the project, diCorcia fixed a set of flashlights to construction scaffolding above people's heads on a busy New York street. When a person clearly entered his 'target' area, diCorcia activated a flash of light, illuminating the walkers in its beam, which then allowed him to photograph them with a long-lens camera. The conceptual engineering in *Heads* lies in the setting up of the apparatus to ensure that the subjects were unaware of being observed and photographed, and an embracing, on the part of the photographer, of this spontaneous and unpredictable form of image-making. The result is a heightened, revelatory experience of being able to take a sustained look at what ordinarily passes us by, and a form of photographic portraiture in which the subjects are entirely unable to influence their representation.

Roni Horn's (b. 1955) *You Are the Weather* [41] consists of sixty-one photographs of the face of a young woman, taken over the course of several days. Her facial expression changes subtly, but because of the repeated close framing of her face throughout the series, when we compare the different images, the minute changes become magnified to a range of emotions, and are given an erotic charge by the close and intense physical scrutiny we are able to give her. The title of the work refers to the fact that she was photographed while standing in water, and her expressions were influenced by the degree of physical ease or discomfort she felt as a result of that day's weather conditions. However, the 'you' of the title is the viewer, who is thereby encouraged to become a participant in the work and to imagine that it is he or she, as the weather, who has provoked the woman's emotions. As we have seen throughout this chapter, the counterbalancing of a determined structure with unpredictable and ungovernable elements can create magical results.

41. **Roni Horn**,
You Are the Weather
(installation shot), 1994–96.

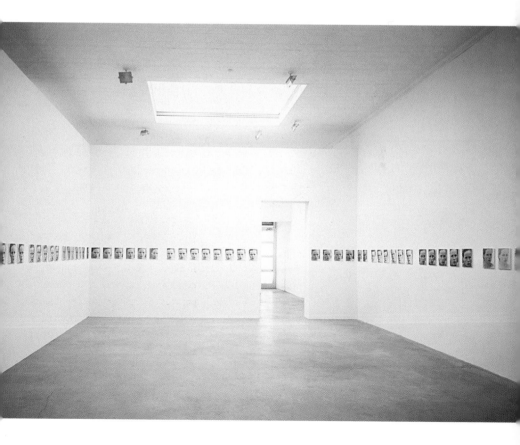

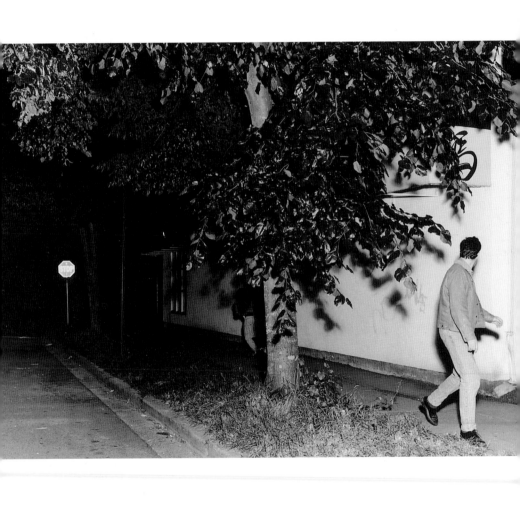

Chapter 2 Once Upon a Time

This chapter considers the use of storytelling in contemporary art photography. Some of the photographs shown here make obvious references to fables, fairy tales, apocryphal events and modern myths that are already part of our collective consciousness. Others offer a much more oblique and open-ended description of something that we know is significant because of the way it is set up in the photograph, but whose meaning is reliant on our investing the image with our own trains of narrative and psychological thought.

This area of photographic practice is often described as tableau or tableau-vivant photography, for pictorial narrative is concentrated into a single image: a stand-alone picture. In the mid-twentieth century, photographic narrative was most often played out sequentially, printed as photo-stories and photo-essays in picture magazines. Although many of the photographs illustrated here are parts of larger bodies of work, narrative is loaded into a single frame. Tableau photography has its precedents in pre-photographic art and figurative painting of the eighteenth and nineteenth centuries, and we rely on the same cultural ability to recognize a combination of characters and props as a pregnant moment in a story. It is important not to think of contemporary photography's affinity to figurative painting as simply one of mimicry or revivalism; instead, it demonstrates a shared understanding of how a scene can be choreographed for the viewer so that he or she can recognize that a story is being told.

One of the leading practitioners of the staged tableau photograph is the Canadian artist Jeff Wall (b. 1946), who came to critical prominence in the late 1980s. His art practice developed in the late 1970s after he had been a postgraduate art history student. Although his photographs are more than mere illustrations of his academic study, they are evidence of a detailed comprehension of how pictures work and are constructed that underpins the best tableau photography. Wall describes his oeuvre

42. **Jeff Wall**, *Passerby*, 1996. Wall divides photographers into two camps, hunters and farmers, the former tracking down and capturing images, the latter cultivating them over time. In a photograph such as *Passerby*, Wall consciously conflates the two by constructing an image that contains a spontaneous street scene, in this case an allegory about the nature of urban living, the physical dangers and the threat of strangers.

as having two broad areas. One is an ornate style in which the artifice of the photograph is made obvious by the fantastic nature of his stories. Since the mid-1980s he has often utilized digital manipulation to create this effect. The other area is the staging of an event that appears much slighter, like a casually glanced-at scene. *Passerby*, a black-and-white photograph with a figure turned and moving away from the camera, is a case in point, since it initially proposes itself as night-time reportage [42]. Wall sets up a tension between the look and substance of a candid, grabbed photographic moment with his actual process, which is to preconceive and construct the scene.

Insomnia [43] is made with compositional devices similar to Renaissance painting, the angles and objects of a kitchen scene directing us through the picture and leading our understanding of the action and narrative. The layout of the interior acts as a set of clues to the events that could have led up to this moment: the

43. **Jeff Wall**,
Insomnia, 1994.

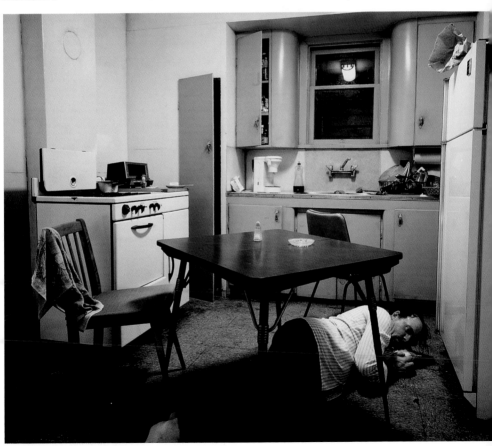

man's movements around the sparse kitchen in his restless state, unsatisfied, resigned to crumpling on the floor in desperation to achieve sleep. The lack of homely details in this kitchen is a reflection perhaps of the lifestyle of the character, of his insomniac state, but also of a theatre set viewed from on stage. The scene is stylized enough for us to suspect that this is a choreographed event functioning as an allegory of psychological distress.

The labour and skill involved in reconstructing such a scene is arguably equivalent to the time and dexterity expended by a painter in his studio. What is also brought into question by such practice, where everything is gathered together expressly for the realization of a photograph, is the idea of the photographer working alone. The use of actors, assistants and technicians needed to create a photographic tableau redefines the photographer as the orchestrator of a cast and crew, the key rather than sole producer. He or she is similar to a film director who imaginatively harnesses collective fantasies and realities.

In galleries, Wall displays many of his images on large light boxes, which, because of their spatial and luminescent qualities, give his photographs a spectacular physical presence. A light box is not quite a photograph, nor is it a painting, but it suggests the experience of both. The use of the light box is often seen as introducing another frame of reference into Wall's work: that of backlit and billboard advertisements. However, although his photographs may have the size and command of advertising, Wall rarely seems to directly critique commercial imagery. Since his work requires the extended looking time of art appreciation, it is fundamentally different from the high and instant impact demanded of street advertisements.

Philip-Lorca diCorcia's *Hollywood* series has set an equally strong and pervasive model for narrative in contemporary art photography. *Hollywood* is a series of portraits of men whom diCorcia met in and around Santa Monica Boulevard in Hollywood and asked to pose for him. The titles of each photograph tell you the name of the man, his age, where he was born and how much diCorcia paid him to pose. The pictures encourage a kind of storytelling in the viewer's mind. For instance, one wonders what aspirations and high hopes brought these young men to Tinseltown; the small sums of money paid lead one to think that they are now down on their luck and driven to being paid for the photographic use of their bodies (the associations with the sex industry are clear). In *Eddie Anderson; 21 years old; Houston, Texas; $20* [44], a man, naked from the waist up, is shown

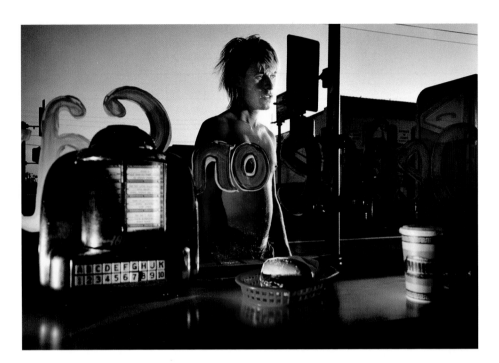

44. Philip-Lorca diCorcia,
Eddie Anderson; 21 years old;
Houston, TX; $20, 1990–92.
Tableau photography often alludes
to the lighting used on a film set,
with lights spotted in a number
of places to create a simulated
naturalism and in anticipation of
actors moving through the scene.
A theatrical and psychological
charge is also added by working
at particular times of day, such
as sunset, where combining
natural and artificial lights leads
to a dramatic sense of place and
narrative.

through the window of a diner. There is a mixed message here: his youthful physique is powerful and available to hire, but at the same time he is literally without a shirt on his back. The image is set at twilight, a time that signifies a turning-point between the safety and normality of daytime and the covert, potentially threatening time of night. This dramatic form of light is often described as 'cinematic', especially in reference to diCorcia's work. Arguably, it is an accurate description of the lighting used in tableau photography in general, which is distinct from the even or single-spotted lighting of photographic portraiture. However, the suggestion that diCorcia's series is cinematic in a wider sense, or indeed that tableau photography proposes itself to be a still version of cinema, is misleading. Tableau photography does not seek to ape the movies in order to enact the same effect on the viewer, and if it were to do so, it would be bound to fail for it does not fully function in the same way. Cinema, figurative painting, the novel and folktales act merely as reference points that help to create the maximum contingent meaning, and to help us accept tableau photography as an imaginative blending of fact and fiction, of a subject and its allegorical and psychological significance.

Theresa Hubbard (b. 1965) and Alexander Birchler (b. 1962) construct photographs that are intentionally ambiguous in their

symbolism, but no less emphatic in their narrative charge.
Hubbard and Birchler build sets, act alongside their selected cast
of professional actors, and direct. In *Untitled* [45], they positioned
the camera as if splicing through the floors and walls of a house,
creating a curiosity and a dread of what lies beyond the frame, left
and right, above and below. The composition has another reading
of a strip of film caught between two frames. What this device
suggests is the conflation of time that is possible in tableau
photography, making a reference to a sequential past, present and
future, or to another moment/frame that is only partly visible.
Such a division of space and the suggestion of time are similar
to the use in Renaissance altarpieces of different moments in the
same picture. Tableau photography often refers to specific works
of earlier art in this way. British artist Sam Taylor-Wood's (b. 1967)
Soliloquy I shows the figure of a beautiful young man, expired on a
sofa, his right arm hanging lifelessly to the floor [46]. This pose,
with the light source positioned behind the figure, emulates a
popular work by the Victorian painter Henry Wallis (1830–1916),
The Death Of Chatterton (1856). The painting shows the shamed

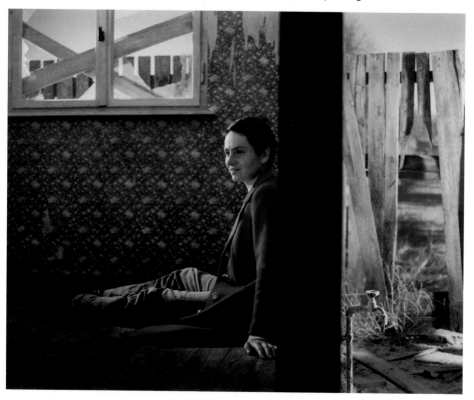

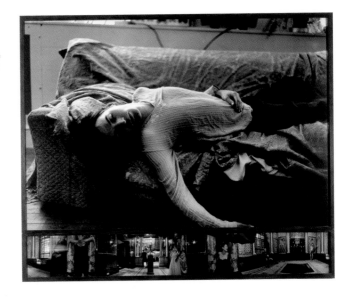

46. Sam Taylor-Wood,
Soliloquy I, 1998.
This image has the rich colour, size and combination of a Pietà-like figure study and frieze of animated action of Renaissance religious paintings and altarpieces. The frieze that runs along the lower edge of the image was made with a 360-degree panning camera.

seventeen-year-old poet committing suicide in 1740, after his poetry, which he had presented as the found writings of a fifteenth-century monk, was exposed as the young man's own work. In the mid-nineteenth century, Chatterton represented the idealized character of the young, misunderstood artist whose spirit is smothered by bourgeois disapproval, and his suicide was seen as his last act of self-determination. In her photograph, Taylor-Wood not only remakes a tableau from a period in art history when that was a prevalent and popular form of picture-making but also consciously revives the idealism bound up in Wallis's painting. Taylor-Wood's rich baroque style is often used to create bohemian and dandyish characterizations. Entwining aspects of her own life in her staged photographs – for instance, by including her close friends – Taylor-Wood plays the role of a contemporary court painter, portraying an artistic and social elite of which she is part.

British artist Tom Hunter's (b. 1965) series *Thoughts of Life and Death* [47] also presents contemporary reworkings of Victorian paintings, specifically those of the Pre-Raphaelite Brotherhood. *The Way Home* is a direct compositional and narrative reference to John Everett Millais's (1829–1896) *Ophelia* (1851–52), a Victorian recasting of William Shakespeare's tragic character from *Hamlet*. The contemporary stimulus for *The Way Home* was the death of a young woman who had drowned on her way home from a party. The work shows this modern-day Ophelia succumbing to the

water and metamorphosing into nature, an allegory that has had a potency for visual artists for centuries. The luscious colour photography on a large scale parallels the luminous clarity of Millais's painting. This is also the case in Hunter's earlier series *Persons Unknown* (1997), inspired by the paintings of Jan Vermeer (1632–1675), which depicts squatters being served with notices of eviction. When historical visual motifs are used in a contemporary photographic subject in this way, they act as a confirmation that contemporary life carries a degree of symbolism and cultural preoccupation parallel with other times in history, and art's position of being a chronicler of contemporary fables is asserted. With the use of large-format cameras there is a harking back to photography's history and nineteenth-century fashions in tableau melodramas that became parlour-game amusements as well as cheap and collectable alternatives to prints of paintings. In an age when digital photography has usurped analogue traditions within amateur, professional and some artistic practice, to employ larger cameras is in itself a pointed reference to forms of historical photography. Such conscious revivalism is

47. Tom Hunter,
The Way Home, 2000.

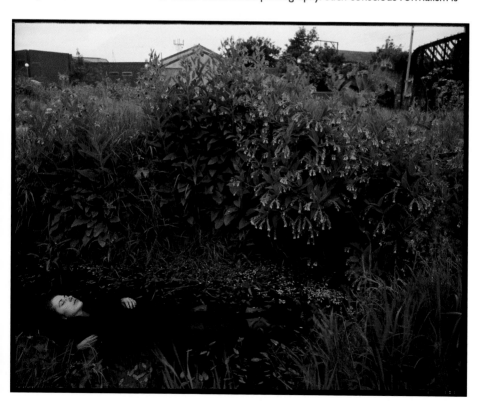

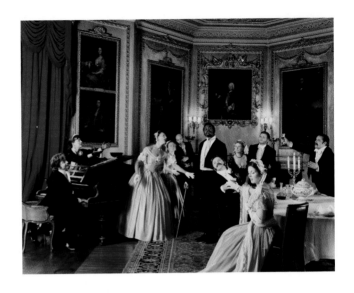

brought into play in the work of British artist Mat Collishaw (b. 1966), who uses outdated, hackneyed and vernacular styles, often with a sentimental or kitsch sensibility, to represent confrontational subjects, such as snowstorm ornaments of tourist sites inhabited by homeless people. Similarly, in *Ideal Boys* (1997), pictures of semi-naked boys are posed within contemporary settings in the quasi-Arcadian manner of the late nineteenth century. The photographs are made with lenticular cameras, a novelty process more commonly used for postcards to create an exaggerated sense of the third dimension. This non-art, lighthearted process allows Collishaw to raise disturbing questions about how our relationship to the bodies of children has shifted from one of sentimentality and adoration to cynicism and difficulty.

Nigerian-born British artist Yinka Shonibare's (b. 1962) *Diary of a Victorian Dandy* [48] features five moments in the day in the life of a dandy, performed by the artist. One of the obvious references is to *The Rake's Progress*, William Hogarth's (1697–1764) painted morality tale of the young cad Tom Rockwell. Hogarth depicted seven episodes in Rockwell's life, each vivid with the pleasure and consequences of the character's debauchery. For his contemporary series, Shonibare constructed scenes representing different moments in the day, all set in historical interiors, with the cast and artist wearing Victorian fancy dress. The Caucasians are shown to be 'colour-blind' to the artist and his skin colour. His place within Victorian society appears to be protected by his guise

as a dandy, the declaration of self-fashioning and authenticity being assured through pronounced artifice in manner and dress. Hogarth's series of paintings, a satire on the state of contemporary society, was engraved and widely published as prints, the eighteenth century's form of mass media. Interestingly, Shonibare's *Victorian Dandy* was commissioned to be shown first as posters on the London Underground system and therefore was intended to function within today's sites of popular and commercial imagery.

Whereas the photographs mentioned above draw on specific imagery and cultural codes for their narratives, other photographers use the tableau formula for much more ambiguous and unreferenced narratives. A dreamlike quality is often created by reducing the specificity of a place and a culture to such a degree that it closes down our expectation of uncovering the 'where and when' of a photograph. In Sarah Dobai's (b. 1965) *Red Room* [49], psychological drama is apparent but left intentionally open-ended. Personal effects are starkly absent from the interior, and it is not clear whether this is a domestic or institutional space. The red blanket could be a sign of a character's taste or a prosaic way of disguising the roughness or dilapidation of the upholstery beneath it. The photograph was in fact taken in Dobai's living space, practical and familiar surroundings in which to stage her psychologically intense series and which allowed some material signs of her life to become part of the work. The pose of the

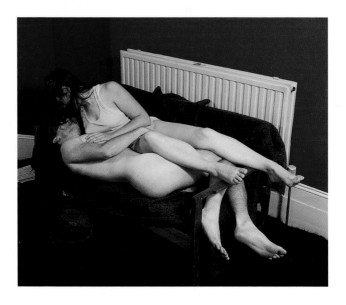

49. **Sarah Dobai**,
Red Room, 2001.
As with other photographs by Sarah Dobai, this has almost oppositional, but equally present, readings. The couple's embrace could be either tender or oppressive, with the woman shown in the more powerful role.

figures is multifaceted, hovering between the moment before or after a kiss or sexual act. Their awkwardness and hidden faces make the encounter tense with uncertainty. The woman's white vest simultaneously denotes the unglamorous nature of domesticated sex and a deep self-consciousness coupled with the common anxiety dream of being seen semi-naked in public.

Dutch artist Liza May Post's (b. 1965) photographs and films have magical, dream-like qualities. She often uses custom-made clothing and props that lift and contort the bodies of the performers into strange forms. In *Shadow* [50], both figures are dressed in androgynous clothes that hide their gender and age. The front figure wears stilted shoes that push the body into a precarious pose. The figure behind is more stable, but is linked by a clawlike prop to a strange wheeled object with a fringed cover extending the sense of fragility of the scene. The details in the photograph are hyper-real and, like a surreal dream, their combination and visual charge leave the narrative open to the viewer's interpretation. One of the great uses of tableau photography is as a format that can carry intense but ambiguous drama that is then shaped by the viewer's own trains of thought.

50. **Liza May Post**, *Shadow*, 1996.

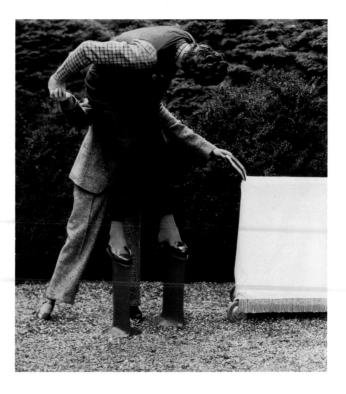

51. **Sharon Lockhart**,
Group #4: Ayako Sano, 1997.
Lockhart draws out the geometry
of the Japanese female basketball
players by isolating gestures,
moving our attention away
from the progress of the match
or practice sessions and towards
the more abstract and imaginative
possibilities their movements
suggest.

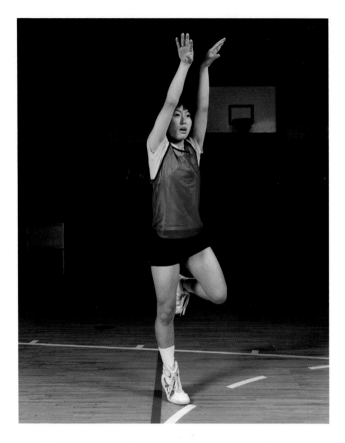

American photographer Sharon Lockhart (b. 1964)
interweaves documentary photography, as a straightforward
representation of a subject, with elements that begin to disrupt
our certainty of such a photographic status. Lockhart's series of
photographs, accompanied by a short film, depicting a Japanese
all-girl basketball team, demonstrates a balance between fact and
fiction for which she is well known [51]. She frames single figures
and groups of players and crops out enough of the indoor court
to begin to abstract the nature of their movements and the
game. In *Group #4: Ayaka Sano*, Lockhart has isolated the balletic
pose of a single figure so that the girl's action, understood as
participation in a match, becomes tenuous, perhaps a posture
that the photographer has orchestrated entirely. That doubt
pervades the meaning of the image; the rules of the game played
and the documentary function are both equally subverted.

One of the pictorial devices used in tableau photography to
engender anxiety or uncertainty about the meaning of an image is

52. Frances Kearney,
Five People Thinking the Same Thing,
III, 1998.

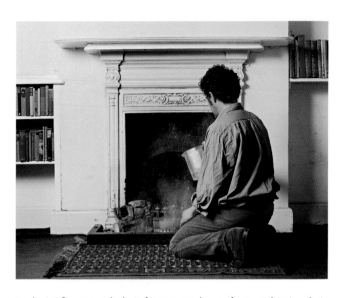

to depict figures with their faces turned away from us, leaving their character unexplained. In Frances Kearney's (b. 1970) series *Five People Thinking the Same Thing* [52], five individuals are shown in this way undertaking simple activities in sparse domestic interiors. The thoughts preoccupying these unidentified figures are not revealed, leaving it up to the viewer's imagination to draw out potential explanations from the subtle and simplified depictions of a person's gestures and habitat.

Hannah Starkey's (b. 1971) *March 2002* [53] uses this same device to give the figure of a woman sitting in an Oriental canteen a surreal and mysterious air. The possible readings of the woman's character are somewhere between a sophisticated urban dweller awaiting an assignation and a more imaginary creature with long grey hair curls around her shoulders like a mermaid from the watery scene on the canteen wall. There is a sense that Starkey's staged photographs elaborate on observations she has made, investing familiar scenes with imaginative potential by restaging and embellishing them as subtle photographic dramas with a fantastical edge. In both Kearney's and Starkey's depictions of figures turned away, we are not given enough visual information to make characterization the focal point of the image. Instead, we make meaning from a dynamic process of connecting interior space and objects with the possible characters of the people depicted. The staging around the figures is much more than the confirmation of their identities; they are the only clue we have to who they might be.

53. Hannah Starkey,
March 2002, 2002.
Starkey's tableau photographs
are highly preconceived. Her
working process starts with the
building of a mental image of a
scene. The search for a location,
casting and choreographing of
the photographs are merely the
practical execution of a picture
that is already complete in the
artist's mind.

This otherworldliness found in contemporary life is also a
theme in the work of the Polish-American artist Justine Kurland
(b. 1969). Her scenes are the playgrounds of nymph-like young
women (although older women and men are now also
represented in her work) in places of natural beauty [54].
Kurland's is a modern-day staging of contemporary idylls with a
hint of nostalgia for the back-to-nature lifestyles of the 1960s, in
locations where the grass is green and the sunsets are beautiful.

British artist Sarah Jones's recent portrayal of young girls
posed in interiors are consciously constructed out of the tension
between the authentic and the projected, both in terms of
imagery and experience. In *The Guest Room (bed) I* [55], a girl is
shown lying on the bed in a faded and impersonal room. Because

54. Justine Kurland,
Buses on the Farm, 2003.
Kurland creates landscapes,
in which she depicts a mainly
female cast of part-woodland
nymphs and part-hippy chicks,
that blend contemporary
and historical elements to
convey a sense of otherwordly
communities.

the indication is that the girl is not portrayed in her own room, the bed becomes a motif, its symbolism drawn from art history (Manet's *Olympia* comes to mind), and the horizon its bulk creates also triggers associations with the formal compositions of land- and seascapes. While the girl's long hair is naturalistic, it is not connected to any specific contemporary fashion, in order that her character retains its ambiguity as both archetypal and personal. Similarly, her pose is in part a spontaneous response to the situation that Jones has orchestrated for the photographic shoot, while at the same time appearing to be drawn from the pre-photographic gestures of reclining female figures in the histories of painting and sculpture.

A related pivoting between choreographing and documenting is evident in Sergey Bratkov's *Italian School* series, which was made in a reform school in his home town of Kharkov in the Ukraine. Bratkov gained the local authorities' permission to photograph the children only by agreeing that the project would include religious instruction. Bratkov decided that he would direct the children, who had been interned for being destitute, stealing and prostitution, in biblical plays within the fenced grounds of the school. He then photographed their performances.

Wendy McMurdo's (b. 1962) *Helen, Backstage, Merlin Theatre (the glance)* [57], in which digital technology is used to represent a child and her doppelgänger, is an example of tableau photography in which the constructed nature of the image is foregrounded. The girls look quizzically at their doubles on a theatre stage (the choice of setting an allusion to the staged photograph as well as to the

56. Sergey Bratkov,
#1, 2001.

As part of an artistic group
in Kharkov in the Ukraine
that also included Boris Mikhailov
(see page 189), Bratkov creates
work in which there is a brutal
clash between artistic performance
and documentary photography.
In the *Italian School* series, Bratkov
photographed dress rehearsals
of religious plays he had directed
at a reform school.

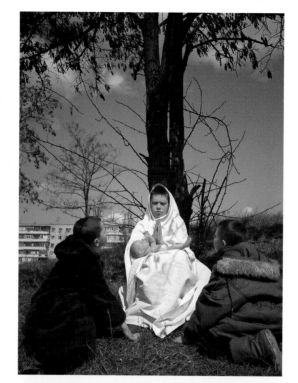

57. Wendy McMurdo,
*Helen, Backstage, Merlin Theatre
(the glance),* 1996.

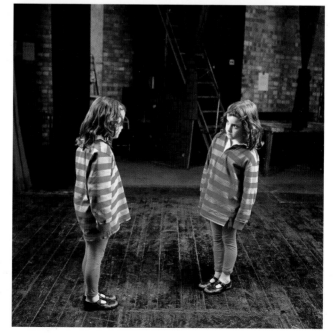

transformative space of theatre). Where tableau photography has visualized collective fears and fantasies with an emphasis on the uncanny, the use of youthful protagonists has been especially prevalent. This has been the visually and psychologically powerful device used by the Cuban artist Deborah Mesa-Pelly (b. 1968), who recasts fairy tales and popular stories with young female characters and with disturbing results. Her sets and props are instantly recognizable as coming from children's stories, such as the red shoes worn by Dorothy in *The Wonderful Wizard of Oz* (1900), made into a popular film in 1939, or the bedroom in which Goldilocks is awakened by the return of the three bears. Mesa-Pelly stages situations that could be scenes from the stories as they are conventionally told, but dramatized and given a sinister edge by her lighting and voyeuristic camera angles. She also, as below, mixes and twists storylines: the legs of Goldilocks, or perhaps Dorothy, are shown with the phallic tail of the pantomime lion curled around her.

58. **Deborah Mesa-Pelly**, *Legs*, 1999.

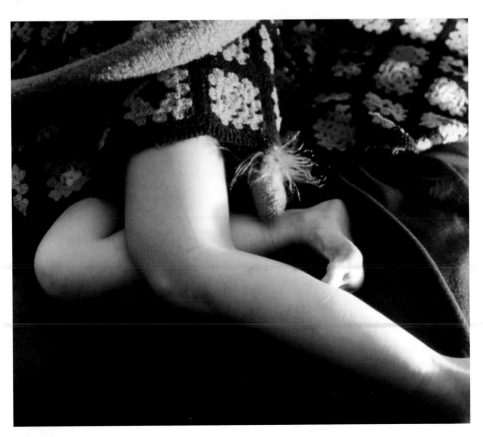

Anna Gaskell's (b. 1969) photographs share this intense storytelling quality that combines a number of the common devices of tableau photography: a cast of children, sometimes with their faces obscured, their play gone awry or turned nasty. The image shown here, from the *By Proxy* series [59], has both a literary source in the Sally Salt character from Rudolf Raspe's (1737–94) *Adventures of Baron Munchausen* (1785) and real-life foundations in the true story of Geneva Jones, a paediatric nurse convicted of murdering her patients in 1984. The photographs mix the seductive and the abhorrent, the good girl and the fetish status of the nurse's costumes, and the enactment of childhood play that seems to take a potentially sinister turn. The physical beauty of the prints, combined with the moral ambiguity of the narrative, makes for an unnerving visual pleasure. This is one of the dominant characteristics of tableau photography that centres on the uncanny: work that is, in terms of it narrative meaning, socially subversive or difficult is often carried in an aesthetic that is rich

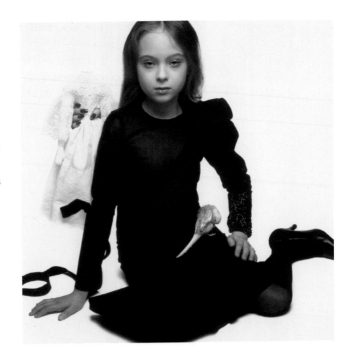

60. Inez van Lamsweerde and Vinoodh Matadin, *The Widow (Black)*, 1997. Van Lamsweerde and Matadin have successful careers creating some of the most innovative photography for advertising and editorial fashion photography. When working in this context, their authorship is shared, but in their art projects van Lamsweerde is cited as the artist (working *with* Vinoodh Matadin), in part an acknowledgment of the art world's preference for single authorship.

and seductive to the eye. We almost realize too late the true meaning of what we have been drawn to, enjoyed and appreciated.

Dutch artist Inez van Lamsweerde (b. 1963) and her partner Vinoodh Matadin (b. 1961) create photographs for both art and fashion, which in the 1990s shared an aesthetic of digitized perfection while presenting troubling narratives. In their series *The Widow* [60], a prepossessed girl is shown immaculately styled into a complex character invested with religious, funereal and fashionable qualities. The process of realizing such intense and mannered art works is close to the working practices of fashion. Van Lamsweerde and Matadin develop intricate storylines and character descriptions before arranging the styling of a shoot, and take great care in the casting of the actors and models. They have, since the early 1990s, used digital technology to refine their otherworldly visions yet further. Fashion requires that they work fast and perpetually change, meeting and often raising the experimental capacities of the industry. Their art projects aim higher (and take longer), unconstrained by the commissioning process and requirements of fashion. There is a sense, however, that the frequent reinvention of a photographic style or approach that fashion requires has acted as a liberation for their art to explore new visual territories, their use of tableau photography

being just one among several aesthetic modes in which they have worked in the last ten years.

In Japanese artist Mariko Mori's (b. 1967) photographs (which, like Jeff Wall's, are often displayed on light boxes) and installations, the production values are like those of luxurious commercial image-making, and they often resemble the architecture and point-of-sale design of contemporary fashion houses. The mixture of Far Eastern traditional arts with contemporary consumer culture is part of Mori's trademark. She cherry-picks a range of styles and cultural references to bring the role of the photographer into close parallel with the visual inventiveness of a fashion stylist and art director. A regular theme in her work is the persona of the artist herself, who is often the central figure in her photographs [61]. Mori's fashion-college and art-school training, together with a stint as a model, gave her the skills to create an art of spectacle, one that is knowingly shaped by its references to consumer culture.

American artist Gregory Crewdson (b. 1962) has said that his elaborately constructed melodramas are influenced by his memory of childhood. His psychoanalyst-father's office was in the basement of their New York City home, and Crewdson would press his ear to the floorboards to try and imagine the stories being told in the therapy sessions. In the mid-1990s, Crewdson's tableau photographs were set in models of suburban backyards and undergrowth built in his studio. They are a mix of the bizarre and the disturbing, yet are also highly camp and entertaining. Stuffed animals and birds perform strange and ominous rituals, while plaster casts of Crewdson's body are shown being slowly

61. **Mariko Mori**,
Burning Desire, 1996–98.

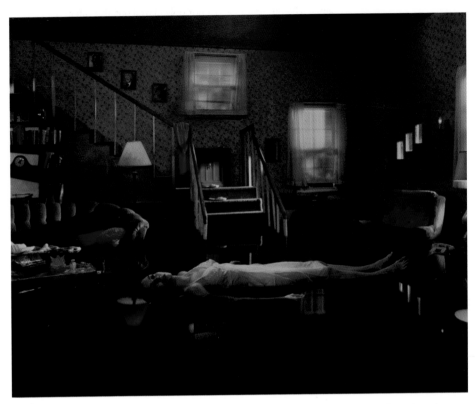

62. Gregory Crewdson,
Untitled (Ophelia), 2001.
In this photograph, Crewdson
recasts Shakespeare's Ophelia
in post-war American suburbia.
The *Twilight* series, of which this
is part, brims with such elaborate
scenes that reference sci-fi films,
fables, modern myths and theatre.

devoured by insects, surrounded by lush foliage. Crewdson later
shifted into a more directorial mode. In his black-and-white series
Hover (1996–97), he staged strange happenings in suburban
housing areas, photographing them from a crane above the
rooftops. More recently, in his *Twilight* series [62], he worked with
a cast and crew of the kind found on a film set. Here it is not only
the display of rituals and the paranormal but also the construction
of archetypal characters who carry out these acts that create the
psychological drama. Significantly, at the back of the book about
the *Twilight* series is a 'documentary views' section that shows the
entire production process, the crew members, and the moments
before and after a photograph is taken, confirming the degree to
which Crewdson's tableau photography is a production issue.

Fellow American Charlie White's (b. 1972) series of nine
photographs *Understanding Joshua* [63] implants the character
of Joshua, a part-human and part-alien puppet crafted out of sci-fi
references, into scenes of American teenage suburban life. Joshua
is White's self-loathing protagonist with a fragile ego manifested in
his physicality, seemingly a difference unnoticed by his friends and

family. The photographs are not only playful but also offer an antidote to the strongly female bias in both subjects and practitioners in tableau photography.

Japanese artist Izima Kaoru's (b. 1954) photography injects a very different form of masculinity through the adoption of a strongly voyeuristic staging of beautiful, erotic accidents that lead to the deaths of women resplendent in designer clothing [64]. These fantasies combine a seductive photographic style with a narrative told from a sexualized point of view. Moreover, Kaoru's titles for his series give the names of the model, often well known, and the name of the designer label she is wearing. This is a homage to the device in fashion photography since the 1970s of pairing ideas of cultural and commercial beauty with abject social narratives.

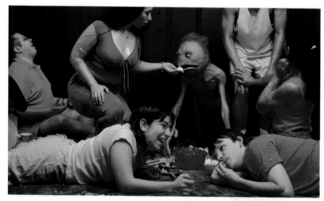

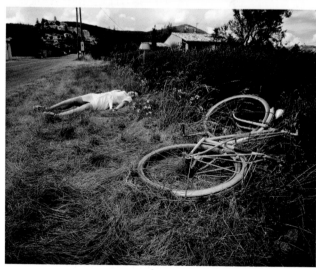

63. **Charlie White**,
Ken's Basement, 2000.
White's photographs perform a difficult task within the context of art, and that is to inject some humour. Since completing this photograph, White has re-created kitsch imagery of sweet animals in fairytale settings that both critique and revel in the saccharine side of popular postcard and calendar imagery.

64. **Izima Kaoru**,
#302, Aure Wears Paul & Joe, 2001.

The indeterminate social or political stance of the photographer in much tableau photography is used to great effect in British artist Christopher Stewart's (b. 1966) *United States of America* [65]. The blinds of a hotel room are closed in daytime; a man possibly of Middle Eastern origin is surreptitiously surveying the outdoors while waiting for the telephone to ring. It feels like a covert operation, but we are unsure if it is within or outside the boundaries of the law. Stewart photographs private security firms (made up of ex- or serving militia personnel), finding contemporary allegories for Western insecurity and paranoia. What is interesting about his approach is that rather than taking the conventional route of documentary or photojournalism in his depiction of real security situations, he chooses to use the formula of tableau photography to give a weighty drama to the stakeouts he witnesses.

The final part of this chapter concentrates on tableau photography that is not reliant on human presence, but that finds drama and allegory in physical and architectural space. Finnish artist Katharina Bosse's (b. 1968) empty interiors are spaces designed for sexual play [66]. These themed rooms in New York,

65. **Christopher Stewart**, *United States of America*, 2002. This photograph was taken while shadowing security professionals on training sessions. What is surprising, given the drama of the lighting and lack of distracting detail in the interior, is that Stewart did not choreograph the figure or alter the interior at all.

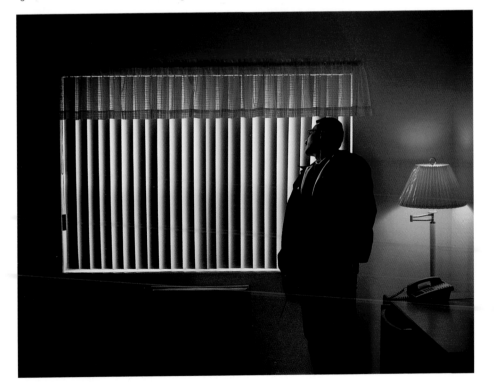

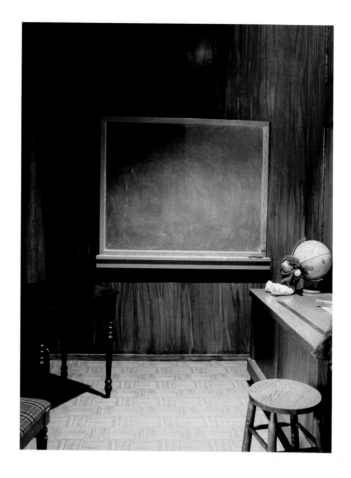

66. **Katharina Bosse**, *Classroom*, 1998. An artist who photographs rooms that can be hired for sex, themed to cater for the most popular sexual fantasies, Bosse depicts them while they are empty, like stage sets before or after a performance.

San Francisco and Los Angeles are legally hired as venues for sex, and what is drawn out in Bosse's representations is the generic and clichéd nature of sexual fantasies, the crossing over from intimate to institutional spaces. This gives Bosse's photographs a poignant reading, one in which architectural spaces contain a trace of an act that will generate stories. Since the mid-1990s, the Swedish artist Miriam Bäckström (b. 1967) has taken a different but parallel form of enquiry in her photographs of room reconstructions in museums and domestic furnishing stores. The seemingly unexceptional room shown on page 72 and the vantage point of the camera mean that at first the image could be taken to be a documentary photograph of a domestic interior or a perfunctory advertising shot for a store [67]. Bäckström is asking us to engage with the plausibility of the room so that we can think about the institutionalized and commercialized construct of the

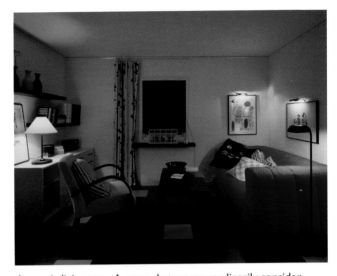

67. Miriam Bäckström,
Museums, Collections and Reconstructions, IKEA Corporate Museum, 'IKEA throughout the Ages'. Älmhult, Sweden, 1999, 1999.

domestic living area. A space that we may ordinarily consider to be defined by an individual's tastes and activities is shown as being prescribed. Our display of personal identity in our homes is not only commercially reproducible but also easily mimicked. Canadian Miles Coolidge's (b. 1963) *Safetyville* project [68] has an uncanny feel in its depiction of an abandoned town, devoid of people, litter and personal details. Safetyville is a model town in California (one third the scale of a real town) built in the 1980s to educate schoolchildren about road safety. In Coolidge's photographs, the corporate and federal signage that gives plausible detail to the town is prominent, highlighting the extent to which the organization of contemporary Western life by business and government pervades even this fake urban space.

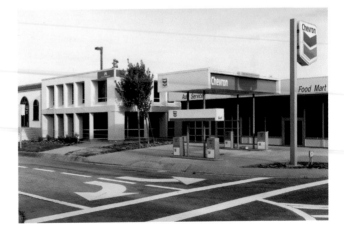

68. Miles Coolidge,
Police Station, Insurance Building, Gas Station, from the *Safetyville* project, 1996.

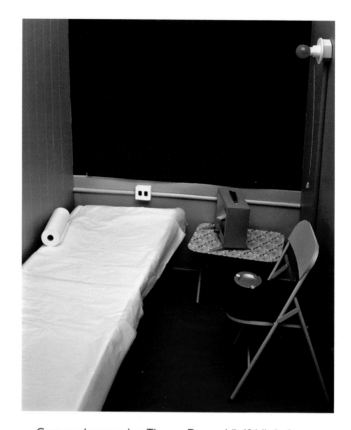

German photographer Thomas Demand (b.1964) deals
with the obstinate presence of inanimate objects, mainly within
architectural interiors [69]. Demand starts his construction
process with a photograph of an architectural place, sometimes
a specific space, such as Jackson Pollock's studio barn or the
underpass in Paris where Princess Diana was fatally injured. He
then builds a simplified model of the scene in his studio, using
Styrofoam, paper and card. At times, he leaves small signs of the
imperfection of his reconstruction, with tears or gaps in the paper
as a way of signalling to the viewer that this is not a fully convincing
reconstruction of a site. He then photographs the scene. Despite
the lack of wear or dirt on the model and the recognition of its
construction from flimsy materials, and hence of its non-
functioning nature, the viewer is encouraged to decipher the
significance of the space and the human acts that might have taken
place there. It makes for a hyperconscious stance, as we look for
narrative form despite the in-built warning signs that this is a
staged, therefore unreal, place. The closeness with which we as

viewers are placed to the scenes and the large scale of the works make us less an audience looking onto an empty stage and more investigators of how little of a physical subject, and how much of the photographic approach, we need in order to start the process of imagining meaning and narrative.

British artist Anne Hardy's (b. 1970) photographs depict interiors that appear abandoned. Like Demand, Hardy constructs sets in her studio with the camera position worked out so that nothing exists beyond what is seen in the photograph. The skill of making a photograph such as *Lumber* [70] is to avoid overloading the image with obvious signs and allegory, but to maintain a sense, albeit a fabricated one, that we are looking at an observed rather than a meticulously constructed scene. Hardy's photographs start with her finding objects that have been discarded on urban streets, objects that have lost their original place and function, around which she then creates sets. In this photograph, the trees were found on the streets of London in the weeks after the Christmas festivities. The space looks like a storeroom for

70. **Anne Hardy**, *Lumber*, 2003–04.

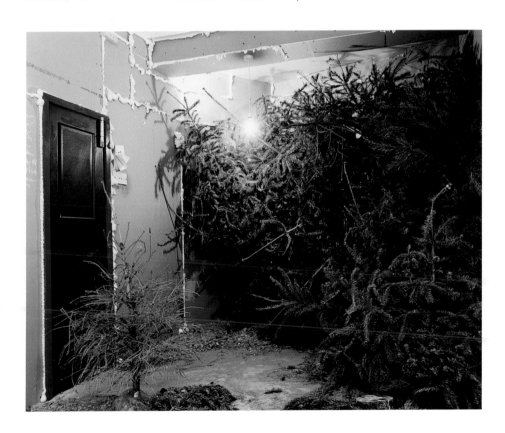

71. **James Casebere**, *Pink Hallway #3*, 2000. Casebere photographs small-scale models that reduce the architectural space to a fragile set of surfaces and disrupt our belief in the solidity and permanence of man-made space.

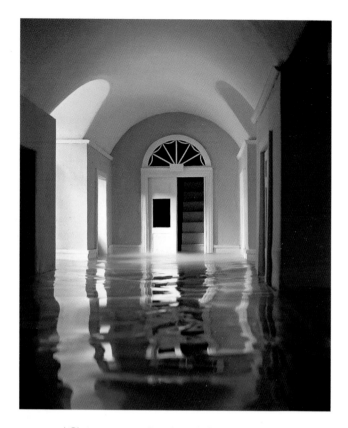

unwanted Christmas trees, but the indoor environment, the menacing shape of the mound of greenery and the thought of what might lie beneath it make for a compelling hovering between what this place might actually be and the unsettling atmosphere within it.

Since the late 1970s, the American James Casebere (b. 1953) has built architectural models for his photographs on a tabletop scale in his studio. His approach is more specifically about investigating institutional spaces in which all paraphernalia of human use has been taken out. His series of photographs of prison and monastery cells reduces the scene to a monochromatic and isolated environment, the sense of waiting and of nothing happening being made emphatic. *Pink Hallway #3* (2000) [71] is a model based on one of the corridors in the Phillips Andover Academy, an early nineteenth-century boarding school in Massachusetts. Casebere has stripped the institution of its details and then flooded the scene in an attempt to create a sense of surreal and claustrophobic disorientation.

German artist Rut Blees Luxemburg (b. 1963) uses the elemental devices of lighting and water reflections to create magnificent amber imagery of urban architecture. The works in her *Liebeslied* (love poem) series (1998–2000) are independent but aesthetically connected architectural scenes. In *In Deeper* [72], the viewer is placed within the scene (at the top of the steps of a river embankment). Footprints are left in the wet silt on the steps leading into the luminescent river, revealed by raking lighting. Luxemburg's photographs are magnificent additions to the visual repertoire of night-time urban photography since the experimental and surreal use of portable flash lighting in the 1920s and 1930s. The principle through the ensuing century has remained the same: when the urban night scene is illuminated in a dramatic way, the surreal and psychologically charged potential of space is emphasized. But each epoch has its own artistic concerns and own particular narrative conclusions. With their uncanny qualities, Luxemburg's pictures take something of the history of night-time photography, but imbues it with the contemporary and personal experience of the city.

72. Rut Blees Luxemburg,
Nach Innen/In Deeper, 1999.

73. Desiree Dolron,
Cerca Paseo de Martì, 2002.

The pictorial conflation of an event just passed and the history of a place embedded in its fabric form the basis of the narratives of Dutch artist Desiree Dolron's (b. 1963) *Cerca Paseo de Martì* [73]. The work depicts a classroom in Havana, Cuba, in which empty chairs face the impassioned political statements chalked on the blackboard and the portrait of a young Fidel Castro to the right. Although more directly political, perhaps, in its narrative than the work of Demand, Casebere, Luxemburg, Hardy and Bosse shown here, this photograph similarly encourages us to mentally fill the visual absence of people through the traces of their actions and thoughts. Dolron's Cuban project takes place in a country whose forty-five-year revolution to build a flourishing and independent country endures to this day. She finds the spirit and contradictions of its culture in poetic erosion, embodied in the peeling paint and cracks of Havana's architecture, and the signs of its continued politicization of daily life.

In both her studio-based still lifes and her street-scene photographs, British artist Hannah Collins (b. 1956) has made a

74. Hannah Collins,
*In the Course of Time, 6 (Factory
Krakow),* 1996.

substantial contribution to developing the phenomenological
effect of architectural tableau photography. Her photographs are
large and backed onto (or directly printed onto) a canvas fabric
that is pinned to gallery walls. *In the Course of Time, 6 (Factory,
Krakow)* [74] is over two metres in height and five metres in length.
In the presence of such a work, the viewer is offered an essentially
physical relationship to the scene. The Polish factory is not life
size, but gives the viewer the feeling of approaching and being
about to enter the pictorial space. Another allusion could be to
a stage set moments before the performance begins. In the 1990s,
much of Collins's work was a meditation on post-Communist
Europe. It traced the way contemporary life, shaped by both

historical and recent events, marks architectural spaces.
Combining the signs of enduring and changing ways of working,
they contain within their fabric the very history of a society.
Collins's photography reveals and draws out these histories.
Her use of the panoramic format aids her in this respect, for
it calls for the sustained and contemplative looking that art has
traditionally required of the viewer, and from which we can
decipher subtle narratives of human behaviour and history.

Chapter 3 Deadpan

More photography has been created for gallery walls in the last decade than in any other period in the medium's history. And the most prominent, and probably most frequently used, style has been that of the deadpan aesthetic: a cool, detached and keenly sharp type of photography. Here the reader is at the mercy of the levelling out that occurs when these photographs are reproduced in a book. The monumental scale and breathtaking visual clarity that predominate when one experiences the photographic print need to be kept in mind. But what can still be seen in a glance if one looks through the images in this chapter is the seeming emotional detachment and command on the part of the photographers. The adoption of a deadpan aesthetic moves art photography outside the hyperbolic, sentimental and subjective. These pictures may engage us with emotive subjects, but our sense of what the photographers' emotions might be is not the obvious guide to understanding the meaning of the images. The emphasis, then, is on photography as a way of seeing beyond the limitations of individual perspective, a way of mapping the extent of the forces, invisible from a single human standpoint, that govern the man-made and natural world. Deadpan photography may be highly specific in its description of its subjects, but its seeming neutrality and totality of vision is of epic proportions.

The deadpan aesthetic became popular in the 1990s, especially with landscape and architectural subjects. In hindsight, it is clear that this form of photography contained elements that matched the gallery and collecting climate of the decade to such a degree that it shifted photography to a more central position in contemporary art. The impetus within art to define new trends that can supersede established 'movements' played in the medium's favour in the early 1990s. Photography that offered an objective and almost clinical mode had a renewed freshness and desirability after a heavy concentration in the 1980s on painting and so-called neo-expressive, subjective art-making. The increased

75. **Celine van Balen**, *Muazez*, 1998.
Van Balen's portraits of residents in temporary accommodation in Amsterdam include a series of head-and-shoulders portraits of Muslim girls. Her choice of the stark, deadpan aesthetic to represent the girls emphasizes the self-possession with which they confront her camera and their presence in contemporary society.

scale of photographic prints since the mid-1980s not only took photography into the same league as painting and installation art but also commanded space in the increasing number of new art centres and commercial galleries. The subjects of these photographs, panning across a range of manufactured locations, of industrial, architectural, ecological and leisure-industry sites, was tantalizingly close to being the perfect, self-referential art for the imposing buildings, often converted from industrial warehouses and factories, in which contemporary art was now being shown. Deadpan photographs, so technically well done, pristine in their presentation, rich with visual information, and with a commanding presence, lent themselves well to the newly privileged site of the gallery as a place for seeing photography.

Although the art world's acknowledgment of this new approach dates to the early 1990s, today's front-ranking practitioners had been working out of the limelight for at least half a decade before. The deadpan aesthetic we see today is often characterized as 'Germanic'. This moniker refers not only to the nationality of many of the key figures but also to the fact that a significant number were educated, under the tutelage of Bernd Becher, at the Kunstakademie in Düsseldorf, Germany. The school was instrumental in unshackling photography education from teaching vocational and professional skills, such as photojournalism, and instead encouraged its students to create independent and artistically led pictures. The 'Germanic' characterization also refers to the traditions of 1920s and 1930s German photography known as New Objectivity (Neue Sachlichkeit). Albert Renger-Patsch (1897–1966), August Sander (1876–1964) and Erwin Blumenfeld (1897–1969) are the most regularly mentioned forefathers of today's deadpan photography. Their approach was encyclopedic: they created typologies of nature, industry, architecture and human society through the sustained photographing of single subjects, their most resounding influence on contemporary art photography.

As discussed in the introduction, Bernd and Hilla Becher have been and continue to be highly influential in the shaping of contemporary deadpan photography. Many of the photographers whose work is shown in this chapter, including Andreas Gursky, Thomas Ruff, Thomas Struth, Candida Höfer, Axel Hütte, Gerhard Stromberg and Simone Nieweg, were their students. The Bechers' collaboration on series of black-and-white photographs of pre-Nazi German industrial and vernacular architecture, such as water towers, gas tanks and mine heads, began in 1957 and is

ongoing [6]. Each building within a series is photographed from the same perspective, notes on each are taken, and a typology is systematically created. The Bechers' work appeared in 'New Topographics: Photographs of Man-Altered Landscape', a touring exhibition that began in 1975 in America. The show was an early attempt to mark European and North American photographers' reinvestment of the genres of topographical and architectural photography with the implications of contemporary urban generation and the ecological consequences of industry. What is significant is that these social and political issues were raised in the context of the art gallery and within the discourses of conceptual art. In this social and political light, it is understandable that what at the time were seen as individual photographic styles would be abandoned in favour of a neutral and objectifying approach.

The photographer who has come to stand as the figurehead of contemporary deadpan photography is Andreas Gursky (b. 1955). Gursky moved towards using large prints in the late 1980s, and through the 1990s pushed photography to new heights and widths. A photograph by him today is often two metres high and five metres wide. His works make for very imposing objects, pictures to stop you in your tracks, and he has become synonymous with work on this scale. The photographs bring together both traditional and new technologies (he has used large-format cameras for maximum clarity and digital manipulation to refine an image) with a fluidity that hitherto had been the preserve of commercial advertising photography. Unusually, Gursky creates photographs that are not primarily contingent on being viewed as part of a series. Instead, he adds to his oeuvre with each satisfyingly complete picture, rather like a painter does, so every photograph he releases has a good chance of contributing to the high reputation enjoyed by his work as a whole. By doing so, Gursky avoids the riskier strategy that most photographers follow of making different and distinguishable bodies of work. While a new series may take a photographer's practice into uncharted territory, when it is received by the public it is automatically compared with earlier works. And if that new body of work is considered inconsistent, or if the photographer is thought to be still working through an artistic idea, that comparison can be negative, diluting his or her overall standing in the art world. Gursky, on the other hand, works within connected themes and releases photographs that stand as discrete visual experiences. His immaculate consistency is an undeniable element of his commercial and critical success.

However, Gursky's importance comes from more than the surface perfection he achieves. It comes from his capacity to travel the world, find his subjects and then convince us that each scene could not have been more fully described than from his chosen perspective. His signature vantage point and, it is often claimed, his first innovation is a viewing platform looking out over distant landscapes and sites of industry, leisure and commerce, such as factories, stock exchanges [76], hotels and public arenas. Gursky often places us so far away from his subjects that we are not part of the action at all but detached, critical viewers. From this position, we are not being asked to interpret the individual experience of a place or event. What we are given instead is a mapping of contemporary life governed by forces that are not possible to see from a position within the crowd. Human figures are usually minute and densely packed in a mass; when individual actions or gestures can be picked out, they are like notes within chords of general activity. At their most vivid, these works give us a sense of omniscience: we see the scene as a whole made up of tiny constituent parts and even feel like a conductor in front of an orchestra. Gursky's liberation from making photographs that propose a monocular perspective of the world (the pseudo-simulation of human vision with which photography has

76. **Andreas Gursky,**
Chicago, Board of Trade II, 1999.

77. **Andreas Gursky**,
Prada I, 1996.

traditionally been credited) is not limited to simply stepping back
to an epic distance. In recent years, other picture types have
appeared in Gursky's work, specifically ones that bring us
dramatically close to a subject, such as his photographs of
enlarged details from paintings of the past, where we are held
in two-dimensional space to a disorientating degree. Gursky has
also constructed his own sets, as shown here in one of his *Prada*
series [77]. This photograph is one of the relatively few instances
in which we are positioned at seemingly human height and
distance from the subject. The even lighting emanating from this
disturbingly clinical, fictive world accentuates the spiritually
barren shrine that is the contemporary shop display.

Although Gursky commands a dominant position within our
understanding of the capacities of deadpan photography, by no
means does he hold the patent on either this style or its range
of subjects. Many photographers have similarly been drawn to
analysing the world through the thoughtfulness and precision
that is possible with large-format cameras, with or without the
aid of digital post-production. Walter Niedermayr's (b. 1952)
large photographs have concentrated primarily on contemporary
tourism, with the cool and unnerving sense of the degree to
which our time, especially time spent away from the workplace,
is administered. In the photograph shown overleaf, the chalets
and leisure-geared community on the snow-capped mountain
look like a fragile imposition onto the vast landscape [78].
By photographing the chalet village from a detached distance,
Niedermayr suggests the experience of looking at a toy town or

78. **Walter Niedermayr,**
Val Thorens II, 1997.
An artist who captures the
encroachment of tourism on a
mountainous landscape,
Niedermayr creates panoramic
representations that are situated
within the aesthetics of landscape
painting and nineteenth-century
topographical photography with
their ambitious size and depiction
of phenomenal terrain. Equally, the
works are about the modern-day
commodification and invasion of
nature by man.

79. **Bridget Smith,**
Airport, Las Vegas, 1999.

80. **Ed Burtynsky,**
Oil Fields #13, Taft, California, 2002.

an architect's model. He raises questions about our desire, when
we are on holiday, to feel like we are in the ungovernable forces
of nature, but always safe in the knowledge that our creature
comforts are within reach. Niedermayr's photographs act as a
diagram of how what might feel like an individualized experience
of being free in nature is in fact controlled by the same layouts
of buildings, routes and ergonomic forces of town planning that
we experience during our daily working lives. Similarly, Bridget
Smith's (b. 1966) explorations of the architecture of Las Vegas [79]
are represented in a photograph of the city's airport with a line
of hotel casinos running at a distance along the horizon. The
buildings are almost comically diminutive, an Egyptian-style
pyramid and sphinx and a Manhattan skyline lodged in the
architectural menagerie of the Las Vegas Strip. Smith's choice
of photographing in daylight rather than at night, when the city
is illuminated and aesthetically far more magical, offers a frank
and more unglamorized impression of the city.

In Ed Burtynsky's (b. 1955) photographs of oilfields in California
[80], the man-made landscape is given over to industry, with oil
pumps and telegraph poles weaving across its surface, up to and
as far as the distant ridge of mountains in the background. While
social, political and ecological issues are embedded into his
subjects, they are visualized as objective evidence of the
consequences of contemporary life. This is one of the major
uses of what, to a contemporary eye, looks like a distinctly
neutral photographic stance. Polemical narratives are raised
for the viewer, but it appears as if this information is being given
impartially. Deadpan photography often acts in this fact-stating

mode: the personal politics of the photographers come into play
in their selection of subject matter and their anticipation of the
viewer's analysis of it, not in any explicit political statement
through text or photographic style.

Japanese artist Takashi Homma (b. 1962) photographs newly
built suburban housing in Japan [81] and the landscaping around it,
in which everything is strategically placed. He gives the houses on
the outer edges of suburban sprawl a sinister element, positioning
his camera at a low vantage point, photographing only when the
sites are devoid of human beings. The sense of the recently
constructed, blueprinted way of life in readiness for habitation
is all-pervasive. Homma develops ideas that first emerged in the
1970s, when the dehumanizing impact and the politics of housing
developments and the industrial use of land were coolly and
categorically raised in photographic practice. One of the major
figures of this earlier period was the American photographer

Lewis Baltz (b. 1945), who first gained international recognition in 1975 through his inclusion in 'New Topographics: Photographs of a Man-Altered Landscape'. In the following decades, Baltz became one of the most influential instigators of a critical reworking of American landscape and architectural photography, his icy-cool black-and-white photographs mapping the uneasy encroachment of industrial and housing developments onto open landscapes. In their own way, and as significantly as the Bechers' work, Baltz's photographs of the 1970s and 1980s harnessed the medium's documentary capacity in its depiction of fast-changing social environments with a conceptual precision that gave it the right tenor for art-world status. After moving from America to Europe in the late 1980s, Baltz regularly worked with colour photography to represent the new high-tech environments of research laboratories and industries, illustrated here with a photograph from his *Power Supply* series [82]. This shift to colour photography was necessary for Baltz to focus attention on the spectacle of 'clean' industries, and the sense of codification and zones of data carried in these pristine spaces.

The German artist Matthias Hoch's (b. 1958) typology of contemporary life has typically centred on architectural detail and interiors. In *Leipzig #47* [83], there is an evident sense of

82. **Lewis Baltz**, *Power Supply No. 1*, 1989–92. This image has the colour and austere geometry that makes the affinity between American and European deadpan photography especially pronounced. The shared concern for visualizing how contemporary life is administered, here in the unsettling perfect world of a 'clean' industry, is also highlighted.

83. **Matthias Hoch,**
Leipzig #47, 1998.

geometry and mapping. The light emanating from the screen flattens the poles in the foreground, emphasizing the nature of the space that determines the subtle drama of the scene. This photograph was taken at one of the signature moments in deadpan's depiction of buildings: the point when, construction completed, the space has been designed with a purpose but is as yet unused, before any idiosyncratic human customizing of the interior has begun. There is, perhaps, a hint of irony in Hoch's depiction of this space with a Far Eastern asymmetry, a sense of how designer Zen is made to engender calm in those who pass through it.

Jacqueline Hassink's (b. 1966) ongoing *Mindscapes* project links a number of investigations of architectural spaces for both public

and private use within transnational businesses [84]. Hassink applied to photograph ten rooms in a hundred American and Japanese corporations (including the CEOs' home offices, archives, lobbies, boardrooms and dining rooms). The refusals and acceptances Hassink received feature on a graph that accompanies the photographs of the rooms to which she gained entrance. The results of her systematic approach spell out the generic links between corporations, regardless of the nature of their business, and the values that each corporation attaches to itself through the demarcation of space. These include whether a board meets at a round or more hierarchically shaped table and whether the business is traditional, its space decked out in wood panelling, or adopts a high-tech minimalist appearance, suggesting a forward-thinking and progressive mode of commerce.

For over fifteen years, Candida Höfer (b. 1944), has made cultural institutions her subject, creating an archive of the spaces in which collections are stored and accessed [85]. It was not until

84. **Jacqueline Hassink**, *Mr. Robert Benmosche, Chief Executive Officer, Metropolitan Life Insurance, New York, NY, April 20, 2000*, 2000.

85. Candida Höfer,
Bibliotheca PHE Madrid I, 2000.
This image depicts a modern
university library in Madrid,
Spain. Höfer photographs historical
and contemporary architecture
spaces and at times, such as here,
draws out the classical structures
in recent architecture, such as
the amphitheatre-like construction
of the bookshelves.

recently that she began to work with a large-format camera
and print to the larger sizes that are current within contemporary
photography. Her use of this kind of camera has also been marked
by an increasingly monochromatic colour range, which the
heightened graphic delineation of this clearest of photographic
formats emphasizes. Höfer's approach was developed while using
a handheld medium-format camera, which allowed her to work
unobserved and with a degree of intuition when looking for her
preferred viewpoint, one that best described what she found in
these spaces. This approach has been carried through in all of
Höfer's photographs and has given her room for unexpected
elements in the construction of her imagery. There is a sense in

86. **Naoya Hatakeyama**,
Untitled, Osaka, 1998–99.

her pictures that the clear and lengthy look onto an interior scene is prevented from being a deadening experience by her choosing a perspective that does not edit out the oddities and contradictions of the space. At times, this is done simply through her choice of vantage point, which only sometimes looks onto the view centrally, so we see the space subtly out of kilter with the architectural symmetries of the site.

Deadpan photography has a great capacity for capturing the wonder of the man-made world in an elegiac manner. For over twenty years, Naoya Hatakeyama (b. 1958) has photographed cities and heavy industrial spaces in his native Japan. His ongoing *Untitled* series, begun in the late 1990s, features views over Tokyo exhibited in a grid of small photographs. They are an evocation of the infinite photographic views onto the chaotic and seemingly unnavigable layout of the city. Hatakeyama has also collaborated with the architect Toyo Ito (b. 1941), photographing Ito's buildings while under construction and engaging with the conceptual thinking and structure that underpins the architectural process. *Untitled, Osaka* [86], is an elevated view into a baseball stadium being converted into a show-home park and represented as a contemporary settlement similar to a classical ruin. There is a breathtaking magic in the photograph suggesting that something that is impossible to see, either at close quarters or in the real-time motion of the busy city, is contained in its awesome observation.

87. Axel Hütte,
The Dogs' Home, Battersea, 2001.
Hütte's night-time photographs
of cities are printed as large
transparencies and then framed
in front of a reflective surface,
which shows through the light
areas of the image. This adds a
subtle luminosity to the works,
light seeming to emanate from
the city.

Axel Hütte (b. 1951) introduced a new element to his deadpan photography in the mid-1990s with a series of photographs of cities taken at night with long exposure times. These photographs are presented as transparencies held in front of a reflective surface, creating a glistening effect in the illuminated areas of the image where the mirror-like backing is visible. Although night-time photography has an implied theatricality that one might not immediately associate with the subject of this chapter, it is part of deadpan photography's presentation of things we cannot perceive with the naked eye. This quality, apparent in both Hütte's picture of Battersea Dogs' Home in London [87] and Hatakeyama's *Untitled, Osaka,* as with all the works illustrated here, offers heightened, protracted observations of the world, a photographic pause on a subject that will mediate the energy and character of the place portrayed.

Since the late 1990s, British artist Dan Holdsworth (b. 1974) has photographed transitional architectural spaces and remote landscapes. Often termed 'liminal spaces', these areas exist where cracks in institutional or commercial definitions appear, and our sense of place is dislocated. In his photographs of the car parks of

a newly built out-of-town shopping centre [88], Holdsworth uses night-time both as the temporal equivalent of, and the best conditions with which to describe, the auspicious spaces he depicts. By setting up his camera for a long exposure, the lights of the car park and the traffic are depicted as radiating luminescence. The image has a distinctly non-human atmosphere, as if showing us an essence that could not be seen by the naked eye. Rather than asking *who* took this photograph, one might reasonably ask *what* took it, the sense being that the unsettling contamination of the night is being recorded mechanically, by a surveillance camera perhaps.

Other deadpan photographers shift the emphasis away from economic and industrial sites and towards less obvious contemporary subjects. Landscapes and historical buildings are shown because of their innate capacity to be understood as sites where time is layered and compacted. We engage not only with the moment the photograph was taken but also with its depiction of the passing of the seasons or the memories of past cultures and historical events.

88. **Dan Holdsworth,**
Untitled (A machine for living), 1999.

89. **Richard Misrach**,
Battleground Point #21, 1999.

For more than thirty years, American photographer Richard Misrach (b. 1949) has created numerous bodies of landscape and architectural photography, with a particular focus on the American West and the traditions of its representation. His political and ecological views come through his images of sites in the aftermath of landscape devastation and man's destruction of natural resources. In 1998, Misrach was commissioned by the Nature Conservancy to photograph the historic landscape of Battleground Point in the Nevada desert (the site of a legendary battle fought by the Native-American Toidikadi tribe), which had been newly desolated by dramatic floods. In the work shown here [89], Misrach represents the remnants of the flood sheltered by a sand dune, contradicting our expectations of the desert landscape and giving the scene an unearthly desolation. He presents the site as one that is monumental and historical yet still changeable. With his objective stance, he has borne witness to a site that has its own story to tell, a site that only photography lacking the overbearing hyperbole of a strong personal signature could visualize effectively.

90. **Thomas Struth,**
Pergamon Museum 1, Berlin, 2001.
In this image of visitors to an art
institution, Struth has framed the
scene in a seemingly neutral way,
so that our act of looking when
surveying the scene feels different
from that of the museum-goers.
Struth's depictions of galleries have
been especially resonant when
hung in museum and gallery spaces,
giving visitors a self-conscious look
at their own cultural behaviour.

The pervading quality of Thomas Struth's (b. 1954)
photography is the awareness it creates of the conditions that
structure images, whether it be the camera's position in the
middle of the road in his street scenes in Düsseldorf, Munich,
London and New York in the 1980s and early 1990s, or the
formal poses of families in Japan and Scotland. His works make
one conscious of looking not only at a clearly depicted subject
but also at the photographic form into which they have been
projected. Struth's subjects are always interesting and stimulating,
but are rarely proposed as an experience into which we can
immerse ourselves psychologically. The invitation here is not for
us to feel part of the scenes or to empathize with the relationships
that are shown, nor to think of the images as revealing heightened
moments in time, but to wonder at their perspectives, at the
pleasure of scrutinizing them as photographs. Struth's images of
galleries and their visitors reveal much about collective cultural
behaviour. The Pergamon Museum in Berlin, for instance [90],
containing ancient Greek sculpture and architecture, is shown
as a site where contemporary social posturing meets the relics of

91. **John Riddy**,
Maputo (Train) 2002, 2002.
In his architectural photographs,
Riddy finds the most balanced
vantage point for the camera. This
conscious decision minimizes our
awareness of the photographer's
perspective on (and reaction to)
the sites and aims to bring the
viewer into a direct relationship
with the subject.

grand civic display of long-dead societies. The poses of the
figures in this photograph are public yet strangely isolated and
mannered as they individually engage with the spectacle of
history and the event of the gallery visit.

The conflation of time in Struth's *Pergamon* photographs
relies on a dulled, almost monochromatic palette. This is a quality
apparent in the photographs of John Riddy when he recently made
the transition from working in black and white to colour. His
reservations about using colour for his architectural photographs
had been that it has a tendency to root the scene in the moment.
What interests Riddy is photography's capacity to conflate time
and its ability to evoke the history of a space. In *Maputa (Train)
2002* [91], the turquoise paintwork and the benches become
the fading signs of a moment in the place's colonial past. Present
time is shown in the train carriage at the centre of the image,
an element we know will soon depart without a trace. Riddy
photographs his scenes from a precise angle where the
architecture falls into a symmetry. This conscious choice
acknowledges the fact that certain angles make the photographer's

perspective (or experience) more evident to the viewer, and others less so. The architectural ruin is also found in more dramatic images, such as Gabriel Basilico's (1944–2013) view across Beirut in 1991 [92]. The city, photographed from a rooftop, is presented as a heavy populated, densely packed expanse. Through the clarity with which Basilico represented this scene, we are given a view of the pockmarks made by bombing, the evidence of the city's late twentieth-century history, physical scars amid the bustle of daily life. Basilico's selection of this viewpoint is important in guiding our reading of the image. He found a position that places the road and its signs of human activity right at the centre of the picture and shows it extending to the horizon. By using this device, he emphasized the sense of humanity's resilience in this war-torn city.

Since 1986, Simone Nieweg's (b. 1962) photographs have concentrated on the agricultural land of the Lower Rhine and Ruhr districts of her native Germany. Although she has worked occasionally in other landscapes, her preference has been to photograph the places near to where she lives, so that she can

92. **Gabriele Basilico**, *Beirut*, 1991.

study them over a lengthy period of time. The deadpan aesthetic
that Nieweg favours, with its signature clarity of vision and diffused
light from an overcast sky, is perfectly matched to her thoughtful
and subtle observations. Conscious of precedents such as
Impressionist painting, Nieweg looks for repetitive forms that
appear in the landscape. There is a special emphasis on the planar
qualities of hedgerow banks and woodland, and the linear
organization of plough furrows and crops. These directions
literally embedded in the land not only create the structure for
her photographs but also provide the vantage point from which
she takes the picture. Her images often include a small disruption
of agricultural order, as in *Grünkohlfeld, Düsseldorf – Kaarst* [93],
where the traces of a contaminated patch of crop are centrally
positioned in the foreground, a subtle allegory of nature's
resistance to farming.

Japanese artist Yoshiko Seino's (b. 1964) photographs often
show places where nature has begun to reclaim a landscape from
man-made efforts to use and shape it, subverting the expected
hierarchy of natural and industrial encounters. Her choice of
non-specific and marginal spaces means that it is not so much the
decay of an architectural or industrial site that is emphasized, but
allegories of how human neglect can give rise to a transformation
back to nature [94]. The photographs of German artist Gerhard
Stromberg (b. 1952), show man-made landscapes (such as a copse
where trees are planted for felling) [95] without the trappings of
an individual photographic style, so that our engagement with the

96 and 97. **Jem Southam**,
Painter's Pool, 2003.

subject feels remarkably present and unmediated. By its very condition as a landscape scene, a traditional subject in art and a site of metaphorical meaning, the photograph offers potential narrative in the brutality of the tree stumps in the foreground and the dense barrier of the woodland behind.

British artist Jem Southam's (b. 1950) *Painter's Pool* is a series of photographs set in a woodland and looking onto a pond that were made at different times of the year and within a twenty-five-metre radius [96, 97]. The area looks overgrown and uncultivated, but it is a site in the south west of England that a painter once dammed to create a pool and where he has worked exclusively ever since. Southam set up a parallel photographic investigation of the site over the course of a year. Only small signs of the painter's visits are visible, such as the ironing board on which he rested his drawing materials. Southam's photographs seem to respond to the quandary faced by the painter – who had worked in this space for more than twenty years but was only recently able to finish a painting of the pool – by showing us how the conditions of the site and the permutations of weather, seasons and light constantly changed, each visit offering a new picture. *Painter's Pool* is typical of Southam's working methods. He spends a great deal of time in the places he photographs and becomes sensitized to the shifts in their state over the course of the project. Each photograph conveys the wonder of approaching the place and seeing it afresh each time.

Korean artist Boo Moon's (b. 1955) series of photographs from the late 1990s of the East China Sea [98] are similar in that they, too, deal with how our sense of place is governed by permutations of light and movements of water. The series intensifies the idea that natural forces have an infinite momentum

and are governable by no one. This type of photographic strategy contemplates the unknowable and uncontrollable character of nature. Such images are consciously out of time, not reliant on the visual signs of contemporary economics, industry or administration, or even on those of the past, but on signs that bring us into contact with profound and destabilizing concepts about our perception of the world.

The images in Clare Richardson's (b. 1973) *Sylvan* series [99] were made in farming communities in Romania. They have a disconcerting impact because they are contemporary photographs of a world that has changed little for centuries. Because of the clarity of Richardson's vision, her images, while revealing the strong visual links these isolated but functioning communities have with premodern living, are free from being overtly sentimental or

98. Boo Moon,
Untitled (East China Sea), 1996.
Because the seascape is framed with the horizon at the centre of each photograph in the series, the permutations of the cloud formations and wave patterns are the only decipherably changing elements.

99. Clare Richardson,
Untitled IX, 2002.
This series of large photographs of Romanian hamlets and farmland balances the beauty of the landscape, remarkably unchanged by modern life, with the exacting deadpan aesthetic. As in many of the photographs in this chapter, historical and contemporary time are conflated.

mocking. The fine balance between the sublime and romantic capacity of a landscape subject and a style of photography that is clear-cut and not obviously subjective has been a fertile creative area for contemporary photographers. Lukas Jasansky (b. 1965) and Martin Polak's (b. 1966) *Czech Landscapes* [100] concentrate on land use and ownership in the post-Communist Czech Republic. Significantly, these photographers work in black and white, which, in the context of Eastern Europe, has much more currency today than in the most commercially developed Western art centres, where colour photography is much more common. To a certain degree, Jasansky and Polak's surveys of Czech architecture and landscape have a similar duality to the Bechers' practice since the 1960s of being relevant both to art in their conceptual framework and also to conservation movements as documents of a changing country. The sense of a land administered

100. **Lukas Jasansky and Martin Polak**, *Untitled*, 1999–2000.

101. Thomas Struth,
Paradise 9 (Xi Shuang Banna Provinz Yunnan), China, 1999. This is an image taken from a series that depicts dense forests and jungles in America, Australia, China and Japan. Struth chose sites that were not too identifiable with a specific part of the world or too exotic, suggesting a botanical garden. Struth offers, through these beautiful and disorienting images, spaces that he considers to be pictorial and emotional sites for meditation.

in ways that have changed little but which is on the threshold of late capitalism echoes through the photographs.

Thomas Struth's *Paradise* series [101] shows forests and jungles whose density, and the way in which he has closely framed sections of it, creates what he describes as 'membranes for meditation'. They have a synergy with his deserted street scenes of the 1980s, in which he attempted to create photography that offered a distilled experience of complex visual scenes. In *Paradise*, every single organic element seems connected and impossible to disentangle. Struth's depictions are considered but intuitive in responding to these intricate sites. He uses photography as a tool for eliciting internal dialogue and contemplation in the viewer.

This chapter draws to a close by considering artists who use the depersonalized deadpan style in portraiture. One of the most influential portrait photographers of the 1980s was German artist Thomas Ruff (b. 1958). As is the case with Struth, Ruff's practice for over twenty years has been far reaching and wide ranging and can only be partially represented here. Regardless of his ostensible subject matter, which includes architecture, stellar constellations and pornography (see Chapter 7), he brings a spectrum of photographic image types into play. Rather than the signature of his photographs being found in a single approach to the medium, Ruff raises a more interesting issue of how we comprehend different subjects through the photographic form. He experiments with the way we understand a subject because of our knowledge or expectation of how it is represented pictorially. In the late

1970s, Ruff began photographing head-and-shoulder images of his friends, reminiscent of passport photographs, although considerably larger in format [102]. His sitters chose from a range of plain-coloured backdrops in front of which they would be photographed. Ruff asked his subjects to remain expressionless and look straight at the camera. With some modifications (in 1986, he replaced the use of a coloured backdrop with a pale neutral background and also increased the size of his prints), it is a formula that Ruff has continued to investigate. At the same time as offering great detail in the sitters' faces, right down to the hair follicles and pores in their skin, the works' blank expressions and lack of visual triggers, such as gesture, confound our expectations of discovering a person's character through their appearance.

Hiroshi Sugimoto's (b. 1948) photographs of museum waxworks place us in a similar position of critical self-awareness.

102. **Thomas Ruff**,
Portrait (A. Volkmann), 1998.

103. **Hiroshi Sugimoto,**
Anne Boleyn, 1999.
This black-and-white photograph
of a waxwork model highlights
how we unconsciously respond
to photographic representations
of human forms. We know that
this photograph does not depict
a real human being but a recent
romanticized model of a queen
from British history. Our response
to Sugimoto's waxwork pictures
is to enquire into the subjects'
characters and personalities as
if they were photographs of
living people.

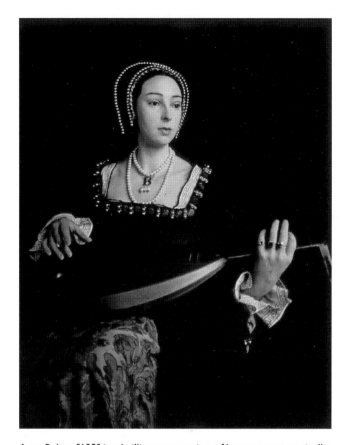

Anne Boleyn [103] is a brilliant summation of how we automatically
search for evidence of character, even in a waxwork, because of
the animated impression a photograph suggests. Sugimoto's and
Ruff's objectively styled pictures dramatically curtail our
expectations that we can know anything essential about a person
through their photographic image. The ideas that the signs of our
biographical details are mapped onto our faces and that our eyes
are the windows into our souls is brought into question. If there
are realities or truths held within the deadpan portrait, they
revolve around very subtle signs of how people react to being
photographed; the observations artists make are about how their
subjects address the camera and photographer in front of them.

Street portraiture is arguably the most prevalent context for
deadpan portrait photography. Joel Sternfeld's (b. 1944) portraits
do more than raise the question of what we can assume to know
about a sitter from their outward appearance. They also propose
the facts of what has transpired: that Sternfeld has negotiated

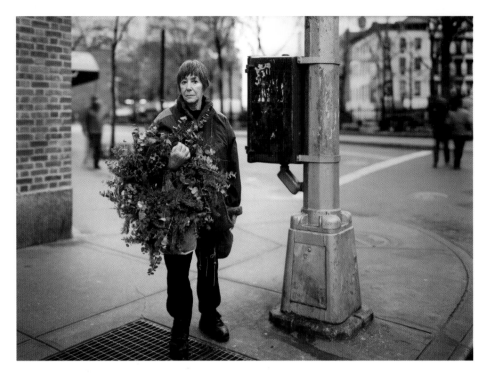

104. Joel Sternfeld,
A Woman with a Wreath, New York, New York, December 1998, 1998. Sternfeld photographs people at a respectful distance. Most of his subjects are aware that they are being photographed and simply stop their activity for the duration of the photograph. Sternfeld's selection of strangers is not a rigid typology. While there are archetypal elements such as the depiction of city traders or housemaids, he also portrays strangers whose appearance does not confirm who or what they are.

with a stranger to photograph them at a polite distance, asking them simply to halt what they are doing and prepare to be photographed. The subject's reaction to what is happening, which includes their resistance, their ambivalence about this brief break in their routine, becomes the portrayed 'fact'. We guess when studying Sternfeld's photographs what it was in a person's demeanour that intrigued the photographer. That search for subtle visual interest is a guiding force in Jitka Hanzlová's (b. 1958) *Female* series, in which she photographs women of different ages and ethnic origins in cities she visits [105]. There is, in her selection of subjects, a developing typology; individual styles and characters seem to become legible because of Hanzlová's serial and systematic approach. How each woman reacts to the camera gives us information about her state of mind. Street portraiture in this vein becomes a transparent testimony to the photographic encounter. It is on this that our imaginings about the sitters pivot, reinforced by the similarities and differences between the images of a single series.

In the late 1990s, Norwegian artist Mette Tronvoll (b. 1965) moved the location of her photographic portraits out of her studio and into the open air, taking the systemized approach to

portraiture she had developed in her studio with her. She has produced a number of series of pictures of remote communities in Greenland and Mongolia that portray the people and their environments [106]. In her portraits of single people and groups, the streets become a backdrop. Just as with the other portraits illustrated in this chapter, the vantage point is straight onto the figures. This convention of photographers working in the deadpan aesthetic to belie the choice of camera angle by selecting the most simple and neutral stance means that we feel our relationship to the people portrayed is direct and that as we look at them, they look back at us.

Albrecht Tübke's (b. 1971) *Celebration* series takes place on the sidelines of processions at public festivals. Tübke invites his

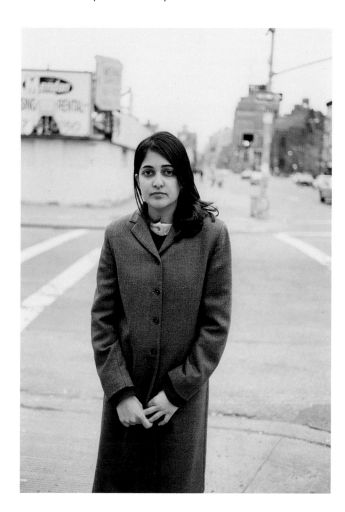

105. **Jitka Hanzlová**, *Indian Woman, NY Chelsea*, 1999. This image is from a series of portraits the photographer took of women she came across in the street. The photographs have a neo-objective quality in the way in which each woman is shown facing and acknowledging the photographer. Because it is a series, the similarities and differences between the women's attitudes and locations become a way for us to apply subjective reasoning to what, beyond their gender, connects and distinguishes these women.

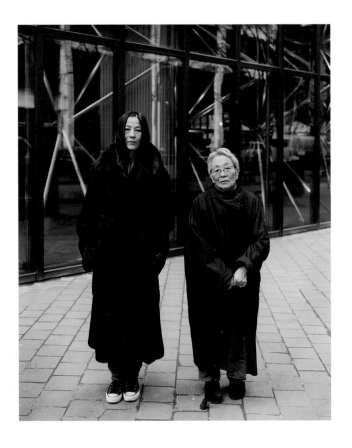

106. **Mette Tronvoll**, *Stella and Katsue, Maiden Lane*, 2001.

subjects to step out of the crowd and then photographs them individually as they cease their revelry for a moment [107]. At times, the only parts of their body not clad in costume are the hands and areas around their eyes. In Tübke's photographs, the sense of the subjects being hidden beneath a masquerade goes beyond the specifics of the events and into the metaphorical realm where little of our true identities are ever visible or what we consciously fashion for ourselves. This has a special resonance in Tübke's images of children on the cusp of adulthood. Dutch artist Celine van Balen's (b. 1965) photographs of young Muslim girls living in temporary accommodation in Amsterdam [75] also work on this level. The unlined faces of youth are belied by the mature self-possession and seeming confidence with which they present themselves to and are depicted by van Balen.

The work of another Dutch artist, Rineke Dijkstra (b. 1959), has also focused on this period of life. In the early to mid-1990s, she photographed children and young teenagers on beaches as they

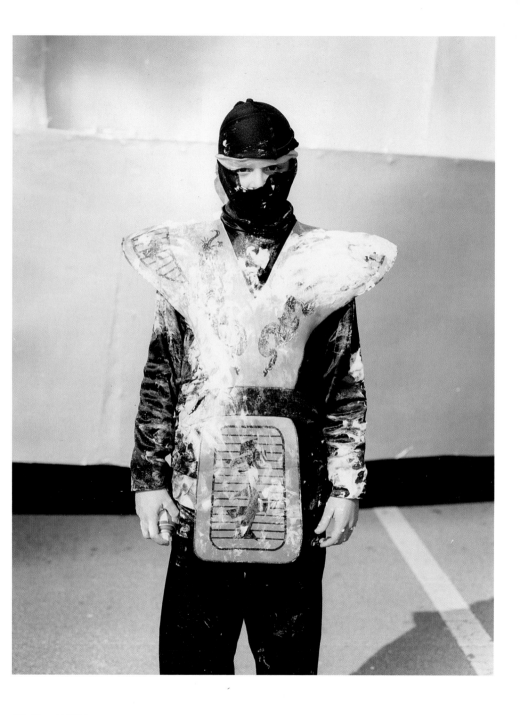

107. **Albrecht Tübke**,
Celebration, 2003.

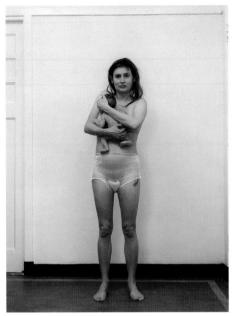 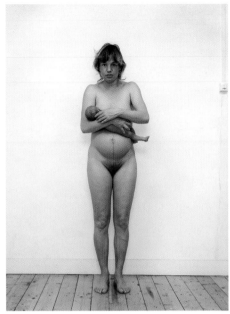

108. **Rineke Dijkstra**,
Julie, Den Haag, Netherlands,
February 29, 1994, 1994.

109. **Rineke Dijkstra**,
Tecla, Amsterdam, Netherlands,
May 16, 1994, 1994.

110. **Rineke Dijkstra**,
Saskia, Harderwijk, Netherlands,
March 16, 1994, 1994.

came out of the sea. Dijkstra captured the vulnerability and physical self-consciousness of her subjects as they were caught in that transitional space of exposure between the protection of being in the water and the anonymity of sitting or lying on a beach towel. The choice of a particular moment or space in which to portray her subjects is a governing element of Dijkstra's work. For example, in her 1994 portraits of matadors, she photographed the men soon after their bullfights, bloodied and with their adrenaline subsiding, their performance and guard dropping away as Dijkstra worked. Also in 1994, she photographed three women: the first, one hour after giving birth; the second, within one day; and the third, after one week. The unsentimental approach that Dijkstra makes in her representation of maternity focuses on the impact of pregnancy and labour on the women, its legibility perhaps lost once the women have begun to recover. These photographs visualize the profound shift in the women's changing relationships to their bodies and the instinctive protection they demonstrate towards their newborn babies, something we might never have observed without such a systematic and detached photographic style.

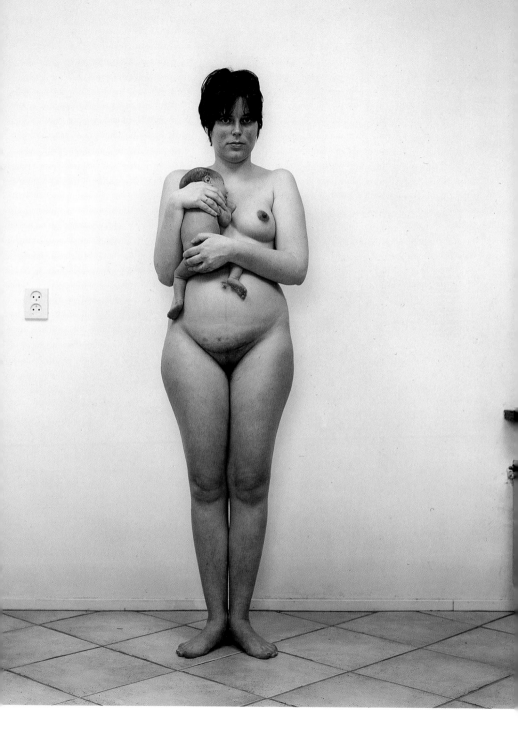

Chapter 4 Something and Nothing

The photographs in this chapter show how non-human things, often quite ordinary, everyday objects, can be made extraordinary by being photographed. As the title suggests, the stuff of daily life ostensibly counts as the subject, the 'something' of the pictures. But because we may ordinarily pass these objects by, or keep them at the periphery of our vision, we may not automatically give them credence as visual subjects within art's lexicon. These photographs retain the thing-ness of what they describe, but their subjects are altered conceptually because of the way they have been represented. Through photography, quotidian matter is given a visual charge and imaginative possibility beyond its everyday function. Luscious and sensual treatment, shifts in scale or typical environments, simple juxtapositions and relationships between shapes or forms – all are employed here. The iconography for this strand of photography includes objects balanced and stacked, the edges or corners of things, abandoned spaces, rubbish and decay, and fugitive or ephemeral forms, such as snow, condensation and light. This inventory may seem like a list of slight and transient things, objects that would barely constitute proper subjects for photographs. But one must be cautious about thinking of this type of photography as primarily concerned with making visible non-subjects, or things in the world that are without visual symbolism. In truth, there is no such thing as an unphotographed or unphotographable subject. It is for us to determine a subject's significance, knowing that it must have one, for the artist has photographed it and thereby designated it as significant. With this type of work, the practitioner fosters our visual curiosity by subtly and imaginatively encouraging us to contemplate the stuff of the world around us in our daily lives in new ways.

Since the mid-1960s, the playful conceptualism of still-life photography has had an important parallel practice in post-Minimalist sculpture. In simple terms, this strand of photography has been driven by related attempts to make art from the matter

III. **Peter Fischli and David Weiss**, *Quiet Afternoon*, 1984–85. Fischli and Weiss's *Quiet Afternoon* is a series of still-life photographs, made in their studio, of ordinary objects propped and stacked together in unexpected combinations. The series has been a great influence on redirecting this traditional genre of art and photography into playful and conceptually driven territories.

of daily life, by breaking down the boundaries between the artist's studio, the gallery and the world. Concomitant to this has been a shared investigation into the creation of work from which overt signs of the artist's technical skill are absent. The viewer will therefore have a different response from that engendered by traditional virtuoso masterpieces in art history. Rather than asking how and by whose hand the work of art was made, the question becomes: How did this object come to be here? And what act or chain of events brought it into focus? Both contemporary sculpture – inspired by, among other things, the example of Marcel Duchamp's readymades in the early years of the twentieth century (see page 22) – and photography can activate the same conceptual dynamic; they both create puzzles and confound our expectations of, say, the weight or scale of objects, or the permanency of an art work. Ultimately they destabilize the notion of an object as a discrete plastic form without connections to the environment in which it appears.

One of the most enduringly influential photographic projects to playfully question our expectations of the nature of a work of art was realized by the Swiss artists Peter Fischli (b. 1952) and David Weiss (1946–2012) in their *Quiet Afternoon* series [111]. The photographs show table-top assemblages of mundane items that seem to have been found close at hand in the artists' studio. Fischli and Weiss created sculptural forms by fixing and balancing these objects together and then photographing them against dull backgrounds with raking shadows, lending a comic drama to their consciously unsophisticated temporary sculptures. The seemingly ad hoc and unglamorous style of photography used in *Quiet Afternoon* suggests an affinity with another strand of art-making that emerged in the 1960s. The creation of documentary photographs (where the photograph is not intended as the final work of art) of Minimalist sculpture and land art was motivated by the desire to create a long-term record of the works. Much of the art of Robert Smithson (1938–1973) and Robert Morris (b. 1931), for example, is experienced and understood only through photography. Using a photograph in this way to disseminate an ephemeral artistic act or temporary work of art contains an inherent irony and ambiguity that has been constantly exploited and reinvented in contemporary art photography.

One of the main protagonists of contemporary still-life photography is the Mexican artist Gabriel Orozco (b. 1962). Orozco's art is full of impossible, witty and imaginative games. Whether in the form of photographs, collages or sculptures,

112. **Gabriel Orozco,**
Breath on Piano, 1993.

or as an animated conversation between these mediums,
his installations and exhibitions display work that, with a
remarkable economy of means, offers exciting and playful
conceptual journeys. He began taking photographs (both Polaroid
and 35mm) as records of found sculptures he discovered lying
among the detritus of the street and then reinstalled in galleries,
the photographs acting as diagrams of the spatial relationships
and elements he was reconstituting. If at first Orozco's
photography seemed to be a functional record of his working
process, it was extended further and more centrally into his
oeuvre to become one of the foremost areas of his exhibited
and published art practice. Orozco constantly questions the very
status of art as a vehicle for ideas, and with photography we are
asked to pay close attention to the nature of photographic images
and the perpetual hovering between being the medium and the
subject. *Breath on Piano* [112] exemplifies his intention to activate
particular trains of thought in the viewer. On one level, the
photograph can be seen as the documentation of the highly
fugitive act of breathing onto the seamlessly shiny surface
of the piano top. Photography, by its ability to capture a
millisecond of time, makes us think about what has (perhaps
just) happened in front of the camera. But this somewhat
forensic reading of *Breath on Piano* belies another equally
important facet of the work, for it makes us see the image *as*
image, as forms on a surface, which is a fundamental condition
of a photographic print. Because the blurred trace of the breath
is framed within a photograph, this slight gesture and the
medium of photography become something within art.

Felix Gonzalez-Torres's (1957–96) use of photography encouraged sensory and playful participation from the viewer, in keeping with the effect of his magical mixed-media installations that used objects from domestic or social life and then recontextualized them in a gallery environment. His untitled billboards [113], initially exhibited in New York in 1991 and then throughout Europe and America, show an unmade bed, the couple absent, with only the traces of their bodies imprinted on the sheets and pillows. The photograph's depiction of such an intimate scene is given its drama by being placed into the public contexts of urban streets and highways for the scrutiny of passers-by. This fusion of public site and private sight and the sensitivity of the photograph allow the viewer to bring their own experiences to the work and imprint their meaning on it. The contract of ownership states that the owners are responsible for displaying the piece at a number of billboard sites simultaneously, in at least

113. **Felix Gonzalez-Torres**,
'Untitled', 1991.
This project was initially shown on advertising hoardings in New York. The billboards depicted an unmade bed with the impressions of the sleepers left on the sheet and pillows, an evocatively intimate sight made resonant by the public context in which they appeared.

114. **Richard Wentworth,**
Kings Cross, London, 1999.

six, but ideally twenty-four, locations. Originally displayed at
the height of AIDS awareness in the West, the work's sense of
loss and absence took on added social and political significance.

For more than thirty years, British artist Richard Wentworth
(b. 1947) has photographed the signs and debris of urban streets.
Often, his photographs set up a visual pun; the objects are
redundant from their original function, often reused or
abandoned, and through photography they gain new, sometimes
comic characterizations. In keeping with the phenomenological
language of his sculptures, Wentworth's photographs draw on
our natural inquisitiveness to understand alternative values or
meanings of things through touch, texture and weight. In the image
shown here [114], the car panels are wedged into a doorway,
presumably as an unconventional yet effective way of preventing
access to the property. More fantastical narratives are suggested
by this intriguing sight – such as, perhaps, the drastic, desperate
measures taken to solve car-parking problems in a busy city, or
the reasons for barricading a door. Wentworth's artistry lies in
his finding and focusing on such curious forms in urban detritus.

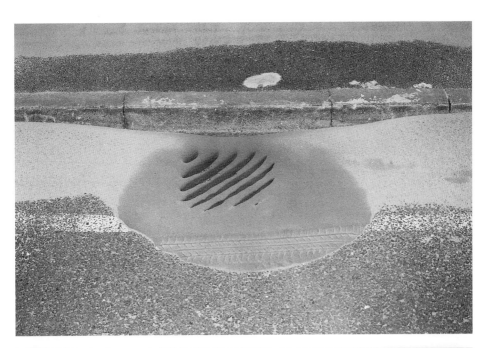

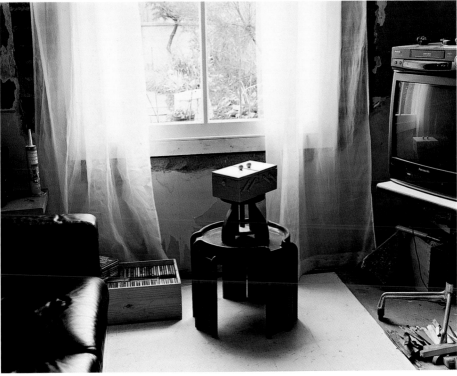

In Jason Evans's (b. 1968) black-and-white series *New Scent* [115], the photographer finds a strange sculptural form in the silted sand built up over a drainage grid after a coastal rainstorm. This photograph shows how a fragile, fleeting phenomenon can be made to resonate through photography; the fact that weather conditions could have created this temporary physical effect, and then be observed by the photographer, has a magical serendipity. Its depiction in mid-tone greys, rather than colour, is not only a gesture to the twentieth-century tradition of street photography but also an essential graphic way in which such a sight can become photographically most resonant. In the *New Scent* series, easily missed, serendipitous details are charged with visual intrigue by being framed and photographed in such a subtle manner.

Played out in the more intimate environment of an interior, Nigel Shafran's (b. 1964) *Sewing kit (on plastic table) Alma Place* [116] invites an imaginary investigation, initiated by the position of the sewing box on the side table, which creates a balancing act, a totem of domesticity. Shafran's photography often uses forms found in daily life – washing-up on a draining board, construction scaffolding, grass cuttings. With an understated photographic style, use of ambient light and relatively long exposures, he transforms these scenes into poetic observations about the ways we conduct our lives through our unconscious acts of ordering, stacking and displaying objects. There is something highly intuitive in Shafran's way of working. He resists the urge to construct a scene to be photographed; rather, his is a process of staying attuned to the possibilities of everyday subjects as a means of exploring our characters and ways of life.

Jennifer Bolande's (b. 1957) *Globe* [117] similarly contemplates the innocent yet meaningful placing of objects in unexpected positions. From street level, Bolande photographed globes stored on the window ledges of homes. By means of this very simple gesture, our perception and understanding of the world are brought into consideration. Most obviously, these photographs draw our attention to the way we receive knowledge about the world from a dwarfed, simplified model. They demonstrate how partial our perspective is, framed as it is by the windows out of which, and into which, we look. Human understanding from micro- to macrocosmic proportions is repeatedly explored through Bolande's work; a sense of constrained human understanding is visualized through simple and subtle observations. *Globe* is also, importantly, part of a series of images

117. **Jennifer Bolande**,
Globe, St Marks Place, NYC, 2001.

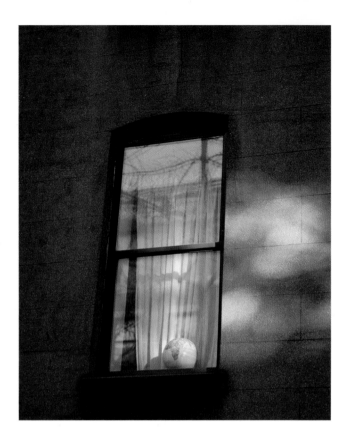

rather than a single photograph. The repetition of Bolande's observation of human behaviour makes it a visual commentary on culture rather than a depiction of a solitary, idiosyncratic gesture.

The photographs in *Something is Missing* by French artist Jean-Marc Bustamante (b. 1952) were taken in many different cities, although their locations are not revealed in their titles. Instead, their identities are worked out from the street signs, advertising and car number plates that appear in some of the images. What Bustamante is finding in these sites is not factual information about a specific geographical location, but simple forms that resonate pictorially. This searching for pictures within landscapes on the edge of cities and other man-made places has been one of the themes of his photography for over twenty-five years. In the image shown here [118], figures on a football pitch are encased both in the foreground by the wire fence and the trailing weed, and in the background by a graveyard of urban housing in stages of neglect. These elements register both as a three-dimensional

space and as a series of two-dimensional picture planes that hinge on the vantage point of the photographer, and therefore of the viewer. The subject of the photograph is the entire picture and its layered complexity, drawn out of the process of walking and seeking pictures in the flow of daily life.

German artist and director Wim Wenders's (b. 1945) photographs have a related sense of the pictures within our environments being recognized and formalized. Wenders is better known for his feature films, but he uses still photography when a site carries its own story and does not require him to construct one cinematically. In *Wall in Paris, Texas* [119], the cracks in the road and the plaster on the side of the building that has fallen away to

118. **Jean-Marc Bustamante**, *Something is Missing (S.I.M. 13.97 B)*, 1997.

119. Wim Wenders,
Wall in Paris, Texas, 2001.

reveal the brickwork beneath create an allegory of the
deterioration and fragility of the place, emphasized by the
fraught diagonal lines of the power cables dissecting the image.

Architecture, in the context of this chapter, tends to be
photographed at the point at which buildings have deteriorated
or outlived their original purpose, abandoned by their inhabitants
to leave only traces of previous human activity. Anthony
Hernandez's (b. 1947) photography through the 1980s and 1990s
concentrated on such architectural spaces. His *Landscapes for the
Homeless,* created in the 1980s, are photographs of the temporary
shelters made on roadsides and wastelands by homeless people.
The movements and characters of the makers of these shelters
are visually retrieved in what they have left behind, a forensics of
private poverty and survival. Hernandez's more recent work,
After L.A. (1998) and *Aliso Village* (2000), centres on spaces about
to be demolished or in the process of gradual deterioration. He
photographs what is overlooked (socially and politically as well
as visually) in these decaying fields of emotional emptiness. In the
image shown here from the *Aliso Village* series [120], Hernandez
observes a small but haunting and profound piece of evidence left
by previous inhabitants of the low-income housing estate in Los
Angeles where he himself was born and raised.

120. Anthony Hernandez,
Aliso Village #3, 2000.
Hernandez draws out the
formal and allegorical resonance
of delapidated and abandoned
spaces. In his *Aliso Village* series,
he returned to the housing
development where he had
grown up after its last resident
had left but before it was
demolished.

121. **Tracey Baran**,
Dewy, 2000.

122. **Peter Fraser**,
Untitled 2002, 2002.
Fraser's *Materials* series
explores the central
theme of this chapter:
how photography maintains
the physicality of, often, quite
ordinary things while opening
up their potential imaginative
and conceptual meanings.

All the photographs in this chapter, in subtle ways, attempt
to shift our perceptions of our daily lives. There is something
anti-triumphant and open ended, yet still resonant, in this form
of photography. Tracey Baran's (1975–2008) highly sensual
photograph, *Dewy* [121], of an etched glass still wet with moisture
and placed on a window sill, light falling onto it through foliage,
is a classic still life. The sense of physicality in this uncontrived
combination of planes and forms is delicately mapped. The image
is reliant on our comprehension that we are looking at a
composition within the tradition of still-life picture-making, found
within daily life. This finding of a known picture form is also at play

in the *Materials* series by British photographer Peter Fraser (b. 1953). The close-up swirl of synthetic dust in the image shown here [122] configures as a vortex, a perfect micro-universe of waste matter and an image of the huge cosmos of dust around us. Fraser's intense photographic consideration of this indeterminate subject converts a scattering of waste that does not have a fixed state, let alone cultural status, into a pictorial form, now charged with magical connotations of a starry constellation.

Manfred Willmann's (b. 1952) *Das Land* series draws out the rituals, idiosyncrasies and passing of the seasons within a community in the Steierland region of Germany [123]. In sixty photographs made over a twelve-year period starting in 1981, Willmann found in still lifes, landscapes and portraits aspects of a rural lifestyle that convey a pungent sense of his experiences of the place. *Das Land* could be construed as a diary of the life of the community. But Willmann's way of photographing does not hold the same degree of subjective narrative or intimacy that we will see in Chapter 5. What seems to have driven this project in the first place, and what is conveyed in the final selection, is the pictorial charge that can be found in a place, perhaps any place, if one looks. In the subtle drama of the exposed wood of the tree where branches have broken off under the weight of the snow,

123. **Manfred Willmann**,
Untitled, 1988.

Willmann finds more than a saccharine scene of a winter landscape. This elegiac trace of a past event is parallel to the representation of abandoned and deteriorating architecture shown earlier in this chapter.

American photographer Roe Ethridge (b. 1974) shifts between photographic styles, depending on the nature of the subject he is photographing. His repertoire includes portraits staged in white-backdrop studios, shot in a contemporary quasi-fashion style, deadpan architectural photographs and brashly coloured snaps of found still lifes [124]. There's a definite indication that Ethridge's confident and diverse photographic practice is about finding twists on the image types that we all see, drawing our attention both to subjects and to the generic or familiar modes of representing them and giving them visual substance.

This artistic dialogue with photography's relationships to its subjects has been brilliantly explored by German artist Wolfgang Tillmans (b. 1968). Since the late 1980s, Tillmans has edited together found and stock images, photocopies and his own photographs, displaying them in several printed forms from postcards to inkjet prints. He has worked across various contexts, from magazines to art galleries and books, producing landscapes, portraits, fashion shoots, still lifes and, more recently, abstract photography triggered by darkroom mistakes. His photographs of fruit ripening on windowsills and the contents of sparse kitchen cupboards have a simple poignancy. Another recurring motif, as shown here in *Suit* [125], is clothing left to dry or abandoned by its

125. **Wolfgang Tillmans**,
Suit, 1997.
Although Tillmans's photographs are exceptionally diverse in terms of their subjects and processes, there are many recurring motifs. These include, as here, the spontaneous sculptures made by clothing hung up or dropped on the floor.

126. **James Welling**,
Ravenstein 6, 2001.

wearers on floors, doors and stair banisters. The limp sculptural forms that are unwittingly made by the discarding of the clothes suggest the shapes of the bodies they once contained, like a shedded animal skin, and the act of undressing, creating a sense of sexual intimacy.

James Welling's (b. 1951) practice has often meditated on the ways that photography can give the slightest of subjects form and intellectual substance. Welling explores the infinite range of possibilities by repeatedly photographing a subject from different vantage points. In the 1980s, he created a series that played with the subject matter by depicting draped and hung fabrics that could either be construed as the backdrop to absent objects or as subjects in their own right. Through subtle shifts in camera position and fall of light onto the same physical details, Welling questions the belief that to see something from a single vantage point is to know it. As the title suggests, in his *Light Sources* series he photographed different light sources, from the sun to fluorescent tube lighting [126], to activate ideas about perception

and subject matter. The *Light Source* series is a prime example of the harnessing of photography's documentary role within a framework of repetition that pushes the work beyond being a sequence of interesting observations and towards a conceptual territory where the subject is not quickly deciphered but gradually made palpable through its range of possible states.

Jeff Wall's *Diagonal Composition no. 3* [127] may at first seem to be an unusual work for him because of the absence of a cast of actors or impressive mise-en-scène (see Chapter 2). It seems to be a casual, awkwardly cropped shot of mundane subjects. The zigzag of the skirting board, cupboard, mop, bucket and dirty linoleum floor is, however, not merely a sight glanced at and then recorded. Wall's careful construction of a grouping of peripheral things prompts questions about our own relationship with photographs: Why are we looking at this? At what point in history and our own lives did a corner of a floor represented in a photograph become iconic, worthy of our attention? To what degree does it need to be abstracted by the seemingly innocent frame in order for us to recognize this grouping of non-subjects to

127. **Jeff Wall**,
Diagonal Composition no. 3, 2000.
Wall's *Diagonal Compositions* are carefully staged still-life photographs made to look like observations of unconsciously grouped everyday objects. In part, they are a meditation on the formal rigour that underpins the transformation of mundane objects into a subject with conceptual substance and visual intrigue.

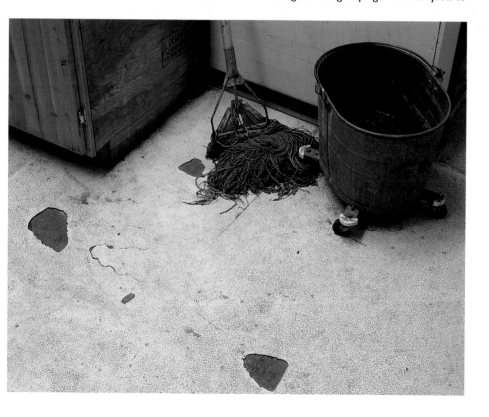

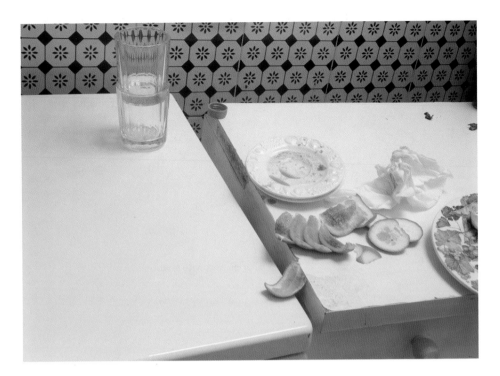

128. **Laura Letinsky,**
Untitled #40, Rome, 2001.
Letinsky constructs the undulating
perspective found in seventeenth-
century Northern European
still-life paintings to develop
her narratives of domesticity and
intimate relationships which can
be read in the remains of a meal.

be a still life? The beauty of Wall's photography is that, while it raises these complex questions, it still satisfies us as works of art.

Laura Letinsky's (b. 1962) photographs simultaneously contemplate the still life as representing the nature of human relationships through the vestiges of domestic life and make us think about this act of pictorial representation [128]. Her photographs of tables immediately after and between mealtimes have obvious compositional references to seventeenth-century Dutch still-life painting. Although Letinsky is not aiming to introduce us to the specific symbolic language of fruits, foods and flowers within this historical genre of painting, she is drawing our attention to the metaphorical and narrative potential of domestic objects when they are represented pictorially. The combination in her photographs between flatness and plasticity creates a tension that dismantles the monocular vantage point traditionally ascribed to photography. Instead, Letinsky uses the shifting multiple perspectives and picture planes of still-life painting, where objects are propped at angles and strategically placed so that we intuit that there is narrative potential in the formal relationships between them. Letinsky's unusual use of a Baroque sensibility from Northern European painting creates photographs of great beauty,

but they have a precariousness of viewing position(s). This quality, within the narratives of domestic still life, suggests fraught emotional states, ending and falling apart.

One of the most dramatic uses of perspective in the context of still life occurs where photographers have placed the emphasis specifically on the ways in which we see (or do not see) the things around us. In part, it is our perception of our environments rather than the things contained within it that are being scrutinized.

German artist Uta Barth's (b. 1956) series *Nowhere Near* [129] pares down its subject matter to the spaces between things. Here she focuses on a window frame and the view beyond, whose blurred forms mark the boundary of what is outside the photograph's visual range. Thus we are made hypersensitive to what we edit out or do not look at, and so do not define as a subject or a concept that can be seen. Barth's photographs, when installed in galleries, resonate phenomenologically. The space between the viewer and the photographs becomes part of the interplay between space and subject, seeing and not seeing.

Italian artist Elisa Sighicelli (b. 1968) uses back-lighting to create a sense of déjà vu in which it is not the objects themselves that feel

129. **Uta Barth,**
Untitled (nw 6), 1999.

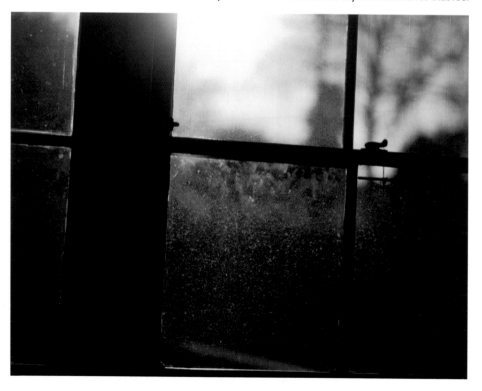

familiar but the ambient sense of the place in which they are set. In the illuminated areas of the image (for example, light coming through a window, or the reflections on a shiny surface), there is a temporal tension from having two sources of light, one fixed in the back of the light box and the other represented in the photographic transparency. Sighicelli uses this phenomena to represent details in interiors that are visually resonant but non-specific: we contemplate the feel of the space in its heightened representation rather than try to imagine the specific use or the character of its inhabitants. She encourages us to recall from our own memories those places of which we have had heightened perception. Sabine Hornig's (b. 1964) use of photography has also concentrated on the spaces between the image and the object, as in *Window with Door* [130]. Conflated into the image are two ends of a room photographed through a window from outside. The building and trees behind the camera also appear, reflected in the windowpanes. Hornig has used a more literal sculptural manner in her installations, where she builds her photographs into free-standing blocks and shapes that evoke corners and edges of Minimalist architecture, taking the image away from the gallery wall and into a three-dimensional space. As with all the works in this chapter, her photographs take our familiarity with everyday sights and invite us to think about the way we see and experience our environments, offering a rich and imaginative glimpse of the world around us.

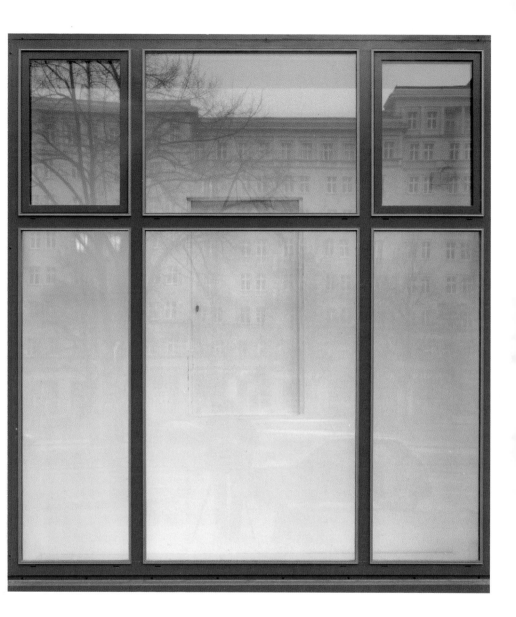

130. **Sabine Hornig**,
Window with Door, 2002.

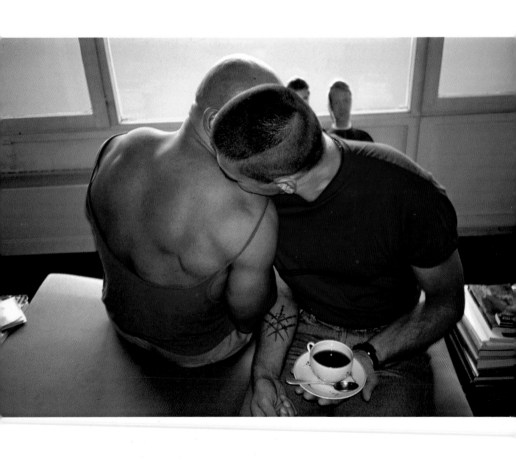

Chapter 5 Intimate Life

This chapter looks at how narratives of domestic and intimate life have been presented in contemporary art photography. The apparently unselfconscious, subjective, day-to-day, confessional modes of many of the photographs shown here contrast markedly with the measured and preconceived strategies we have seen up to now in this book. A useful starting-point for considering how intimate photography is structured is to think about how it borrows and redirects the language of domestic photography and family snaps for public display. Unless there is a keen amateur photographer within a household, aspiring to produce photography that is above the ordinary, most family photographs are not particularly distinguished on the level of technical skill or approach. We may wish in retrospect that we had taken extra care in composing a photograph of our friends and families, that the regular mishaps of a finger over the lens or 'red-eye' had been avoided. But ultimately these are not the criteria by which such photographs succeed or fail for us. What is important is the presence of loved ones at a significant event or moment that prompted the taking of the image. Many of the photographs illustrated in this chapter have some of these familiar 'mistakes'. Out-of-kilter framing, blur, uneven flashlight, the colouration of the machine-printed snap – all are used. But in intimate photography, these technical shortcomings of domestic, non-art photographs are employed as the language through which private experience is communicated to the viewer. The use of seemingly unskilled photography is an intentional device that signals the intimacy of the relationship between the photographer and his or her subject.

We generally take pictures at symbolic points in family life, at times when we acknowledge our relationship bonds and social achievements. They are moments we want to hold onto, emotionally and visually. Typically, the situations are shared cultural events: throwing confetti after a wedding ceremony,

131. **Nan Goldin**, *Gilles and Gotscho Embracing, Paris*, 1992. One of the presiding themes of Nan Goldin's photography for close to thirty years has been the depiction of the tenderness between lovers. This touching observation of Goldin's friends Gilles and Gotscho is part of a series that she made in 1992 and 1993, as Gotscho supported his lover Gilles until his death from AIDS-related illnesses.

blowing out candles on a birthday cake, serving the family meal at religious festivals. Or they demarcate our rites of passage: a newborn baby being brought home, a ride on a new bicycle, a grandparent teaching a child to read or tie shoelaces. In family photography, and now in home video, the celebratory is sought out through the visualization of healthily functioning familial roles. What remains absent in such images, however, are things we perceive as culturally mundane or taboo. Art photography, on the other hand, while embellishing the aesthetics of family snaps, often substitutes the emotional flip-side for their expected scenarios: sadness, disputes, addiction and illness. It also takes as its subjects the non-events of daily life: sleeping, talking on the phone, travelling by car, being bored and uncommunicative. Where social events do appear, they often strain against the overall scene, creating a pastiche of normality or a poignant sense of the failure of social convention to maintain order, perhaps a vibrant bouquet of flowers beside a hospital bed or a subject's forced smile for the camera while their eyes brim with tears.

Intimate photography is also a reconstitution of the subtexts in our family snaps. We can all find signs of the undercurrents of specific family relationships in our private photographs. Who stands next to whom in the group portrait? Who is absent? Who is taking the photograph? And with hindsight, we search for visual clues to later events, as evidence of predestination: can we see signs on the wedding day of a later divorce? Or something in a child's posture that predicts antisocial behaviour in adulthood? Similarly, intimate photography is an exercise in pathology, an editing and sequencing of seemingly unguarded private moments that reveal the origins and manifestations of the subjects' emotional lives.

The photographer who has had the most direct and obvious influence on the photography of intimate lives is the American Nan Goldin (b. 1953). Her thirty-year (and continuing) exploration of her selected 'family' of friends and lovers not only chronicles the narratives of her circle but also, in a number of ways, sets the standard by which intimate photography and its creators are judged. Although Goldin began taking pictures of her friends in the early 1970s, it was not until the early 1990s that her work gained international acclaim and a strong foothold in the art market. The start of her practice is highly significant (not least because it is continually retold in the literature about Goldin's work). Goldin's first photographs, which she took in her late

teens, were a series of black-and-white images entitled *Drag Queens*, which empathetically portrayed the daily lives of two drag queens with whom she lived and their social circle. In the mid-1970s, Goldin attended the School of the Museum of Fine Arts in Boston, Massachusetts. During a year's leave from the programme (when she had no access to a darkroom to develop or print her black-and-white film), she began to use colour slides. She has used colour predominantly ever since.

Goldin moved to the Lower East Side of Manhattan in 1978 and continued to record the events, situations and developing friendships within the bohemian circle of which she had become part. The first public showings of her slide images were held in New York clubs in 1979, either with a music sequence selected by Goldin or as an accompaniment to live gigs. Goldin modified the soundtrack (which remained fixed after 1987) to include music that had a personal resonance to her and her friends, and songs recommended to her that offered a musical parallel or ironic element to the slide show. In the early 1980s, the audience for Goldin's shows were mainly artists, actors, filmmakers and musicians, many of whom were her friends and who appeared in the images. The inclusion of Goldin in the 1985 Whitney Biennial in New York marked the first high-profile institutional interest in her work, and the publication the following year of her first book, *The Ballad of Sexual Dependency*, brought the intensity of her prolific image-making to a wider audience. By this point, Goldin was consciously sequencing her photographs into themes that directed the viewer to think beyond the specifics of her subjects' lives and about general narratives of universal experience. *The Ballad of Sexual Dependency*, for example, was a personalized contemplation of the nature of subjects such as sexual relationships, male social isolation, domestic violence and substance abuse. Goldin's essay in the book powerfully states the psychological necessity for her to make photographs of her loved ones. Her description of the effect of her sister's suicide at the age of eighteen (when Nan was eleven years old) vividly justifies the sense of urgency with which she photographs what is emotionally significant to her, as a way of holding onto her own version of her history.

By the late 1980s, Goldin was being invited to exhibit at art institutions and events around the world, and she also began to have solo exhibitions. The refreshing direction of her work fed back into the art-school system from which she had come herself, and by the end of the decade, Goldin's approach had been

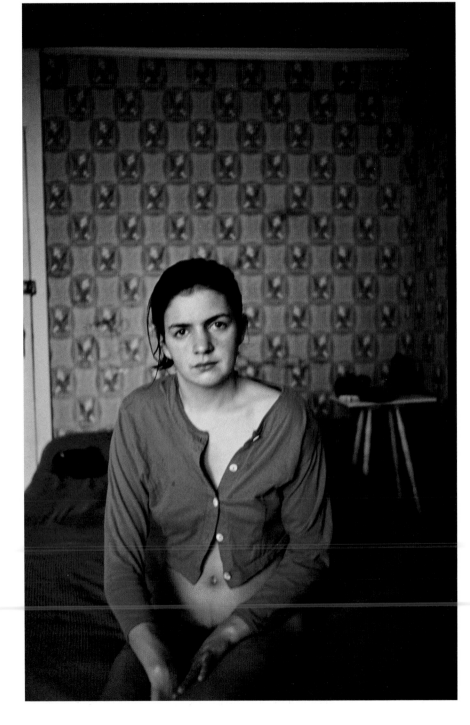

132. **Nan Goldin**,
*Siobhan at the A House #1,
Provincetown, MA,* 1990.
One of the many qualities
of Goldin's photography is
her capacity to combine a sense
of the emotionally charged and
spontaneous observation of
her loved ones with a highly
developed aesthetic sensibility.
This unguarded and frank portrait
has a rich colouration and
painterly quality.

accepted and celebrated as a successful strategy for photographic art-making. In the early 1990s, with the publication of *I'll be Your Mirror* (1992), Goldin's photographs of those around her counterbalanced celebration with loss. Her intense record of the impact of HIV and AIDS-related illness, drug addiction and rehabilitation on her and her friends' lives offered art audiences a profound engagement with these social issues, spelt out in personal terms. Goldin also began to photograph people with whom she felt an affinity but who were not longstanding friends. *The Other Side* (1993) showed transvestites and transsexuals in cities she visited (principally Manila and Bangkok). Although Goldin is sometimes perceived as being exclusively a recorder of bohemian and counterculture lifestyles, as her life and those of her intimate circle change, new subjects emerge. In recent years, as Goldin has broken her cycle of drug addiction and, literally, has begun to see more sunshine, she has incorporated daylight into her photographs (as opposed to the flash-illuminated low light of clubs and bars of her earlier work). Her most recent work shows new themes and subjects such as the young children and babies of her friends, sex within committed relationships, poetic landscapes and baroque still lifes.

Goldin's openness in talking about her traumatic childhood and life in Lower East Side bohemia and her battles with addiction and a destructive sexual relationship are central to our belief that her intimate photographs are a genuine record of a personal life and not simply pseudo-empathetic observations. Equally important to subsequent photographers of intimate life is the fact that Goldin's photographs reached the art world almost serendipitously: her initial motivation was to take these photographs for personal reasons rather than to make a high-profile career as a photographer. Her emergence through a liberal-arts education, rather than by the professional route of assisting a commercial photographer, additionally allays concerns about Goldin's glamorizing or embellishing the lifestyles she portrays, which has been a suspicion levelled at some photographers who have followed in her footsteps.

There is an in-built protection of intimate photography from serious and especially negative art criticism. By developing a body of work over time, the photographer links his or her life with the continued taking of photographs. A new book or exhibition is rarely judged an outright failure because that would suggest a moral criticism of the photographer's life, as well as of their motivations. This has been the case with the reception of

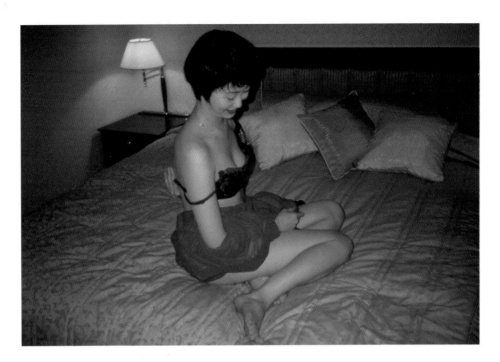

133. **Nobuyoshi Araki**,
Shikijyo Sexual Desire, 1994–96.

another long-term photographer of intimate life, the Japanese
artist Nobuyoshi Araki (b. 1940). Araki initially came to
prominence in the 1960s for his grainy, dynamic photographs
of Japanese street life. As a contributor to the Provoke Group's
magazines and books in Japan, he was part of one of the most
daring and experimental periods for photography in tandem
with innovative graphic design. Today, Araki is best known as one
of the key art photographers to present sexually explicit work.
He is the epitome of the promiscuous photographer, taking
tens of thousands of pictures, using a range of cameras, with a
predatory fluidity that gives a woman's body, a flower, a bowl
of food or a street scene a literal and psychological sexual charge.
Araki is a major celebrity in Japan, having published close to two
hundred books of energetically gridded, juxtaposed and
sequenced photographs.

It was not until the early 1990s that Araki became well known
outside Japan, however. His acceptance as an artist in the West
has relied on the subjectivity as well as the boldness of his work.
Araki's photographs of young Japanese women are seen as a visual
diary of his sexual life, for he clams to have had sex with most
of the women depicted. His images are often seen as a kind of
photographic foreplay, rather than a detached and exploitative

voyeurism. The infrequency with which other men appear (typically as clients or sexual partners of the women whom Araki photographs) is important in preserving this reading of the work. Sometimes the relationship between the photographer and his models is described as collaborative, to the extent that it is also suggested that Araki and his cameras are conduits for these women's sexual fantasies. Perhaps a more accurate description would be that the female subjects have a desire and curiosity to be in Araki's photo-shoots and to be part of his infamous oeuvre. Since his photography is considered to be a diary, one that promotes his genuine desire for these women, much of the potential debate about the possible pornographic and exploitative aspects of his work is curtailed. This shying away from obvious readings of Araki's images demonstrates how intimate photography can circumvent debates that surround so much other contemporary art photographers and photographic imagery in general.

American photographer and film director Larry Clark's (b. 1943) explicit portrayals of teenagers and young adults have, like the work of Goldin and Araki, been highly influential on contemporary photography. His books – *Tulsa* (1971), *Teenage Lust* (1983), *1992* (1992) and *The Perfect Childhood* (1993) – all

134. **Larry Clark**,
Untitled, 1972.

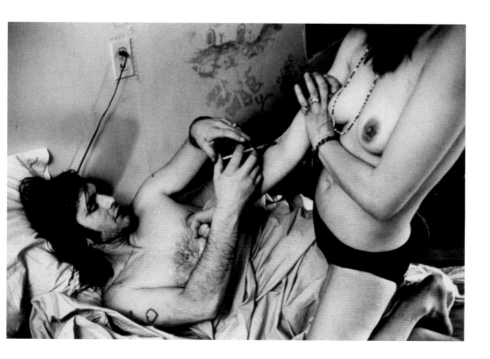

centre on a self-destructive combination of sex, drugs and guns in the hands of out-of-control young people. *Tulsa* contains grainy black-and-white photographs taken by Clark throughout his twenties, starting in 1963 [134]. They are his most strictly autobiographical works as they diaristically document his youth and that of his friends. By the time *Teenage Lust* was published, Clark was approaching thirty, and his portrayal of youth was transferred to a younger generation of rebels, a subject with which he empathized as well as socialized. The sense of Clark's being an insider, recording the teenagers' nihilistic progress into adulthood, is emphasized in an essay in which he both describes experiences from his own life that mirror the events in his photographs and declares his motivation as an adult to take the photographs he wished he had made as a child. Although Clark received some art-world recognition in the 1980s, it was not until the release of his independent film *Kids* in 1995 that he became well known to a wider audience. This led to a revisiting of his earlier books and a greater acknowledgment of his troubling debunking of anodyne or lyrical representations of teenagers.

In the mid-1990s, the moral implications of subjective photographic realism were centred not in the art world but in the sphere of fashion photography. A thorough exploration of the relationship between art and fashion is beyond the scope of this book, but it is important to mention that as photography developed its standing in the art market (although still invariably priced lower than painting or sculpture) and contemporary art became more fashionable, it was inevitable that stylistic signs from art practice would find their way into fashion photography. In particular, the rise of intimate photography offered a spur for the injection of a gritty realism into fashion images. Starting in the late 1980s, mainly with photographers, stylists and art directors based in London, what soon became known as 'grunge' fashion photography began to appear on the pages of lifestyle magazines. Inspired by books such as Goldin's *The Ballad of Sexual Dependency* and Clark's *Tulsa* and *Teenage Lust*, the emerging fashion photographers of the 1990s and their supporters sought to divest their medium of the faked glamour of high-production fashion shoots that had been prevalent in the mid-1980s, and instead represented fashion as it was customized and used by young people. Thinner and younger models were cast, heavy make-up and hairstyling were abandoned, and exotic locations were replaced by bare studios and unglamorous, often suburban

interiors. In its perpetual search for the new, the fashion industry as a whole soon began to absorb these anti-commercial gestures into its advertising and glossy editorial pages, prompting increased media criticism that accused the fashion world of promoting child abuse, eating disorders and drug-taking. In May 1997, then President Bill Clinton made an infamous speech that brought the term 'heroin chic' into general currency. Clinton was primarily attacking advertising campaigns that used gaunt, unsmiling models who, he claimed, glamorized drug addiction at a time when heroin was becoming a fashionable social drug. On the whole, contemporary art photography escaped the censures faced by fashion photography (although Clinton did cite the work of Dan [sic] Goldin in his speech). The reason it did so perhaps lies in its inherent self-protective qualities mentioned earlier. Without the authenticity of the photographer's biography, without the possibility of presenting the sad and emotionally ugly flip-side of intimate life, fashion photography, with its obvious commercial remit, was bound to be the target of social campaigners.

Out of this climate, two photographers emerged in the art world. The German artist Juergen Teller (b. 1964) had begun to traverse the fashion and art worlds long before Clinton's condemnations. Already by the early 1990s, his photography had started to command high status within the fashion industry. His subsequent re-presentation of his casual-looking fashion photographs, taken with a 35mm camera, alongside unpublished still lifes and photographs of his family in books and exhibitions had also started to meet with some critical appreciation. But at first, although Teller's capacity for creating intriguing photographs and for editing his work eloquently was not in question, the privileged lifestyle of his cast of models and pop stars was perhaps thought too glamorous to be treated seriously by the art world. But, in 1999, Teller produced his *Go Sees* project, which included a short film, a book and various exhibitions, and it struck the right chord for art-world endorsement. A 'go see' is when a model is sent to meet a photographer by her agent with the hope of future bookings for fashion shoots. Over the course of a year, Teller photographed the models who came to meet him, simply and vividly recording the unglamorous, false hopes of the girls' lives. This project demonstrated his capacity to do much more than be a refreshing yet still consumable creator of fashion imagery, and showed that he could also critique this industry. He has continued in this vein in more recent years. In his book

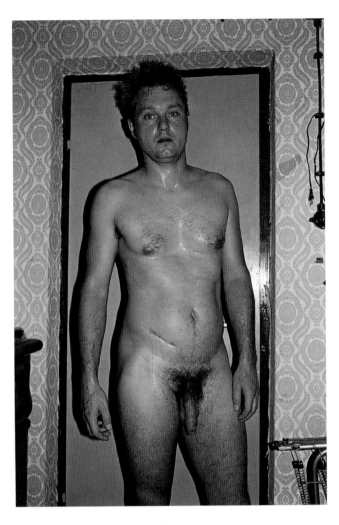

Märchenstüberl (2002), Teller has pushed his frank, even brutal, photographic sensibility even further. This work includes – significantly given the fashion context in which he first gained recognition – his turning the camera onto himself [135].

Despite their rare and sustained confrontational spirit, Corinne Day (1965–2010) wisely chose not to re-present her fashion photographs of the early 1990s in the arena of the art world. Day's first involvement in photography was as a fashion model. She began to take photographs of her fellow models, who used her images in their portfolios. This brought her to the attention of the art director at *The Face* magazine in London, who responded to the lack of pretension or conceit in Day's pictures.

With her knowledge of life on both sides of the camera, Day used the commissions she received to debunk the glamorous myth-making of fashion photography. Her antagonism towards the fashion industry meant that her movement into art was enhanced by her biography rather than made difficult. She was rare because of her seeming lack of commercial ambition for her fashion photographs; moreover, her casual start in photography was as artless as could be wished for, by now almost a prerequisite for photographers of intimate life. Day declined offers to transfer her best-known fashion images – those of Kate Moss – into the art world, perhaps acknowledging that what stood as a radical gesture in the context of a magazine would be lost in a gallery. Instead, she published a personal chronicle of her life in the late 1990s, focusing on the period when she suffered a life-threatening seizure that led to hospitalization and the discovery of a brain tumour. In *Diary* (2000), images of Day in hospital leading up to an operation to remove the tumour and her recovery appear like staccato notes through the book's sequence of photographs of the highs and lows of her social circle. The style of the book and

136. **Corinne Day,**
Tara sitting on the loo, 1995.

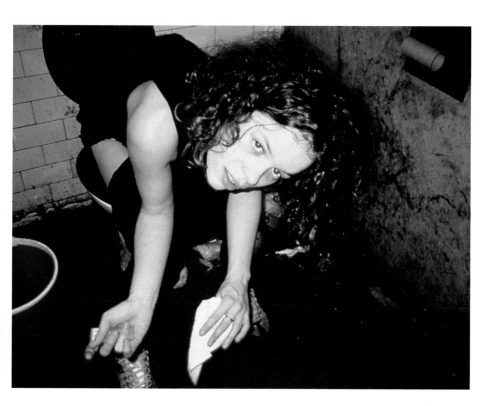

137. **Wolfgang Tillmans**, *Lutz & Alex holding each other*, 1992.

accompanying exhibitions followed what by then were established patterns for the presentation of intimate photography. The only texts in the book, apart from endmatter, were the handwritten titles to the pictures, reminiscent of Larry Clark's *Teenage Lust*. In terms of content, Day's willingness to photograph vulnerable and intimate moments in her and her friends' lives [136] meant that the scope and depth of human emotion narrated in *Diary* fit well within the tradition established by Nan Goldin.

Wolfgang Tillmans has been inaccurately described as someone who started out in fashion photography and then made a switch to fine art. In fact, Tillmans demonstrated from the outset a confident understanding of the potential shifting of the meaning and currency of his images by experimenting with a range of contexts including magazines, art galleries and books. In the early 1990s, the anti-commercial stance of youth magazines meant that these were exciting, and the most accessible, vehicles for a young photographer's work. Tillmans's photographs of friends, clubbers and ravers from the early 1990s, often using a snapshot aesthetic, found a relatively natural home in the pages of London-based *i-D* magazine [137]. But his investigations were driven by something

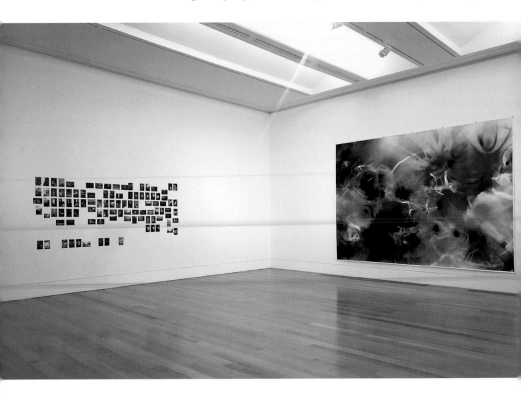

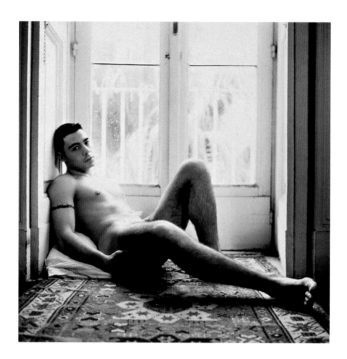

139. **Jack Pierson**,
Reclining Neapolitan Boy, 1995.

138. **Wolfgang Tillmans**,
'If one thing matters, everything matters', installation view, Tate Britain, London, 2003. Tillmans has made some of the most influential innovations in the presentation of photographic imagery in the gallery context. He mixes scale, processes and genres, and shapes the relationships between and experience of his photographs for each exhibition venue.

much more interesting than the challenge to get his pictures seen. Tillmans takes the reproducibility of the photographic image and makes it dynamic to construct a narrative: he mixes postcards, tearsheets, ink-jet prints and colour prints in an array of sizes that creates an exciting, challenging non-hierarchical way of looking at photographs. His installations [138], in which his back catalogue of images are like raw matter shaped into new rhythms and interrelations for each site, bring another level of immediacy to the experience of his photography. The move, as typified in Tillmans's work, away from the more traditional and rarefied presentation of images in frames hanging in a line on gallery walls became one of the hallmarks of exhibiting art photography.

The tempo and narrative embellishment that casual photography could give mixed-media art installations came into vogue in the early 1990s. Jack Pierson's pictures of nature, semi-naked figures and male nudes typify how sensuous photography could be in dialogue with installation pieces, such as *Silver Jackie* (1991), a small platform with a trashy metallic curtain hung behind it. Pierson's inclusion of intimate photography in his slacker style suggested who or what reflected his visual or sexual desires, and enhanced the sense of his art as being hinged on autobiographical narratives. But equally, given the staged feeling of many of the

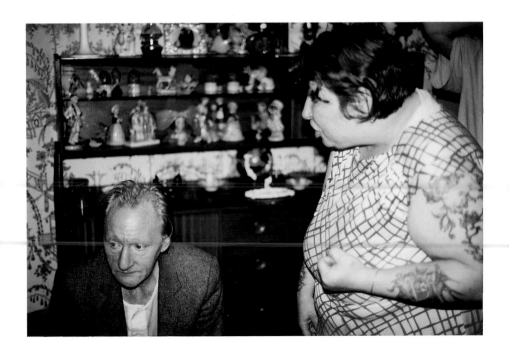

140. **Richard Billingham**,
Untitled, 1994.

photographs, to the point that they take the forms of popular clichés, Pierson also seems to have been consciously investing contemporary art with the vocabulary of vernacular genres of photography.

The meteoric rise of British artist Richard Billingham (b. 1970) began in the early 1990s when he started to create a memorable record of his family life. At the time, he was studying fine art (specializing in painting) at Sunderland Art College, and he had taken a series of photographs of his parents, Ray and Liz, and his brother Jason as 'sketches' for his paintings. A visiting examiner who also happened to be the picture editor of a newspaper magazine saw the photographs in Billingham's studio and encouraged him to consider these, rather than his paintings, as the best expression of his family. In 1996, a book of Billingham's photographs, *Ray's a Laugh*, was published, with a minimal amount of text and a high-impact sequence of images of Ray drinking home-brewed beer and falling over, Liz and Ray fighting, and Jason playing computer games, all in their cramped and untidy council flat in the West Midlands [140]. Written accounts of the work repeatedly focus on Billingham's youth, guileless manner and naivety, and the poverty of his background. It is true that Billingham had no idea, when he was taking these photographs,

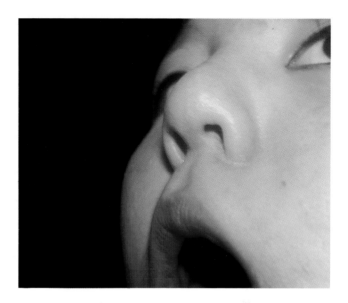

that they would end up on the walls of London's Royal Academy
(in the infamous 1997 'Sensation' show), but the argument that he
was simply taking snaps of his family in a manner that was entirely
unexpressive of his artistic vision is hard to believe. On a primary
level, he was taking these photographs to inform his painting and
so was using the camera, no matter how much he lacked
professional or technical skill, to find formal compositions that
he could transfer into art. Billingham had focused on the chaotic
and despairing points of domestic life in his work before, and
even if he was unaware that this was an existing strategy within
contemporary photography, his was the stance of someone who
sought a more critical understanding of the daily reality of his life.

Nick Waplington's (b. 1965) complex and energized sequence
of images and handwritten notes in his book *Safety in Numbers* was
an ambitious, high-momentum look at youth culture in an intense
period of global travel [141]. The project was a collaboration with
the British magazine *Dazed and Confused*, which committed to
publishing Waplington's project in instalments in the form of a
supplement. The sense of shared attitudes, as well as the
particulars of the social groups that Waplington moved through –
from New York to Tokyo to Sydney – is brilliantly captured in both
the casual photographic style and the high-impact book design.
Perhaps at the other end of the scale, but with no less eloquence,
aspects of social behaviour are revealed in Anna Fox's (b. 1961)
recent pictures. Although Fox's best-known documentary work

142. **Anna Fox,**
From the series Rise and Fall of Father Christmas, November/December 2002, 2002.
This is one of a series of photographs where Fox depicts the construction, reworking and final form of her eldest son's Father Christmas project. In all its stages, the model has an uncanny and grotesque presence that the rich colouration of the Instamatic camera's machine prints emphasizes.

has been made outside the home, such as her series concentrating on office environments in the mid-1980s, she has also captured her family life. Photographing at home offers a close-at-hand set of subjects and scenarios to satisfy a practitioner's need to see what something might look like photographically, but it also provides the opportunity to acknowledge and celebrate the particulars of his or her domestic life. In recent years, Fox has deviated from her earlier practice of making single images of things her children have made or abandoned into creating series that have an action-based narrative. In the work shown here, Fox has photographed her eldest son's making of a model Father Christmas over the course of a few days [142]. The comic and creepy sculpture takes shape through the series, Fox recording not only the product of her children's imagination but also the affinity between play and creativity inherent in both the sculpture and the act of photographing in this casual and intuitive way.

Ryan McGinley's (b. 1977) exhibition at the Whitney Museum of American Art in New York in 2003 was advertised in terms that suggested that intimate photography had become an established genre, with young practitioners like McGinley now making authentic records of their lifestyles in full awareness of the traditions within contemporary art of this type of work. The

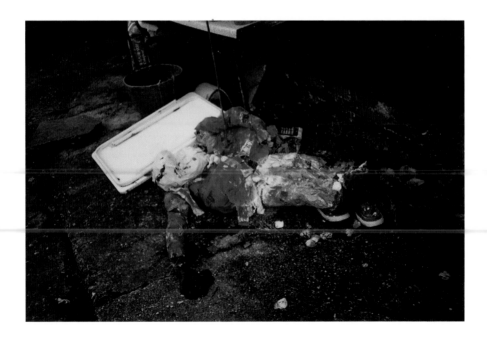

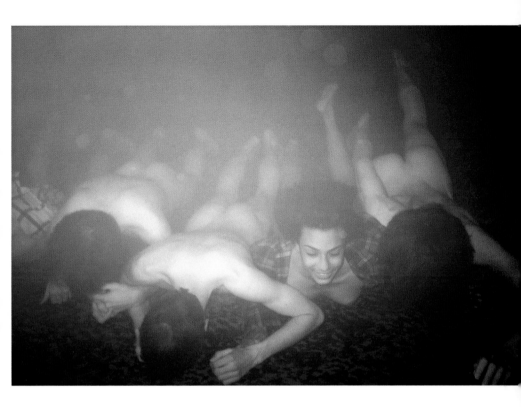

143. **Ryan McGinley**, *Gloria*, 2003.

prospect of an emerging photographer's having only an unwitting affinity with the work of Nan Goldin is increasingly unlikely. As a teenager, McGinley had met Larry Clark and taken up photography while studying graphic design in New York. The implication of this publicized biography is that, early on, he knew that there was a possibility that his images of his and his friends' lives could one day receive public attention. The location of many of McGinley's photographs – the Lower East Side of Manhattan – although gentrified beyond recognition since the late 1970s, was also the site of Nan Goldin's early work. This is perhaps one indication that McGinley's version of photography of intimate life was a response to and rephrasing of a recognized heritage. What is new in his work is a lack of angst and pathos apparent in so much earlier intimate photography, now substituted by a knowing playfulness in collaboration with his subjects to help shape the narratives for the public context of the art world [143].

Hiromix's (Toshikawa Hiromi) (b. 1976) snapshot photographs, including self-portraits and images of her friends, travels and domestic life, have brought her cult status in her native Japan. The

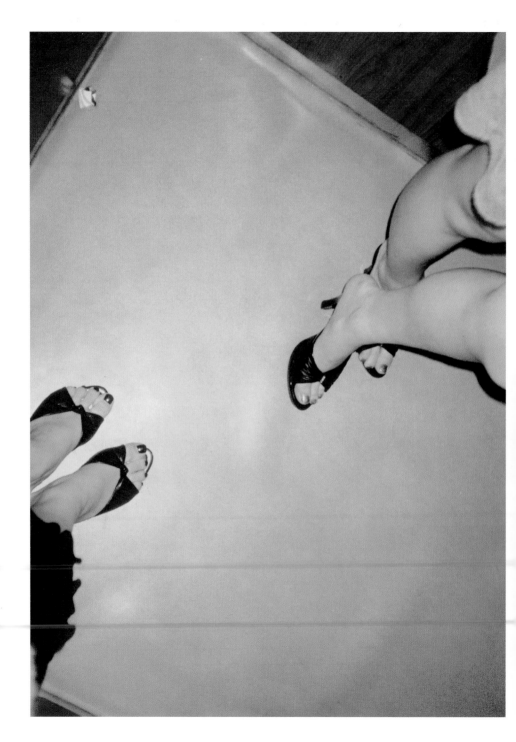

144. Hiromix,
from *Hiromix*, 1998.
By the age of twenty-four, Hiromix had published five books of her photographs. This in part reflects the suitability of diaristic, intimate photography to the book format, using juxtaposition and visual rhythm on the page to create narrative. It also indicates the popularity in Japan for realizing photographic projects as books, which have in turn influenced photography book design in the West.

145. Yang Yong,
Fancy in Tunnel, 2003.

promotion of her diary-like photographs centres on their being the offerings of a new generation of photographers who have adopted the spontaneity and immediacy of Nobuyoshi Araki but with new attitudes and stories to tell. Hiromix's gender, physical beauty and youth significantly matches the profile of many of Araki's models. She delivers a sense of the artistic liberation that intimate photography can offer: the persona of the photographer being bound up in the description of his or her life rather than in more stereotypical notions of age and gender with which other practice often deals [144].

Some intimate photography involves an entire group's presenting their lives for consumption as art. Chinese artist Yang Yong (b. 1975) photographs friends to evoke the attitudes of young urban people living in China [145]. His images are taken mainly at night in the streets of one of China's financial centres, Shenzhen, and are staged in collaboration with his subjects. In these works, the photographs are not highly performative, for emotions such as boredom are usually the focus. There is an air of waiting, of having little to do. There is a sense of Yang Yong and his collaborators imbuing their own lives with attitudes and postures that refer to fashion and lifestyle magazines, particularly the

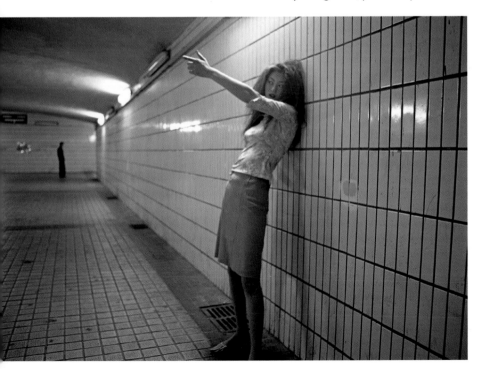

146. **Alessandra Sanguinetti**,
Vida mia, 2002.

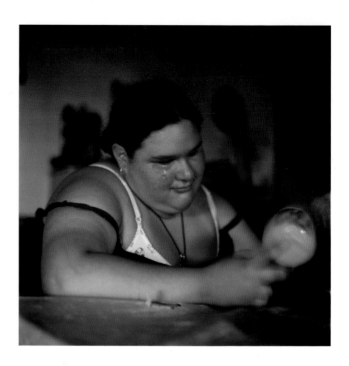

representation of youth culture in the 1990s. Alessandra
Sanguinetti (b. 1968) undertook a four-year photographic project
with two female cousins who lived just outside Buenos Aires,
Argentina [146]. Their collaboration centred on the girls'
decisions about how to represent themselves, often involving
theatrical performances and dressing-up. The role of the
photographer is one of recording or facilitating the girls'
self-expression rather than as a choreographer of their
representation. What developed from this close and trusting
relationship between Sanguinetti and the cousins was the
possibility of her being able to make other, more observational
images that caught the girls when they were out of their
performed characters.

For more than twenty years, Annelies Strba (b. 1947) has
photographed her immediate family, her two daughters and,
lately, her grandson Samuel-Macia [147]. There is a sense of a
family used to and at ease with Strba's photographing of their daily
lives. The tilted camera angle and image blur indicate that Strba
works unobtrusively and quickly to record her family's routines
and interactions. She is rarely shown in her photographs, but her
presence and point of view are felt in the observations she makes.
At times, this is experienced when her subjects face and react to

Strba and her camera. In a more subtle way, her place within her family is implied in her choice of when to photograph them as they eat, sleep, wash and move about their home. In her book *Shades of Time* (1998), Strba interweaves her domestic images with landscape and architectural views, as well as old family photographs, to give the historical, geographical and personal context for the depiction of her family.

Both Ruth Erdt's (b. 1965) [148] and Elinor Carucci's (b. 1971) [149] photographing of their respective families sensuously emphasize the archetypal narratives of personal lives, for example the bonds between mother and daughter, or a child on the cusp of adulthood. There is a neutrality in their techniques rather than a pronounced style such as that of a family snap. The search here is

147. **Annelies Strba**, *In the Mirror*, 1997.

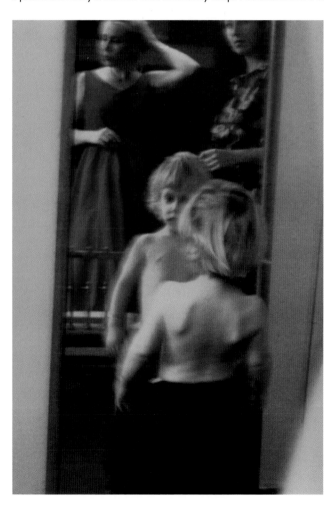

149. (above) **Elinor Carucci**,
My Mother and I, 2000.

148. (opposite) **Ruth Erdt**,
Pablo, 2001.
The Swiss photographer Ruth Erdt
published a collection of portraits
she made of friends, lovers and
family over sixteen years.
Spontaneous and posed
portraits are blended into the
book sequence, giving over the
sense of how her photographing of
daily life is both accepted by and a
collaboration with her loved ones.

for a form of photography that, while remaining an account of
the relationships between the photographers and their loved
ones, triggers in us a sense of the universality of these bonds and
moments in life. In both Carucci's and Erdt's works is a conscious
paring down of detail, such as dress and mise-en-scène, that would
date or overly particularize a photograph. This approach keeps
the symbolic and non-specific readings of their depictions of
their personal relationships to the fore.

The photography of private and daily existence has, as we
have seen, often been realized with a snapshot aesthetic or
openness on the part of the photographer to represent the
spontaneity of domestic life. But these are not the only ways in
which chronicles of intimacy have been represented. Tina Barney's
(b. 1945) long-term photographing of her affluent American East
Coast family creates one of the benchmarks for art photography's
capacity to visualize familial bonds outside the mannerisms of
snap photography. With an approach that Barney describes as
being akin to an anthropological survey, her photographs define
the rituals, gestures and environments that act as clues to the
cultural construction of personal relationships and social
positioning. Her pictures look staged in comparison with many
of the images in this chapter. The composure of Barney's subjects
is, in part, a simple reflection of the acknowledgment of being

photographed [150]. In a manner similar to nineteenth-century
photographic portraiture, activity and motion go on behind the
camera as Barney rapidly changes film cases and composes her
shots, the subjects compliantly suspending their animation as
she works. Barney's approach may differ from the casual style
and process of using an Instamatic camera but still hinges on her
perceiving how a subject's gestures and demeanour unconsciously
display the nature of personal identity and relationships. The
spatial connections between her subjects become pronounced,
and signs of psychological closeness and distance between family
members are revealed in elements such as who looks at or away
from the camera. With the careful containment of the group
within the frame, the impression is one of individuals making up
a family unit, with the dynamics between them contained within
their portrayal.

One of the most influential and comprehensive portrayals
of the dynamics within family relationships has been made by

American artist Larry Sultan (1946–2009). His book *Pictures from Home* was published in 1992, ten years after he first began the project. The book is an evocative study of his mother and father. Some of the photographs are posed, and Sultan describes these as images he traded or negotiated with his parents as he won their agreement to be photographed while they undertook household chores. Others, such as the one shown below, are casual observations in which he remained emotionally involved in his parents' daily routine. The book also includes family photographs and sequences of stills from 8mm film footage. This selection includes photographs of his parents at professional and social gatherings, showing the aspects of their lives in which Sultan did not participate as a child. There are photographs of his mother and footage, taken by his father, of Sultan as a boy, emphasizing how such images innocently reveal the relationships between loved ones. This sense of a family's history being retrieved also comes across in transcribed conversations the three had about Sultan's project.

152. **Mitch Epstein**,
Dad IV, 2003.
Epstein's project *Family Business*
revolves around the central figure
of the artist's father. The work
considers the personal changes
in his father's life, set against the
backdrop of cultural and economic
change in American society during
the same period.

American Mitch Epstein's (b. 1952) *Family Business* is a four-year
documentation that revolves around the central character of the
photographer's father [152]. The beginnings of this project were
prompted by Epstein's return to his family home to support his
parents through a crisis that jeopardized his father's livelihood.
Epstein began to use photography, and also a DVD camera, to
investigate how his father's hard-working and honest ethics, which
had been so in keeping with cultural values in post-war America,
had almost resulted in a personal and familial tragedy. *Family
Business* has a number of visual elements. Epstein photographed
the interiors that were the spaces of his father's life, including
his home, businesses and country club. He also made a series
of portraits of people, such as his father's employees, family and
friends. On the DVD, Epstein represented key moments in that
stage of his father's life, including his recuperation from heart
surgery and his preparing the stock of his furniture store for a
liquidation sale. The intensity of this project comes from the

palpable sense of a photographer's visualizing a subject in subtle ways from a position of intense emotional knowledge, capturing everything from the simplest human gesture to the symbolism of what from the outside might seem like unexpressive details. As with the photographs of Tina Barney, there is a compelling blend of a photographically distant perspective with a subject that is intimately known.

The role of the camera in Colin Gray's (b. 1956) relationship with his parents has taken a number of forms in his long-term documentation of their family life. When talking about his formative experiences of photography, Gray describes the camera as being a symbolic control over, and way of visualizing, the bonds within his family. From 1980, he has returned to their home and involved his parents as subjects and performers in staged dramas for the camera, including re-enacting shared memories of past events as a way of recognizing the dynamics between them. In the most recent stage of the collaboration, begun in 2000, the emphasis is on his elderly parents' physical deterioration [153]. The series marks the shifts in their routines, such as the increasing number of visits they make to hospitals and to their church. They also represent the changes in the role of his mother after a stroke and that of his father as her primary carer. Gray

153. **Colin Gray**, *Untitled*, 2002.

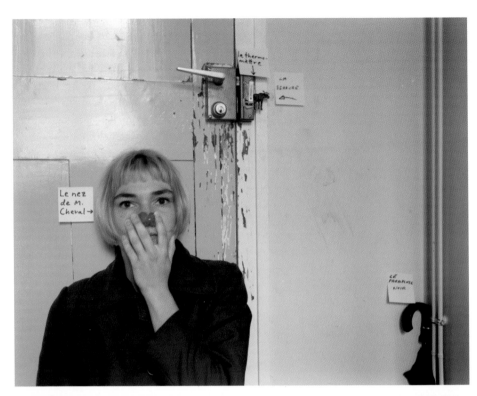

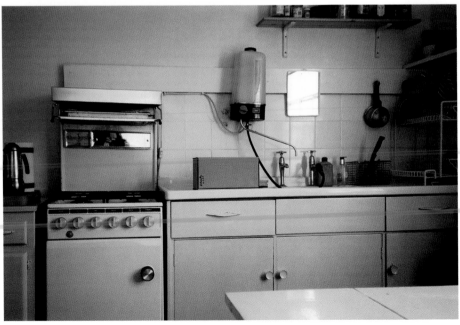

describes the project as a way of engaging the viewer in his own quiet agony of being essentially helpless at the decline of his loved ones. Photography is used here to communicate the shared experience of gradual personal loss, as well as being a means of catharsis for the photographer.

In the previous few pages, the photography of intimate life has turned away from vibrant portrayal of circles of friends and domestic dramas towards more isolated, detached and solitary portraits. This state has been a recurring theme in the photographs of Finnish artist Elina Brotherus (b. 1972), who has poignantly photographed her life at times when she felt at her most uncertain or unstable. *Suites Françaises* [154] was a series made while Brotherus was undertaking an artist's residency in France in 1999, struggling with the separation from her normal life and her inability to communicate fully in a foreign language. Post-It notes giving the French words and phrases that Brotherus was learning were placed in her modest living accommodation. The photographs show the technique she employed to try to learn the language, with touching and comedic effect. Some of the phrases had practical use in the navigation of her daily life in a foreign country; others were put together by Brotherus, and she then acted them out (as here), playfully pointing out her state of being able to communicate only with the banality and enforced childishness that comes from learning a new language.

The photographer's emotional state is also touchingly conveyed in Breda Beban's (b. 1952) series *The Miracle of Death* [155]. These images capture the profound sense of loss that Beban experienced after the death of her partner and artistic collaborator Hrvoje Horvatic in 1997. The box containing his ashes is photographed in their home, in rooms still containing his personal belongings and signs of their cohabitation. The series documents Beban's moving of the box, unable to give it a fixed place, thus indicating her inability to reconcile herself to her loss. Beban's photographs epitomize the capacity of intimate photography to describe a detail of life simply and without obvious elaboration, and to invest it with the profundity of human emotion.

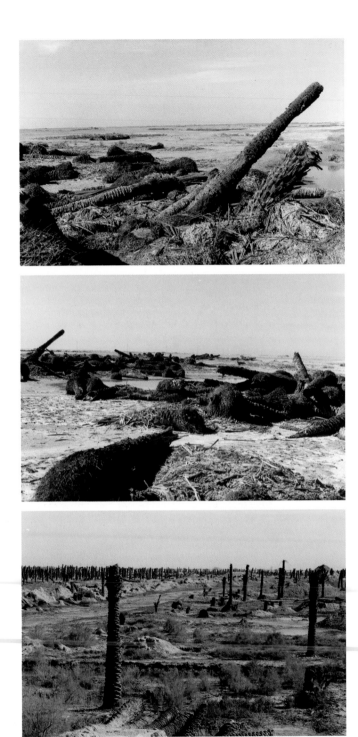

Chapter 6 Moments in History

This chapter considers how photography can bear witness to the ways of life and events of the world. How do photographers move from a critique of image-making that implies the loss of the documentary power of photography to a practice that utilizes art strategies to maintain the social relevance of the photograph? Faced with a gap left by the decrease of commissioned documentary projects and the usurping of television and digital media as the most immediate carriers of information, photography's answer has been to make an asset out of the different climates and context that art offers.

Contemporary art photographers have, in the main, taken an anti-reportage stance: slowing down image-making, remaining out of the hub of action, and arriving after the decisive moment. The use of medium- and large-format cameras (as opposed to 35mm format), not normally seen at the sites of war and human disaster – not, at least, since the mid-nineteenth century – has become a sign that a new breed of photographers is framing the social world in a measured and contemplative manner. The subject matter has been different, too; rather than being caught up in the chaotic midst of an event, or at close quarters to individual pain and suffering, photographers choose instead to represent what is left behind in the wake of such tragedies, often doing so with styles that propose a qualifying perspective.

One of the most influential photographers working in this mode is French artist Sophie Ristelhueber (b. 1949). From her photographs of Beirut in the early 1980s during the Lebanese Civil War to her depiction of the fragile borders of Uzbekistan, Tajikistan and Azerbaijan at the beginning of the new century, Ristelhueber has visualized the tragic repetition of the destruction of nature and civilizations. In 1991, in the wake of the first Gulf War, she worked in Kuwait making aerial photographs of the traces of bombing and troop movements and, on the ground, photographing the poignant residues of combat, such as

156. **Sophie Ristelhueber**, *Iraq*, 2001.
Sophie Ristelhueber has described her experiences in Iraq in 2000 and 2001 as 'a striking shortcut of thousands of years: from the oldest civilizations who had lain on this land to those of the first Gulf War, while the American F-16s were flying over our heads on surveillance missions. The fossilized vision is a pattern that haunted me since the Beirut work, a cycle of more than twenty years that is on the verge of ending.'

abandoned clothing and mounds of spent explosive shells. The project was entitled *Fait,* meaning 'fact' and also 'done' or 'made' in French. The bleak and unfathomable chain of consequence and effect of war is very pronounced in Ristelhueber's images of Iraq in 2000 and 2001 [156]. In some of her starkest visualizations of the decimation created by war, burnt tree stumps act as metaphors for the loss of life as well as the ecological richness of the region.

Northern Irish artist Willie Doherty (b. 1959) has, since the 1980s, made conflict in Northern Ireland the central subject of his video and photographic work. He uses a combination of forms as a way of extending the complex experience of Irish history to a gallery context; for instance, he sometimes uses audio to establish the different voices that constitute the political standpoints of those involved in the conflict. Doherty uses still photography to present the corroded detritus of marginal and abandoned spaces, a sense of the economic and social scarification of Northern Ireland as a consequence of its political and military turbulence. *Dark Stains* [157] typifies the mournful desolation of Doherty's photographs, the title referring to the Christian idea of original sin and its place in the rhetoric of Irish politics.

Zarina Bhimji (b. 1963) works with film and photography to recount the physicality and time of unidentified spaces, and in doing so she considers the way in which images can resonate with general narratives of elimination, extermination and erasure. Her aesthetic evocation is similar to the practices of other artists in this chapter: she chooses forms that function as allegories which, through their extreme economy of means, always remain open-ended and unresolved. In one of her series of lightboxes,

158. **Zarina Bhimji,**
Memories Were Trapped Inside the Asphalt, 1998–2003.
Bhimji's describes her project about Uganda as 'learning to listen to difference: listening with the eyes, listening to changes in tone, differences in colour'.

159. **Anthony Haughey,**
Minefield, Bosnia, 1999.
Anthony Haughey's *Disputed Territory* series, set in Ireland, Bosnia and Kosova, identifies in the landscape the tenuous markings of boundaries as a metaphor for the political and social legacy of civil war.

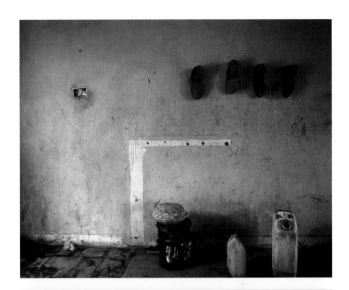

Memories Were Trapped Inside the Asphalt [158], Bhimji composes a still life that acts as a metaphor for an altered and suspended situation, where the logic of the everyday no longer applies.

The use of allegory is also shown in the work of Anthony Haughey (b. 1963), who has photographed at territorial borders, including the Balkans in the late 1990s, as part of *Disputed Territory*

160. **Ori Gersht**,
Untitled Space 3, 2001.
Taken on a journey Gersht made
through the Judean Desert, this
photograph depicts a place where
political dissidents and refugees
have traditionally sought shelter
from persecution. Taken at the
beginning of the current *intifada*,
this place represents a fraught
and potentially dangerous place.

161. **Paul Seawright**,
Valley, 2002.

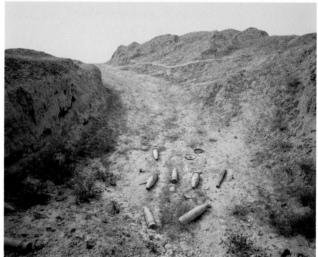

[159], an ongoing project that began on the borders of the
Republic and Northern Ireland. It is in the details of his
photographs that a sense of a place or culture, indelibly changed
by traumatic events, can be found. In post-conflict Bosnia and
Kosova, Haughey utilizes an iconography of slight and ambiguous
traces of past acts of violence that has become prevalent within
contemporary art photography. Israeli artist Ori Gersht's
(b. 1967) *Untitled Space 3* [160] is part of a series he has made
at night in the Judean Desert, where, beyond the beams of
the photographer's lights, darkness engulfs the way ahead.

162. **Simon Norfolk,**
Destroyed Radio Installations,
Kabul, December 2001, 2001.
Norfolk's images of a decimated
Afghanistan depict the landscape
in a similar vein to the European
artists of the Romantic era,
who painted the decline of
great civilizations. The war in
Afghanistan has scarred the
landscape, and Norfolk
photographs the remains like
an ancient archeological site.

A metaphor for uncertainty and exodus, binding contemporary
Israel to Old Testament history, the darkness is a visualization of
a void, of inhuman nothingness and loss; it is also an allegory for the
problems faced by photographers documenting war of how
to visualize the enormity and complexity of human suffering and
conflict. The use of artistic conventions to translate social events
and consequences of history into visual forms is now well
established. British artist Paul Seawright's (b. 1965) series *Hidden*,
a mournful generalized view of the futility of war, was produced
in 2002, when he was one of the artists commissioned by the
Imperial War Museum in London to respond to the conflict in
Afghanistan. In *Valley* [161], Seawright uses the twisting hill road
littered with artillery shells in a compositional manner reminiscent
of the earliest photographs of conflict zones by British
photographer Roger Fenton (1819–1869), whose photographs of
the Crimean War included desolate landscapes littered with
cannon balls in the aftermath of a battle. This mediation of
contemporary world events through pre-existing image-making is
evident in Simon Norfolk's (b. 1963) photographs of Afghanistan

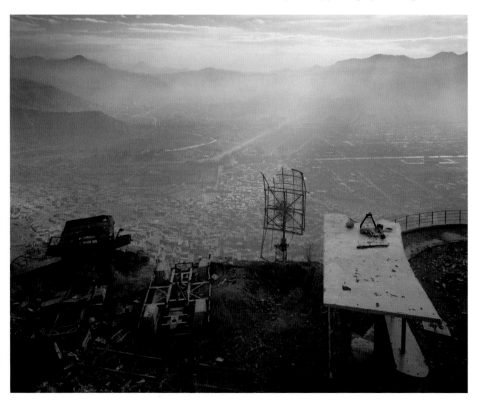

in which the skeletons of bombed-out buildings are shown as romantic ruins on deserted plains, reminiscent of late-eighteenth-century Western landscape paintings. There is a legitimate and specific reasoning behind this return to a pictorial style of the past. It makes a pointed and ironic reference to the fact that, because of the decimation of war, this ancient and culturally rich region has been returned to a premodern state.

Where photographic projects concentrate on human subjects and consequences of social crisis or injustice, one of the most prevalent forms is the deadpan style of photograph that we encountered in Chapter 3. The claim that is often made about such photography is that it allows the subjects to control their representation, the photographer merely bearing witness to their existence and self-possession. Essays and captions accompanying the photographs are often crucial here, and are used to carry factual information about what the subjects have endured and survived, and who and where they were when the photograph was taken. At times, quotes from the subjects are also displayed, not only to give them a voice, but also to confirm the role of the photographer as their mediator. The photographing of groups and communities for art galleries and books tends to be done on longer timescales than for commissioned news stories, and usually with more repeated visits. This fact is often mentioned in the supporting texts as evidence of an art project's ethical, counter-reportage dimension. A photographer has been able to spend time with the subjects, waiting for the right moment and photographing them from an informed, albeit an outsider's, position.

Fazal Sheikh (b. 1965) has primarily photographed individuals and families living in refugee camps. He uses black-and-white photography, which both makes a declaration of resistance against the seductive fashion in art of colour prints and identifies the work as documentary portraiture with a serious intent. The photograph shown here is from his series *A Camel for the Son* [163], in which Sheikh photographed Somali refugees in camps in Kenya. Concentrating on the mainly female refugees, Sheikh recorded the human-rights abuses they had suffered in Somalia and in the camps. Sheikh's singling out of figures and his giving them a dignified and quasi-timeless quality in the use of black-and-white film, together with the texts that detail their individual stories, means the photographs hover somewhere between portraits and portrayals. Sheikh goes to great lengths so that we know the histories of each of his subjects. We read their tales of injustice and are invited to map this onto their faces and bodies.

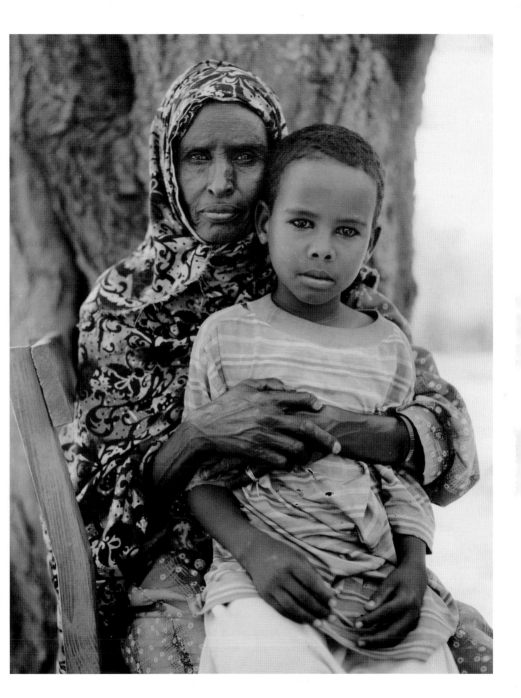

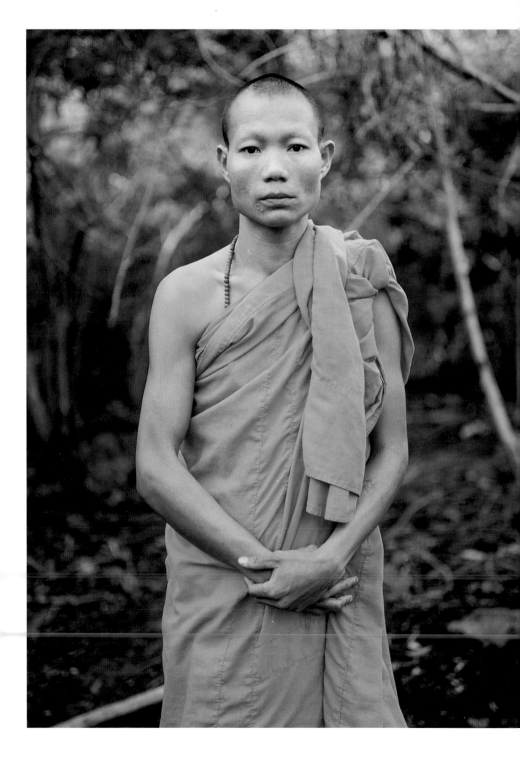

164. Chan Chao,
Young Buddhist Monk, June 1997,
2000.
Chan Chao has described his
Something Went Wrong series
as 'very much a kind of self-
reckoning'. The series was made on
a number of visits to refugee camps
bordering on his native Burma
(now Myanmar) and portrayed
people who had been displaced or
forced out of the country after he
had migrated West.

165. Zwelethu Mthethwa,
Untitled, 2003.

Chan Chao's (b. 1966) *Something Went Wrong* is a series of portraits of Burmese refugees who fled Myanmar (previously Burma) after the State Law and Order Restoration Council took repressive power in 1988. Single figures, stoically conducting their lives in displaced communities, are shown temporarily halting their routine in the jungle squatter camps to be photographed. The extended title of *Young Buddhist Monk, June 1997* [164] states that the young man was a former member of the ABSDF, an armed student group. The implication of the caption is not only that textual information is of importance to the understanding of the image, but also that documentary photography can be no more than a sign of someone's survival and an indicator of their personal story. Visualizing the maintenance of identity and self-respect in challenging circumstances is strongly present in South African photographer Zwelethu Mthethwa's (b. 1960) extensive documentation of the homes and people in the shanty towns on the outskirts of Cape Town [165]. The increased toleration in the 1980s of black people's migration out of the apartheid system's reserves led to a massive influx of rural blacks in search of work to these makeshift communities. Even though the ANC government

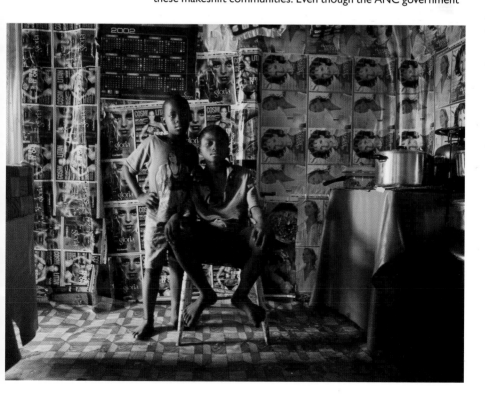

came to power in 1994, these settlements have remained relatively unchanged. Mthethwa documents the homemade individuality of the shanty houses. He involves his subjects in the ways they will be depicted: they choose what to wear, how to pose themselves and how to arrange their personal effects.

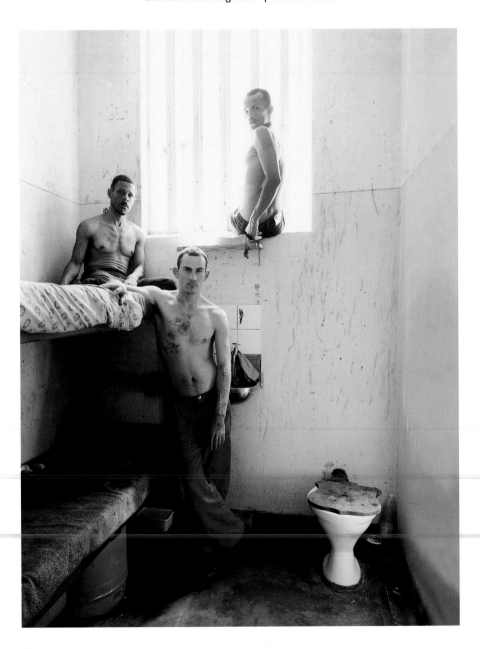

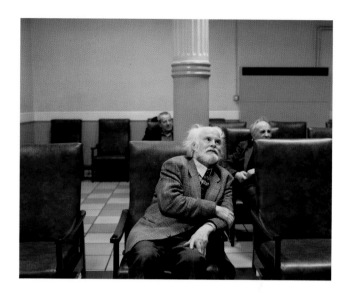

In the early 2000s, Adam Broomberg (b. 1970) and Oliver Chanarin (b. 1971) gained access to different international communities in their roles as photographers and creative editors of Benetton's *Colors* magazine (one of the few photography magazines in recent years to have explicitly addressed global issues). They edited issues on social themes such as the treatment of mental illness, refugees and the penal system. The photograph seen here [166] first appeared in *Colors* and then in their book *Ghetto* (2003) and accompanying exhibitions. In each context, the subjects were named and quotes ascribed to them. The fact that the activity in the prison was edited out and slowed down long enough to be visualized on Broomberg and Chanarin's large-format camera relates the project to nineteenth-century documentary photography, and also serves to detach it from the conventions of photojournalism. In Deirdre O'Callaghan's (b. 1969) portrait of a resident in a men's hostel in London, the subject's incongruous string of pearls functions as a sign of his wilful self-determination [167]. O'Callaghan's *Hide That Can* project is a culmination of four years of spending time and photographing in the hostel. Many of the people who lived there were Irish men in their fifties and sixties who came to London as young adults to earn money as manual labourers. O'Callaghan moved to London in the early 1990s, as did many young Irish men and women, in search of work, and her affinity with the hostel's residents stemmed from her own economic migration. To begin with, O'Callaghan photographed the men only occasionally,

166. (left) **Adam Broomberg and Oliver Chanarin**, *Timmy, Peter and Frederick, Pollsmoor Prison*, 2002. 'They place three in a room so there's one to be a witness if one of the three does something bad to one of the others. One of us is the security against evil.'

167. (right) **Deidre O'Callaghan**, *BBC 1*, March 2001. O'Callaghan's *Hide That Can* project portrays the residents of a hostel for men in London. O'Callaghan also accompanied some of the men on holidays back to Ireland and witnessed the transformation of the men's behaviour and self-esteem when outside their institutionalized daily life. In a few instances, the Irish men were reunited with their families on these holidays, sometimes after decades having no contact.

168. Trine Søndergaard,
Untitled, image #24, 1997.
The women depicted in
Søndergaard's photographs are
prostitutes. They are invariably
shown as being conscious of
the camera, collaborating with
the photographer in the
documentation of their lives
and trade. The male clients are
rarely fully shown, more often
represented as temporary and
anonymous presences.

169. Dinu Li,
Untitled, May 2001.
These photographs were taken
in the modest living quarters of
illegal Chinese immigrants living
in the north of England. Li
photographed the mementoes
they had brought from China,
such as a small bag of soil. Li
also photographed the visual
ironies of these interiors, such as
the 'lucky boat' cardboard box
used as a bedside table.

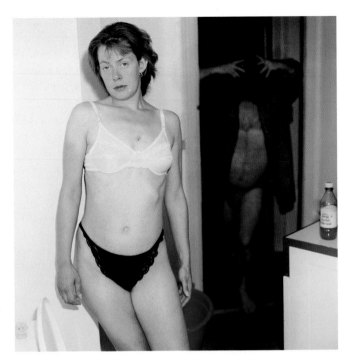

spending more of her time becoming a familiar face in the hostel. Her photographic project then became part of the men's daily routine and O'Callaghan would talk to them about their personal histories, becoming a witness to their situations.

Danish artist Trine Søndergaard's (b. 1972) photographs of women sex workers, either with their clients or off duty around the Central Station in Copenhagen, Denmark, were taken in 1997–98 [168]. The lack of glamour in the images is a poignant vision of the reality of the women's situation. Søndergaard's project is well balanced in the sense that it does not concentrate on the salacious moments of the women's working lives but is tempered through depictions of their daily routines and environments. As a result, we come to understand how they survive the dehumanizing aspect of their work. For Dinu Li's (b. 1965) *Secret Shadows* series [169], making portraits of illegal Chinese immigrants in the north of England was not an option, for, given their illegal status, their individual identities needed to be kept secret. Instead, their personal effects became the subject of Li's photographs as a way of visualizing the values, practicalities and memories that form the identities of these workers. Margareta Klingberg's (b. 1942) approach to the unseen and unprotected workforce of immigrant labourers was to seek out

170. **Margareta Klingberg**, *Lövsjöhöjden*, 2000–01.

171. Allan Sekula,
Conclusion of Search for the Disabled and Drifting Sailboat 'Happy Ending',
1993–2000.
Allan Sekula's series *Fish Story* presents the history and current condition of the maritime industry. The photographs were taken at sea and in port cities in America, Korea, Scotland and Poland. Sekula constructs a detailed story through photographs, texts and slide shows.

Thai and Eastern European fruit pickers working for jam companies in the fields and forests of northern Sweden [170]. The workers are aware of being photographed, but there is a casualness in composition that suggests that these photographs were taken relatively quickly, almost like a family portrait or holiday snap. A more composed type of photograph with a camera on a tripod might have raised concern in the subjects' minds that Klingberg had an official reason to photograph them. The impact of these photographs comes from looking at a social group we do not normally see in our daily lives or in visual representations.

The depiction of marginalized groups that are socially overlooked has been a concern of documentary photography since the coining of the term in the 1920s. The fact that today these images are more likely to appear in artist's books and exhibitions, rather than in magazines or newspaper supplements, is a sign of the shift in the context of photography. And while documentary is by no means the dominant photographic form in the art world, in the hands of a few key artists it remains an important social and political tool.

For more than twenty-five years, Canadian artist Allan Sekula (b. 1951) has, in his writing and photographs, put forward one of the strongest arguments for why and how art can accommodate thorough and politicized investigations of the major economic and social forces that shape our world. Sekula's photographs are intentionally difficult to reduce to iconic images or soundbites on the subjects he researches. By working in this way, he has resisted being consumed by the art market while still governing a prominent place in international (especially European) exhibition programmes. In *Fish Story* [171], a vast undertaking spread over many years, Sekula examined the realities of the modern maritime industry. His photographs, slide sequences and texts interweave the history of sea trade routes with the problems facing this industry today. Rather than international sea ports being represented as historical and nostalgic places, Sekula depicts this dispersed (across the world's seas) trading as an often forgotten but politically resonant aspect of globalization.

Paul Graham's (b. 1956) *American Night* series [172, 173] was made over a five-year period from 1998. Most of the photographs are disarmingly bleached-out images of roadsides and pedestrian walkways where barely visible Afro-American figures walk. The dramatic bleaching or misting of these photographs is suggestive of the political invisibility and social blindness to poverty and racism in America. Clear, colour-saturated photographs of wealthy suburban

172. **Paul Graham**,
Untitled 2002 (Augusta) #60, 2002.
Since the mid-1980s, Graham
has tested the visual boundaries
of contemporary art practice
engaged with social and political
issues. *American Night* is perhaps
his most extreme use to date
of photographic aesthetics to
represent the lack of visibility
in American politics of its social
and economic racial divide.

173. **Paul Graham**,
Untitled 2001 (California), 2001.

homes punctuate the series and also reflect Graham's stark visions
of contemporary American society. The representation of a social
divide is brought to the fore by Graham's use of a startling
aesthetic difference that frustrates our expectations of
photography's documentary style and capacity, as well as acting as a
metaphor for American social divisions. This is turn reminds us of
the degree to which all documentary photography is, on some
level, subjective and partial in its visioning of one social world.

Another highly influential British photographer Martin Parr
(b. 1952) has also consistently tested the boundaries of
documentary style. Parr has employed a number of visual formats

for his documentary projects, and in the mid-1990s began using a hand-held camera with a flashlight in combination with a macro-lens that focuses close up on a subject. Parr's *Common Sense* [174–77] creates the brash and graphic depiction of everyday objects and observations for which he is well known. The overall theme of the series is the vernacular fashioning of junk food, tacky souvenirs and package holidays. Although the project has been promoted as global in its scope (Parr travelled extensively in pursuit of his images) his choice of subjects has a peculiarly British appeal. A chequered tearoom tablecloth or an old man's flat cap could easily be found in any resort in any country to which the British might migrate, and Parr is suggesting that these are cultural idiosyncrasies that are dying out. There is a democracy of sorts in Parr's project, as every subject is given the same visual treatment: closely cropped, flash-lit, and the heightened colour of a snappy snap, whether an image shows the back of a person's head, a plate of food or a prized possession. It is in his editing skills that Parr shapes the narratives of a project, treating his own photographs like his collection of photographic memorabilia and postcards, as vernacular visual records that he compiles into groups, juxtapositions and rapid sequences. *Common Sense* epitomizes photographic promiscuity – the taking of hundreds of photographs, which in their combination offer one dynamic and subjective image of the world. In 2000, multiple sets of laser-jet prints of the series were sent to a number of galleries around the world participating in a global, simultaneous showing of the project. The galleries were able to choose their own way of installing the images, most deciding to fly-post them in grids in the exhibition space and outside at public sites.

174. (top, left) **Martin Parr**, *Budapest, Hungary*, 1998.

175. (top, right) **Martin Parr**, *Weston-Super-Mare, United Kingdom*, 1998.

176. (bottom, left) **Martin Parr**, *Bristol, United Kingdom*, 1998.

177. (bottom, right) **Martin Parr**, *Venice Beach, California, USA*, 1998.

The gravitas and monumental scale of French artist Luc Delahaye's (b. 1962) ongoing *History* series [178] stands in opposition to this approach. Delahaye began this sequence of photographs in 2001, selecting to date an average of four images per year to include in the work. All of the photographs have a panoramic format and, when printed, are close to two and half metres in length. They revolve around military conflict and include images taken in war zones, such as Afghanistan and Iraq, and others showing the consequences of war, such as the trial of former Yugoslav president Slobodan Milosevic in The Hague in 2002. Delahaye takes what is ostensibly the archetypal subject of photojournalism and represents it in the grand, tableau format of art photography. They make for shocking images, in part because some of his subjects – such as here on *Kabul Road*, where a group of men pose for the camera with corpses in the centre in crystal clear colour imagery – are so composed. The shock is also in the aesthetically seductive qualities of the prints. Delahaye takes a subject more familiar in photojournalism and creates a historical tableau, making the materiality of traumatic recent history strongly resonant and haunting.

Ziyah Gafic's (b. 1980) photographs made in Bosnia-Herzegovina during 2001–02 in the aftermath of civil war often capture the return to ordinary life, with the results of the conflict's genocide still dramatically present. In the photograph shown here [179], the Commission for Missing Persons had organized the excavation of the bodies of massacred Muslim villagers in Matuzici, laid on white bags behind a mosque, for identification. The dissonance between the skeletons and the

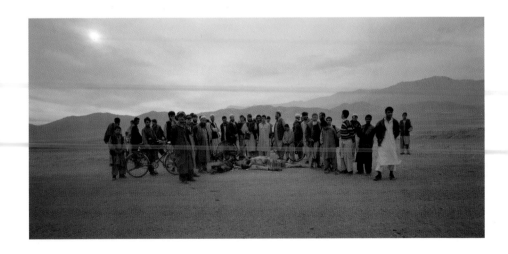

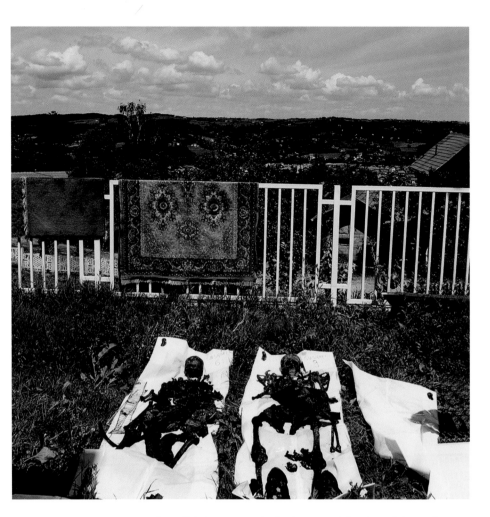

179. **Ziyah Gafic,**
Quest for ID, 2001
The Commission for
Missing Persons organized the
identification of a dozen bodies,
killed when the Serbian army
occupied the Bosnian village of
Matuzici in 1992. Bodies were
displayed behind the local mosque;
they were simply laid down on
uncut grass. Someone from the
village was cleaning carpets and
they were drying on the ground
nearby; later he hung them on
the nearest fence to dry.

beautiful view across the landscape and the signs of domestic
activity in the carpets hung up to dry is profoundly shocking.

Andrea Robbins (b. 1963) and Max Becher (b. 1964) also
consider the residue of historical events on contemporary society.
In *Colonial Remains* (1991), they documented the Germanic styles
of houses of the former German colony of South West Africa,
now Namibia. In the text for the exhibitions of the series, the
brutal facts of the colonization, led by the father of Adolph Hitler's
aide Hermann Göring, in which more than seventy-five per cent of
the indigenous Herero people were exterminated, are described.
The photograph featured here is from their *German Indians* series
[180] and was taken near Dresden in Germany at an annual festival
honouring the German writer Karl May (1842–1912), a writer

180. **Andrea Robbins and Max Becher**, *German Indians Meeting*, 1997–98.
This somewhat bizarre and comical depiction of Germans dressed as Native-American Indians is accompanied by photographer's research into the history of the revival in the twentieth-century of the writings of Karl May, as part of the search for historical validation of Nazi politics.

whose nineteenth-century evocation of the decline of native American ways of life in the face of Western encroachment was claimed by the Nazi regime as a fable of how a nation had been weakened by cultural corruption.

The idea in documentary photography of the realities of societies being shown to contradict generally held preconceptions – as visual 'proof' of things being different from what we imagine – has been fertile ground for exploration. Iranian artist Shirana Shahbazi's (b. 1974) photographs of daily life in Tehran cut across our expectations of what is considered a more exotic culture. In Shahbazi's mosaic-like installations of her photographs (some formal, others casual in composition) and large-scale paintings of her images by Iranian billboard painters, Shahbazi uses and confounds the stereotypes of Islamic art and daily actuality, proposing that a culture of such size, history and complexity cannot be represented through one visual form. Esko Mannikko's (b. 1959) photographs focus on the particularities of the Finnish rural culture, and are displayed in secondhand frames that emphasize the handicraft lives of his predominantly male subjects [182]. His images of the farming hamlets dotted along the coast outside of the city of Oulu are both humorous and strange, depicting the isolated existence of the mainly male inhabitants in the face of environmentally harsh conditions. Mannikko's approach consciously proposes photography as being capable of a level of unpretentiousness, in an art context where high production values dominate, that is sensitive to his subjects' modest lifestyles.

181. Shirana Shahbazi,
Shadi-01-2000, 2000.
Shahbazi reconsiders the
representation of life in Iran,
twenty-five years after the
Islamic Revolution. More than
fifty per cent of the population
was born after the Revolution
and must navigate Iran's theocratic
law as well as the same commercial
and popular trends as other
countries. Shahbazi's photographs
reveal this dichotomy and present
a complex and changing society.

182. Esko Mannikko,
Savukoski, 1994.
Mannikko uses secondhand frames
for his photographs of rural life in
Finland in order to emphasize their
individualistic way of living.

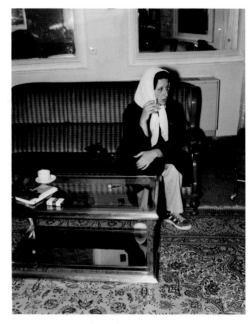

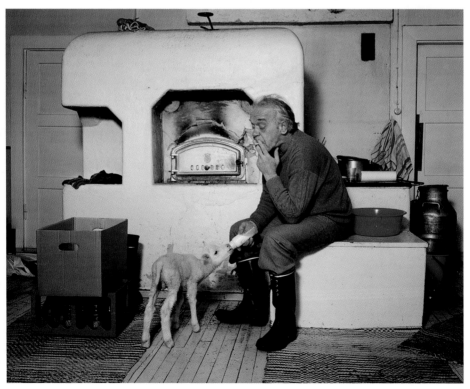

In 1982, Roger Ballen (b. 1950) began photographing the homes and people of smalltown South Africa, observing and photographing his many Boer subjects as individuals but also as archetypes of introverted communities. In the late 1990s, it became clear in the photographs that Ballen's relationship with the people and places on the outskirts of Johannesburg and Pretoria had changed. His photographs became more obviously staged compositions of people and animals and the interiors they inhabit. Ballen describes the Brechtian theatricality of these photographs as being jointly directed by him and his subjects, many of whom he had photographed for years. To shift to a more aesthetic and depoliticized territory was seen by some as an inappropriate visualization of post-apartheid South Africa. Furthermore, Ballen's photographs are black and white in the tradition of humanist documentary photography, but without any obvious narrative content that depicts social or political change. There is perhaps a greater affinity between Ballen's imagery and monochromatic painting or drawing than there is with photography's social history. Ballen appears to be drawn to the forms that are constructed in the places he photographs rather than seeking to represent his values and beliefs in the subjects he photographs.

A similar discourse and interest has been generated by the photographs of Ukranian artist Boris Mikhailov (b. 1938). He has been a photographer in many different guises since the 1960s:

as an engineer photographer, a photojournalist and now a prominent figure in contemporary art. These shifts, to some degree, reflect the sanctioned possibilities of being a photographer in Communist and post-Communist Ukraine. Mikhailov began his *Case History* project of more than five hundred photographs in the late 1990s [184]. In this work, he recorded homeless people in his hometown of Kharkov, paying them to pose for him. They re-created scenes from their personal histories or Christian iconography, or undressed to show the ravages of poverty and violence on their bodies. Like the work of Ballen, Mikhailov's photographs are collaborations, and the frank and intense depictions of those he considers to be his anti-heroes are a combination of his emotional closeness to his subjects and the critical detachment of a photographer of brutal realities. But there is a tension in Mikhailov's work for it is seen as a voyeuristic spectacle as well as the photographer's empathetic identification with the subject. Mikhailov's payment of his subjects to pose and perform for the camera is, for him, little more than a mirror image of the degrading reality for the disenfranchised of the former Soviet Union. Furthermore, it is a self-conscious act that reminds us that photography mediates life and society through the motivations and subjectivities of its makers.

184. **Boris Mikhailov**, *Untitled*, 1997–98.

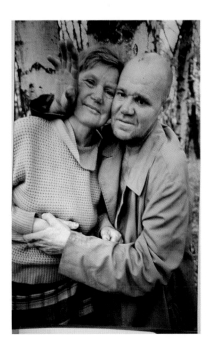

Chapter 7 Revived and Remade

Since at least the mid-1970s, the theory of photography has been concerned with the idea that photographs can be understood as processes of signification and cultural coding. Postmodernist analysis has offered alternative ways for understanding the meaning of photographs outside the tenets of modernist perspectives. Modernism had predominantly considered photography in terms of its authorship and the aesthetic and technical developments and innovations of the medium, which was seen to have a discrete and inner logic to it. The effect of modernist criticism was to create a canon of master practitioners, a history of trailblazers driving photography's capacities, the 'few' who could be distinguished from the 'many' everyday producers of photographs. In photography's modernist canon, the few are those who typify formal and intellectual transcendence over the functional, jobbing, vernacular and popular anonymity of most photographic production. Postmodernism, in contrast, considered photography from a different standpoint, one that was not intended to serve the construction of a pantheon of photographic creators that mirrored those established for painting and sculpture. Instead, it examined the medium in terms of its production, dissemination and reception, and engaged with its inherent reproducibility, mimicry and falsity. Rather than being evidence of the photographer's originality (or lack of it) or statements of authorial intention, photographs were seen as *signs* that acquired their significance or value from their place within the larger system of social and cultural coding. Heavily influenced by the principles of structural linguistics and its philosophical off-shoots structuralism and post-structuralism, particularly as formulated by French thinkers such as Roland Barthes (1915–80) and Michel Foucault (1926–84), this theory postulated that the meaning of any image was not of its author's making or necessarily under his or her control, but was determined only by reference to other images or signs.

185. **Vik Muniz,**
Action Photo 1, 1997.
Vik Muniz copied this photograph of the abstract expressionist painter Jackson Pollock by Hans Namuth by drawing the image in chocolate syrup and then photographing it. This suitably dripping re-presentation of the famous artist makes for a dynamic mental relay: we recognize this as a photograph of a drawing of a photograph of, what has become, a syrupy mystification of the creative act of the artist.

186. **Cindy Sherman**,
Untitled #400, 2000.
In recent years, Sherman
has created some of her best
portrayals of female characters:
East and West Coast American
women, well kept and affluent,
posed as if having their portraits
taken in a professional
photographer's studio.

This chapter will look at contemporary art photography that has been born out of this way of thinking. What is apparent when viewing the illustrations is that they offer experiences that hinge on our memory's stock of images: family snaps, magazine advertising, stills from films, surveillance and scientific studies, old photographs, fine art photographs, paintings, and so on. There is something deeply familiar about these works; the key to their meaning comes from our own cultural knowledge of generic as well as specific images. These are photographs that invite us to be self-conscious of what we see, how we see, and how images trigger and shape our emotions and understanding of the world. Postmodernist critiques of photographic imagery have been an invitation both to practitioners and to viewers to explicitly acknowledge the cultural coding that photography mediates.

The work of American artist Cindy Sherman (b. 1954), with its acute invocation of iconic mannerisms from cinematic stills, fashion photography, pornography and painting, is in many respects the prime exemplar of postmodern art photography. Of all the photographs that have received critical attention since the late 1970s for their appropriation and pastiche of generic types of visual images, it is Sherman's that are most widely written about. In the 1990s, her *Untitled Film Stills* series [187] was heralded

(somewhat ironically in modernist terms of originality) as a seminal and early realization of self-consciously postmodernist artistic practice. Each of the sixty-nine modestly sized photographs shows a single figure of a woman portrayed in a scenario that evokes enigmatic yet narratively charged moments from 1950s and 1960s black-and-white films. One of the most startling aspects of the series is the ease with which each feminine 'type' is recognizable. Even though we know only the gist of the possible film plots being staged, because of our familiarity with the coding of such films, we begin easily to read the narratives implied by the images. *Untitled Film Stills* is therefore a demonstration of the argument advanced by feminist theory that 'femininity' is a construction of cultural codes and not a quality that is naturally inherent or essential to women. Both the photographer and the model in the pictures is Sherman herself, making the series a perfect condensation of postmodernist photographic practice: she is both observer and observed. And since she is the only model to appear, the series also shows that femininity can be literally put on and performed, changed and mimicked by one actor. The conflation of roles, with Sherman as both subject and creator, is a way of visualizing femininity that confronts some of the issues raised by images of women, such as *who* is being represented, and *by* whom is this projection of the 'feminine' being constructed and *for* whom.

Much of Sherman's work examining image and identity is reached through the route of visual pleasure. The satisfaction and

187. **Cindy Sherman**, *Untitled #48*, 1979. Sherman's *Untitled Film Stills* series from the late 1970s, which shows the artist adopting a number of feminine types from movies, demonstrates how femininity is a popularly constructed notion, not a quality that is naturally inherent to women.

188. **Yasumasa Morimura**, *Self-portrait (Actress) after Vivien Leigh 4*, 1996.

enjoyment of developing narratives for the *Untitled Film Stills*, for example, is a part of the viewer's experience. Another untitled series of large-scale, richly coloured photographs showing Sherman dressed and posed with heavy stage make-up and ill-fitting prosthetic facial and bodily parts, as historical portrait paintings remains one of her most commercially successful works. Their qualities as spectacular works of art that command the walls of galleries, combined with their ironic allusions to traditional patronage of poprtrait artists, cover an impressive scope of aesthetic grandeur and critical postmodern thinking.

One of the best-known artists to be working in a manner clearly linked to Sherman's practice is the Japanese photographer Yasumasa Morimura (b. 1951), who began dressing and staging himself for an ongoing project entitled *Self-Portrait as Art History* in 1985. The first work in the series shows the artist as Vincent van Gogh, the most famous European artist in Japan at the time. Fame is the salient theme of the photographs as Morimura pursues the alignment of his own malleable identity with those of famous artists and actresses and with art's most glamorous archetypes [188]. In part, Morimura's status as a non-Western man creates an alternative axis to Sherman's work, but it nonetheless still hinges on our understanding of the idea of beauty and glamour within Western popular imagery. His photographs repeatedly direct us to the two roles that Morimura takes on: the playful ego of the photographer and the cult status of particular artists and actors.

A mixture of observation, performance and photography can also be seen in the work of Nikki S. Lee (b. 1970). Lee calls her bodies of work 'projects', which conveys the degree of research and preparation that underpins her photographs of the artist assimilating herself into a range of social groups, mainly in America. Lee's photographs have included the *Hispanic*, *Strippers*, *Punk*, *Yuppie* and *Wall Street Broker* projects. She first scrutinizes the social conventions, dress and body language of these groups, then changes her appearance to become a plausible member. The photographs are taken either by a friend who accompanies her on the projects or by a member of the infiltrated group. The photograph shown here is from *The Hispanic Project* [189], in which Lee (on the right) changed her weight and hair, eye and skin colour.

189. **Nikki S. Lee**,
The Hispanic Project (2), 1998.

190. **Trish Morrissey**,
July 22nd, 1972, 2003.

191. **Gillian Wearing**,
*Self-Portrait as my father
Brian Wearing*, 2003.
In Wearing's *Album* series, the
artist has restaged photographs
from her family albums. She wears
prosthetic masks, the edges of
which are left intentionally visible
around her eyes. The uncanny
sense of her trying on the
photographic identities of her
family and friends and moments of
their histories is brilliantly realized.

Trish Morrissey's (b. 1967) *Seven Years* [190] provides a link
between Morrissey's own family experiences, remembered
through personal photographs, and the common tropes of
domestic photography. Family snaps can be the trigger for re-
remembering and reappraising identities and familial relationships.
In collaboration with her elder sister, who is the other performer
in the series, Morrissey attempted to make the subject of *Seven
Years* the subtexts of relationships that are embedded in family
photographs. The props and clothing are a combination of objects
found in Morrissey's parents' attic and secondhand items she
collected for the staging of each photograph.

Gillian Wearing's *Album* series [191] also engages with family
history. It is an unsettling restaging of a small number of
photographs of Wearing's parents, brother, uncle and herself.
They include a photo-booth portrait of Wearing as a teenager, a
casual snap of her brother in his bedroom and a studio portrait
of her mother before Wearing was born. In the image shown here
[191], she adopts the identity of her father as a dapper young man.
Wearing wears prosthetic masks custom made to facial features
and expressions depicted in family photographs. In all the images,

Wearing has left one pointed rupture in the seamless mimicry of the portraits: the edges of the eyeholes in the masks are undisguised. As a result, the sense of Wearing literally trying on these identities is subtly but powerfully conveyed.

The remaking of iconic popular images has also been common in contemporary art photography. Jemima Stehli's (b. 1961) *After Helmut Newton's 'Here They Come'* [192, 193] shows the artist posed as one of the figures in fashion photographer Newton's (1920–2004) 1981 diptych showing four models stepping towards the camera. In one image, she is fully clothed and in the other she is naked except for high-heeled shoes. Stehli not only emulates the position of one of the models in Newton's original photograph but also his stylistic signature of black and white, her authorship of both made evident in the shutter-release cable that she presses with her left hand. As in Cindy Sherman *Untitled Film Stills*, Stehli's strategy for critiquing (and to some degree reclaiming) Newton's iconic images hinges on her being both the subject and object of her work. It generates its own form of objectification and visual stereotyping and also marks the shift in the years between Newton's and Stehli's photographs from the magazine page to the gallery wall.

Hans Namuth's (1917–90) iconic 1950 photograph of the American Abstract Expressionist painter Jackson Pollock (1912–56) creating his action paintings is immediately recognizable, like a blurred, badly printed reproduction, in Brazilian artist Vik Muniz's (b. 1961) *Action Photo I* [185]. Muniz has redrawn the composition of the Namuth photograph by using

192 and 193. **Jemima Stehli**,
After Helmut Newton's 'Here They Come', 1999.

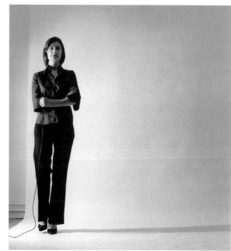

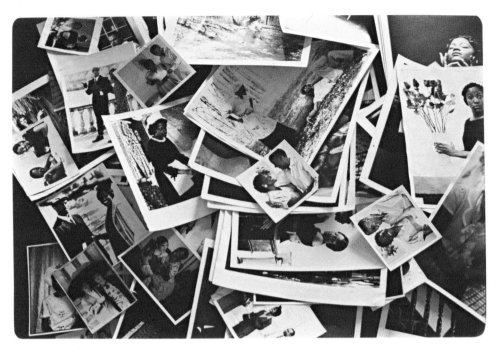

194, 195 and 196. **Zoe Leonard and Cheryl Dunye**, *The Fae Richards Photo Archive*, 1993–96.

chocolate syrup, a witty, appropriately dripping portrait which he then photographs. Muniz has made other photographs that show similarly highly skilled illusions using rudimentary substances such as chocolate, thread, dust, wire, sugar, soil and even spaghetti bolognese (in the re-creation of portrait by Caravaggio).

The artistic appropriation of visual styles and stereotypes is utilized by Zoe Leonard (b. 1961) and Cheryl Dunye (b. 1966) in *The Fae Richards Photo Archive* [194–96]. Leonard and Dunye created an archive of photographs of a fictional woman called Fae Richards, supposedly an early to mid-twentieth-century black film and cabaret star. The photographs, created for Dunye's film *Watermelon Woman*, are careful forgeries of signed publicity shots, film stills and personal photographs, complete with the creases and stains of tattered vintage prints. These items were then displayed like historical ephemera in glass-topped cases. Richards's constructed biography is an amalgamation of events from the lives of real twentieth-century black artists, but her portrayal as a successful, creative, affluent and happy lesbian who died peacefully in old age is in deliberate contrast with the famously tragic lives of many black singers and performers from the era. The archive photographs are sufficiently plausible for the viewer to be uncertain whether this is a pastiche or real.

American photographer Collier Schorr's (b. 1963) *Helga/Jens* project portrays a German schoolboy named Jens in poses and scenarios in the German landscapes and interiors. These poses are taken from the *Helga* paintings and drawings by American artist Andrew Wyeth (1917–2009), made public in 1986, which controversially and explicitly showed Wyeth's sexual fascination for the young woman. Schorr's previous photographs often centred on the representation of youthful masculinity, offering

197. **Collier Schorr,** *Jens F (114, 115)*, 2002.

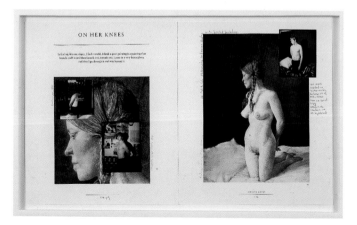

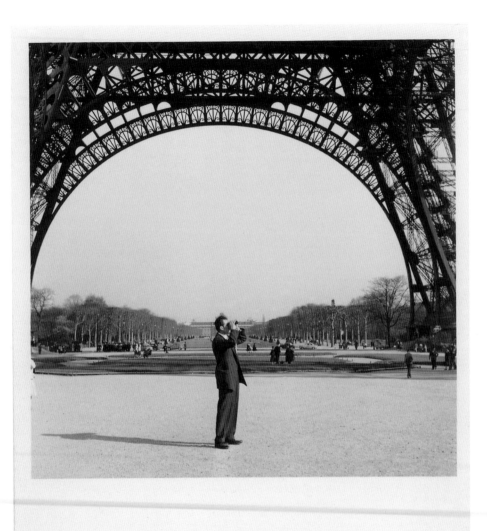

something of a visual respite in the 1990s to the abundance of photographic bodies of work that concentrated on young female subjects. In the intermediate stage of the *Helga/Jens* project shown here [197], Schorr attached small contact prints of her staged images that were responses to Helga paintings with contemporary props and critical twists on gender dynamics and sexual projection. Schorr's project is not only a restaging of another artist's body of work. Schorr uses the *Helga* paintings as a cue to think about the relationship between artist and model conveyed in Wyeth's images. Schorr's photographs are concerned with dialogue rather than mimicry, and they become a way through which she can actively pursue her own investigations to the point where desire and projection of the artists come together.

The delivery of counter-memory or history through a fictionalized account is the basis of *The Atlas Project* (1999–date), made principally by the Lebanese artist Walid Ra'ad (b. 1967). The work is an artistic testimony of the human-rights abuses and social consequences, as well as the role of the media, in the Lebanese Civil War (1975–91). This mixed-media project includes slides, video footage and also the notebooks of a Dr Fadi Fakhouri (now deceased), the foremost historian of the war. Ra'ad presents the *Project* through screenings, photographic reproductions and slide lectures, so that it is not apparent whether this is genuine archival material or – as is really the case – a fake. The work examines how the idiosyncrasies of archive material can trigger partial and emotive understandings of social unrest and history. While this use of fantasy in the construction of the fake archive has here been used sparingly to address serious political issues directly, more often fakery is a comic fabrication of a photographic archive that is too good to be true, as in the case of Spanish photographer Joan Fontcuberta's (b. 1955) work. His *Herbarum* series (1982–85) depicts surreal plant forms, elegantly and sculpturally photographed against white backgrounds in the style of the early twentieth-century photographer Carl Blossfeldt (1865–1932). On closer inspection, the plants turn out to be unfeasible collages of different plants and matter, including animal parts. In *Fauna* (1988), Fontcuberta played with the conventions of exploration and anthropological photography and constructed the archive of a fictional German scientist-explorer, Peter Amersen-Haufen, which included the scientist's discovery of giant bats and flying elephants. In Fontcuberta's *Sirens* project [199], the recently discovered fossilized remains of beautiful mermaids are documented and analyzed to determine the age and lifestyle of the

198. **The Atlas Group/Walid Ra'ad**, *Civilizationally We Do Not Dig Holes to Bury Ourselves (CDH:A876)*, 1958–2003. Displayed alongside this image is the caption 'Document summary: the only available photographs of Dr Fadl Fakhouri are a series of self-portrait photographs that he produced in 1959 during his one and only trip to France. The photographs were preserved in a small brown envelope titled in Arabic "Never that I remember".'

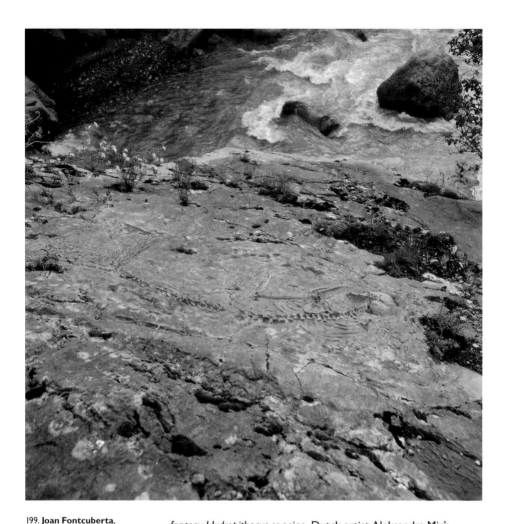

199. **Joan Fontcuberta**,
Hydropithecus, 2001.
'Various theories are being
considered that would explain
its exceptionally well-preserved
state. The arched posture of the
spine and the fact that the front
limbs are close together and the
cranium side-on reveal that this
hydropithecus was buried rapidly
while it slept, which would also
explain why the bones have
not broken up, despite the
disappearance of the soft parts
(muscles, ligaments etc.). The
cause of death and subsequent
covering-up of the skeleton
could be an underwater landslide.'

fantasy *Hydropithecus* species. Dutch artist Aleksandra Mir's
(b. 1967) *First Woman on the Moon* involved the epic operation
of constructing a fake lunar landscape on a sandy strip of the
Dutch coastline for the thirtieth anniversary of the lunar landing.
Mir's project includes fake publicity images for a corps of all-
female astronauts, representing them as a cross between
stereotypes of air stewardesses and wives of astronauts waving
off their spouses, a cheerful version of the performance art of
the late 1960s. In the photograph shown here [200], Mir also
poked fun at land art of the same period by building a huge
sandcastle into which she planted an American flag, a slanting
aerial view capturing the temporary site for posterity with
the earnestness of a professional photographer.

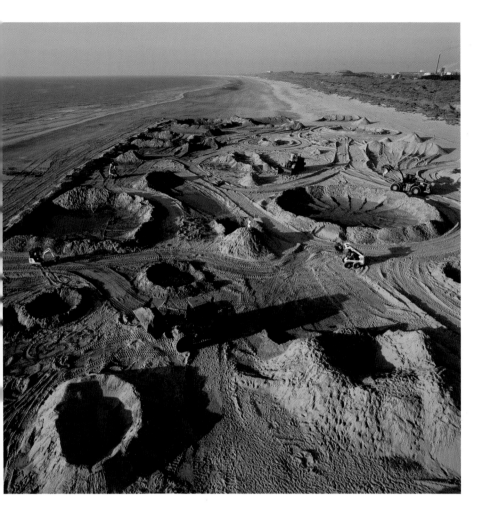

The works discussed in this chapter so far refer to twentieth-century photographic styles and genres. Nineteenth-century photographic processes and formats, however, have been also utilized by several contemporary artists. Tracey Moffatt's *Laudanum* series [201] of nineteen photogravure prints (a subtle photomechanical printing process developed in the mid-nineteenth century) creates a vivid and fantastical narrative, presented in the physical form of the past. One of the strongest influences that Moffatt draws upon is popular Victorian melodrama, which would have been presented as a sequence of lantern slides or stereoscopic photographs for parlour entertainment. She also refers to the dramatic use of shadows in early twentieth-century German Expressionist film. The two

200. **Aleksandra Mir**,
First Woman on the Moon, 1999.

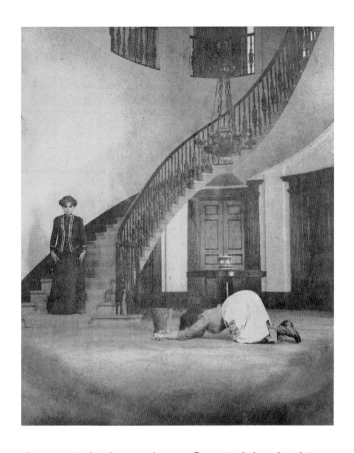

characters in the photographs are a Caucasian lady and an Asian servant, and the psychodramas that Moffatt stages centre on slavery in terms of colonialism, class, sexuality and addiction. Moffatt's approach to representing the conditions of history gives us an experience of how sociohistorical issues that are normally explored through anthropology and writing can be imaginatively addressed through art.

Another magically unexpected use of traditional forms of photography to explore a subject has been used since the mid-1990s by the British artist Cornelia Parker (b. 1956) in her ongoing *Avoided Objects* series. Parker selects the relics that have survived as the physical manifestations of history's most important events and figures, such as the equations chalked onto a blackboard by the physicist and mathematician Albert Einstein, or, as shown here, the record collection of Adolph Hitler. Parker uses microphotography, more commonly used in scientific research, and also photographs at very close range so that the

202. **Cornelia Parker**,
*Grooves in a Record that belonged
to Hitler (Nutcracker Suite)*, 1996.

203. **Vera Lutter**,
Frankfurt Airport, V: April 19, 2001.

objects are visually transformed into abstractions. We are invited to comprehend these remains of history through metaphor and intuition. Einstein's equations, which would remain incomprehensible to us if photographed in their entirety, appear like molecular-like structures (often just the almost pure calcium carbonate chalk dust) embedded on the board with each of Einstein's marks. In Parker's microphotographs of the grooves of a record owned by Hitler [202], we think about the history of the object, including when and by whom were the scratches on the surface made, but also the aberrant duality of Hitler as an aesthete and despot.

An early and more basic form of photographic device that has also been used by contemporary art photographers is the camera obscura, which came into Western use by painters during the Renaissance. It consists of a large boxlike space – either a room or a constructed box – within which an inverted image of the scene outside is projected onto a wall via an aperture on the opposite wall through which light can pass. German artist Vera Lutter (b. 1960) has made her own version of the device. She hung sheets of photographic paper on the back wall of a chamber, and made a pinhole aperture on the opposite wall through which the illumination of the scene outside penetrated and exposed an upside-down and negative image on the paper. As we see in the three-segment photograph made in a maintenance yard at Frankfurt Airport [203], the shadows and other darks areas of the scene are represented as glowing illuminations in these awesomely large works. The blurred, ominous, darkness of the image is caused by the camera having mapped the comings and goings of a number of aeroplanes during the exposure time, which lasted a number of days.

204. **Susan Derges,**
River, 23 November, 1998, 1998.
Derges reinvigorates one of
photography's oldest techniques of
cameraless photography, the
photogram, in which shadows of
objects positioned on or above a
sheet of photographic paper are
captured simply by being sensitized
to light. Working at night, Derges
lays photographic paper beneath
the surface of a river and lets off
a flashlight from overhanging
branches. The movement patterns
of the water and the branches are
visualized in this highly intuitive
form of photography.

Photographic processes from the late 1830s and 1840s have
been revived in recent years as a way of returning to early
photography's alchemical magic in its tracings of living things.
The earliest photographic process was the photogram (also
called a photogenic drawing), where small objects were placed
on light-sensitized writing paper and exposed to the sun. When
washed, a negative silhouette of the object was left on the paper
surface. Utilizing only the chemical element of photography,
without the optical equipment of a camera, the photogram was
a viscerally immediate way of making a representation and one
that did not mirror human perception.

British artist Susan Derges (b. 1955) has used this process to
record the movement of river and seawater [204]. Derges,
working at night, places large sheets of photographic paper, held
within a metal box, beneath the surface of a river or sea and then,
after taking the lid off the box, flashes the paper with light so that
the movement of the water is captured on the surface of the
paper. In some of her photographs of the River Taw in southwest
England, Derges positions the light above the branches of trees
that have grown over the river's edge so that they are held like
shadows over the water. The colour of the prints depends on
two key factors: the amount of ambient light from towns and
villages contaminating the night sky and the temperature of the
water as it changes through the year. The photographs are at a
human scale and size, so when seen in a gallery they have a
powerful phenomenological effect. We feel submerged beneath
the intricate and unique flows of water. Derges's photographs have
reconstituted in contemporary art the kinds of experimentation

that galvanized photography's earliest practitioners. By taking her darkroom into the night landscape and using the flow of rivers and seas as a quasi strip of film, she offers a reminder of the responsive and intuitive manner of photography's early history and its pertinence in communicating artists' ideas today. In comparison, Adam Fuss's (b. 1961) equally phenomenal photograms have been made mainly in the studio, where he has photographed rippled water, flowers, rabbit entrails, wafts of smoke and the flight of birds. Fuss has also been one of a very few contemporary artists to revive the first patented photographic process, the daguerreotype. This type of photograph is, like the photogram, a unique image in that there is no negative from which to print multiples. The daguerreotype is a process in which the photographic image is etched by light-sensitive chemicals onto a silver-coated plate, the areas where the light most strongly hits the plate becoming frosted. Fuss's daguerreotypes, like their early nineteenth-century ancestors, are small in scale and obscure and have their own

205. **Adam Fuss**,
From the series *'My Ghost'*, 2000.

206. **John Divola**,
Installation: 'Chairs', 2002.
Image: 'Heir Chaser' (Jimmy the Gent),
1934/2002.
Divola compiled photographs
from the 1930s film sets that
were originally made for reference
purposes to check the continuity
of lighting and prop positions
between takes. The inherent
drama of these constructed
interiors has a visual intrigue
similar to that of tableau
photography.

inbuilt revelatory quality as the viewer moves his or her body and
eyes to try to see the ghostly image. Fuss has used the process
for suitably elegiac subjects such as lace christening dresses,
butterflies, a swan and, here, a faint self-portrait [205].

Contemporary art photography's appropriation and reworking
of imagery is also achieved by collating existing photographs, often
vernacular and anonymous, into grids, schemes and juxtapositions.
To a certain degree, the role of the artist here is like that of a
picture editor or a curator, shaping the meaning of photographs
through acts of interpretation rather than by the making of the
imagery. American artist John Divola (b. 1949) has collected an
archive of continuity photographs made on film sets in the early
1930s, mainly at Warner Brothers Studios in Hollywood [206].
The photographs were originally taken to record the exact
position of props, lighting and sometimes actors within film sets.
They are, in the contemporary context, unwitting precursors to
tableau and constructed photographs (see Chapter 2) that have
figured prominently within photography. The photographs that
Divola has compiled are not only pertinent because the scenes

documented are entirely artificial and made for the camera, but also because they offer a meditation on the historical fictions of domestic or normal life that cinema has created. American Richard Prince (b. 1949) is an artist who emerged within the first wave of postmodernist use of photography in the late 1970s. He photographs billboard advertisements, cropping out the branding and texts and showing only the grainy colour-saturated visual fantasies of developed capitalism. The romanticized visions of American cowboys in the Marlboro cigarette advertisements that Prince rephotographed in 1986 both critique and champion the seduction of advertising. In its lifting of popular imagery and storytelling, Prince's pan-media practice is witty, deft and subversive. In his Untitled (Girlfriends) series [207], he compiles so many amateur photographs of the two trophies of biker culture – girl and machine – that it is recognizable as almost a genre of photography, as well as being an acute observation of macho culture. German artist Hans-Peter Feldmann's (b. 1941) principal output is books of photographs, which come in a range of sizes from small flipbooks, such as Voyeur [208], to large-format volumes, and make playful juxtapositions and repetitions of found, stock and gathered anonymous images. Without captions or dates, the experience of Feldmann's sequences is of viewing photographs

207. **Richard Prince**,
Untitled (Girlfriend), 1993.

free of function and history, a context-less context, dependent on the triggering of thought processes through the relations between images within the sequence. The experience of looking at Feldmann's non-hierarchical approach to photographic imagery – drawn from the glut of vernacular and popular imagery of the twentieth-century – is highly effective in reminding us how subjectively and subconsciously we interpret photographs.

The American photographer Susan Meiselas (b. 1948) initiated one of the most monumental projects of archive-retrieval in 1991. Meiselas was well known for her photojournalistic projects, such as her award-winning footage of the 1978 insurrection in

208. **Hans-Peter Feldmann**, page from *Voyeur*, 1997.

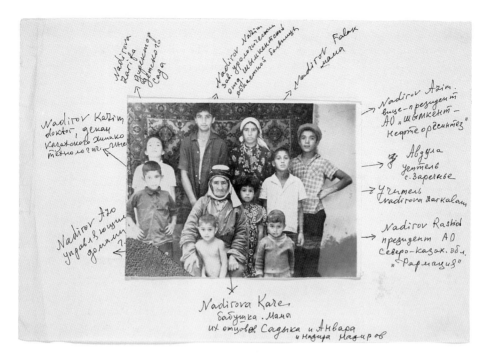

Nadirova Zarifa заведущий детского сада

Nadirov Nazim зал урологическим отд. Шымкентской областной больницы

Nadirov Falok мама

Nadirov Katim доктор, декан Казахского химико технолог 2 ин-те

Nadirov Azim. вице-президент АО "ШЫМКЕНТ - Нефтеоргсинтез"

Абдула учитель с. Зарелкье

Учитель Nadirova Заркалап

Nadirov Rashid президент АО Северо-Казах. обл. "Фармация"

Nadirov Azo управляющий домам ?

Nadirova Kare, бабушка. Мама их отцовв Садыка и Анвара и Надира Надиров

209. Nadir Nadirov in collaboration with Susan Meiselas,
Family Narrative, 1996.
'Our family still lives in the village. The special relocation caused people for decades to fight for their physical survival, so our grandfather struggled so that our family got an education. This is who we've become: (centre) Karei Nadirova, grandmother and mother of the fathers of Sadik, Anvar and Nadir Nadirov; (counter clockwise) Rashid, president 'Pharmacia', shareholders association of northern Kazakhstan; Zarkal, teacher; Abdullah, teacher; Azim, vice president, oil shareholding company 'Shimkent Nefteorient'; Falok, mother; Nazim, head of Urological Department of Shimkent Regional Hospital; Zarifa, director of kindergarten; Kazim, Ph.D., dean of Kazakhstan's Institute of Chemistry and Technology; and Azo, housing administrator, Shimkent.' 1960s, Nadir K. Nadirov

Nicaragua. In the early 1990s, after the first Persian Gulf War, Meiselas began to photograph the mass graves and refugee camps of Kurds in Northern Iraq, dispossessed and persecuted by Iraq's leadership. The Kurdish peoples' homeland of Kurdistan had been carved up in the aftermath of the First World War, and Kurdish identity and culture had been threatened ever since. Meiselas activated a re-finding of personal photographs, government documents and media reports that had been dispersed internationally within the Kurdish diaspora. Collectively in the archive that Meiselas gathered, the history of Kurdistan and its relationship with the West could be explored. *Kurdistan: In the Shadow of History* is an extensive book, exhibition and web-based initiative in which these regrouped archival materials are used as a catalyst for remembrance, not only for Kurdish people but also the journalists, missionaries, and colonial administrators who encountered Kurdish culture in Kurdistan's history.

British artist Tacita Dean's (b. 1965) *The Russian Ending* series developed from her finding some early twentieth-century Russian postcards at a fleamarket. Some depict events that are easy to read, such as a funeral procession or the aftermath of war, while others represent strange performances, their significance hard to discern [210]. Dean re-presents the postcards enlarged and softly

210. **Tacita Dean,**
Ein Sklave des Kapitals, 2000.

211. **Joachim Schmid,**
No. 460, Rio de Janeiro,
December 1996.
Schmid's ongoing *Pictures from*
the Street project is made up of
all the photographs that he has
found lost or thrown away on
the streets. In some, the sense
of the subject's being consciously
rejected or deleted from the
previous owner's emotional life
is especially pronounced.

printed as photogravures. Each image is shown with Dean's
handwritten annotations. These notes are scattered throughout
the images' compositions, reading like a film director's directives
for how the narrative of each scene will cinematically be
developed. As the title of the body of work suggests, Dean pays
special attention to the range of dramatic endings to the screenplays
she describes. She examines how uncertain and ambiguous our
understanding of history is when gleaned from pictorial forms, and
how heavily implicated the director or image-maker is in the
fictionalizing of history.

German artist Joachim Schmid (b. 1955) salvages discarded
photographs, postcards and newspaper images. He organizes these
items into archives and recycles their meaning, in a quasi-curatorial
practice, by creating taxonomies of the most artistically under-
valued types of photographs. He began his *Pictures from the Street*

project [211], consisting of almost a thousand photographs found in different cities, in 1982. The only criterion for a photograph to be added to the archive is that Schmid must have found it discarded; every photograph he picks up is added. Some are scratched and worn; others are ripped or defaced. By being discarded, the photographs represent the loss of personal memories and also their active rejection. These differing processes of archive-construction emphasize that what is being retrieved from the pictures is their status as evidence; that the contiguity between image and object can be shaped to create a re-engagement with forgotten histories and also our projected fantasies of their historical and emotional resonance.

While the reclaiming or retrieval of existing photographs creates a reinvigoration of the subjects they explicitly or implicitly denote, another area of contemporary art photography queries whether reality is immobilized when photographed. There is still a pertinent dialogue with the ideas prevalent in late 1970s postmodern photography, that a photograph is an image of a pre-existing image and not an unmediated depiction of its given subject. In his *Nudes* series of the early 2000s, Thomas Ruff downloaded pornographic images from the internet and enlarged and enhanced the digital pixellation, creating photographs that depict the remoteness of the actual sex acts [212]. With their saccharine tonal ranges, these are

212. **Thomas Ruff,**
Nudes pf07, 2001.

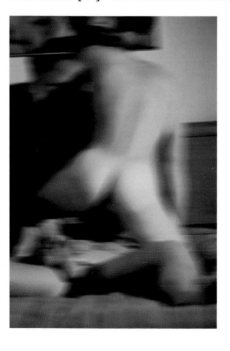

beautiful images that demonstrate how idealization is key to the representation of a subject, and that potentially any subject (and here a relatively new form of image-making and viewing) can become a meditation on aesthetic form.

As soon as the first photographs were made, all photographic practice thereafter was created and understood in comparison with and relation to earlier images. On the basis of individual practice, other photographs became the hurdles over which to jump, the standards to meet and the discourses to counter. In American photographer Susan Lipper's (b. 1953) *Trip* sequence of fifty black-and-white photographs of smalltown America, the artist identified not only various sites but also the heritage of their representation within American documentary photography. Lipper finds in these contemporary places connections with pre-existing images, such as here in the formal reference to American photographer Paul Strand's (1890–1976) *The White Fence* (1916), a photograph that has come to embody a key moment in photography's modernist history.

Markéta Othová's (b. 1968) conceptually driven use of the monochrome has been controversial in her native Czech Republic, where black-and-white photography as opposed to colour remains the currency of most artistic and documentary photography. In *Something I Can't Remember* [214], Othová has photographed in a

213. **Susan Lipper**, *untitled*, 1993–98.

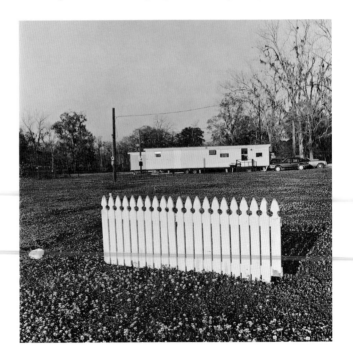

214. Markéta Othová,
Something I Can't Remember, 2000.

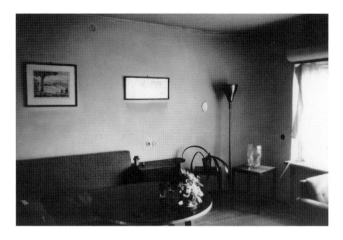

manner which, apart from the size of the print (close to 150 centimetres in length), has an 'unauthored' and historical style. In fact, because the image is grainy it could easily be a rephotographed photograph from the 1930s. It depicts a room in a villa owned by the Czech film director Martin Fric (1902–68), which he had commissioned from the architect Ladislav Zak (1900–73) in 1934. Fric's widow, who died several months before Othová went to visit the house in 2000, had fastidiously preserved the decor as it had been during her marriage. Othová responded to the sense of time's standing still by photographing it in such a way that mimics the style of documentary photography of the era in which it was built, reinforcing the sense of the place's history.

Torbjørn Rødland's (b. 1970) depictions of Nordic landscapes show the sublime beauty and clichés of landscape art [215]. The composition of the image illustrated here is aping the conventions of how to represent a beautiful landscape, including the choice of misty sunrise or sunset as the classic idylls of nature in pictorial form, handed down from landscape painting to professional nature photography and to our holiday snap attempts. Rødland is conscious of the irony that, in order to experience the sentimental emotions of these landscapes, the viewer recalls other images that function in the same emotive way. Portraying a subject through a pre-existing style of a photographic genre is also present in Katy Grannan's (b. 1969) series *Sugar Camp Road* [216], for which she advertised for models in local American newspapers. Her subjects were strangers, and they decided in advance what they wanted to wear and how they wanted to be posed. Grannan was, therefore, in part photographing the picture the sitters had already imagined for their portrayal. In this image, the subject decided upon a lyrical

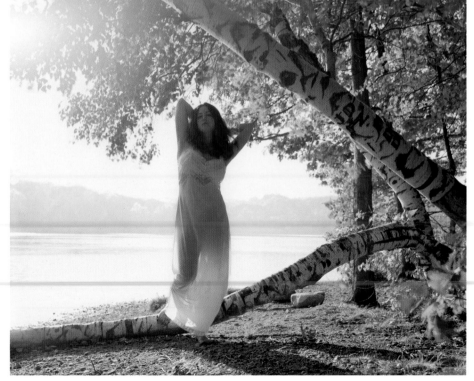

representation that reflected the pose of the Venus de Milo statue as well as kitsch 1960s commercial photography, with the hazy sunlight passing through her flimsy dress.

In the image shown here from Norwegian artist Vibeke Tandberg's (b. 1967) *Line* series, there is the suggestion that the photographer's relationship with the subject would be intimate, professional, detached, or a simulation of all these positions. In fact, Tandberg has used digital manipulation to blend fragments of her own facial features with those of her friend, illustrating how a photographic portrait, no matter how guileless it may seem, is partly the photographer's projection of herself onto her subject. At the heart of this lie the possibilities that postmodernist practice represents for contemporary art photographers: to be able to knowingly shape the subjects that intrigue them, conscious of the heritage of the imagery into which they are entering, and to see the contemporary world though the pictures we already know.

215. (opposite, top) **Torbjørn Rødland**, *Island*, 2000.

216. (opposite, bottom) **Katy Grannan**, *Joshi, Mystic Lake, Medford, MA*, 2004.

217. (right) **Vibeke Tandberg**, *Line #1 – 5*, 1999.
At first glance, Tandberg's portrait of Line seems to be a straightforward photograph of her friend in her home. By using digital technology to merge her own facial features with those of her friend, Tandberg has literally invested the image with the intimacy and connection that exists between photographer and subject.

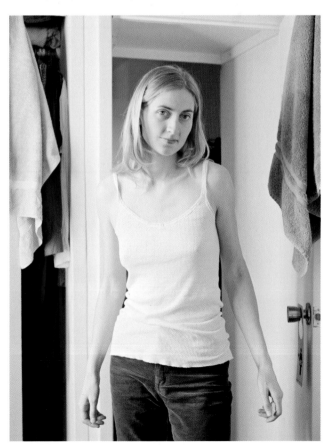

Chapter 8 Physical and Material

The title of this chapter is derived from a short, eloquent essay by the artist Tacita Dean (see Chapter 7), written for a catalogue entitled *Analogue* that was published in 2006 to accompany her film *Kodak*. Dean's 44-minute film was made in Kodak's Chalon-sur-Saône factory and shows the running of large machines for making analogue camera film, inexplicably threaded with brown paper rather than translucent film. In *Analogue*, Dean quotes a manager at the factory who, when asked why Kodak's analogue film stock will become obsolete, replies that no one notices the difference between analogue and digital photography any more. This chapter concerns artists who not only notice the difference, but who consciously fold the shifting meanings and associations of photography into the narrative of their work.

In broad terms, digital photography – and the ease and speed of its dissemination – has radically reshaped photography's commercial industries and the ways that we use photography in our professional and personal lives. There has been a shift in the current understanding of what photography encompasses and what it means to propose photographic works as art. More than ever, this involves some disclosure of the context and conditions that have shaped the completed artwork. Contemporary art photography has become less about applying a pre-existing, fully functioning visual technology and more concerned with active choices in every step of the process. This is tied to an enhanced appreciation of the materiality and objecthood of the medium that reaches back to the early nineteenth-century roots of photography.

It is in this climate that the artists represented in this chapter explore our increased consciousness of the physical characteristics of photographic prints, no longer the default platform for photography but an increasingly rarefied craft divorced from our day-to-day experiences of the medium.

218. **Florian Maier-Aichen,** *The Best General View,* 2007. In this work, Maier-Aichen appropriates an existing image, creating a photograph of a photomechanical print of a photograph. He draws attention to the ability of contemporary photography to recontextualize and mediate even the most seemingly straightforward images.

219. James Welling,
Crescendo B89, 1980.
Welling's *Foil* series referenced the classic history of early twentieth-century photography in its presentation of small, mounted and traditionally framed black and white prints. He created his seemingly abstract and transcendental photographs from variably lit sheets of crumpled aluminium foil.

Some of the artists discussed in this chapter look at the vast amount of visual information that is at our disposal and how that affects our reading of, and the relationships between, the images that we see. Others capitalize on the resonance of photography's analogue past, a resonance made all the more weighty by the now ubiquitous nature of digital photography. The desire to hold on to enduring elements of analogue photography's rich history, especially its permission to experiment and make an (albeit flat) object while embracing the mistakes and luck of an imprecise science, is a partial explanation for the relative caution with which contemporary art photographers have introduced digital technologies into their practice. Neither the art market nor art schools have chosen to diverge radically from the established conventions of making, printing or selling photography – caught, perhaps, between the quality of affordable digital capture and printing, and the expense of commercial post-production. The Doomsday prophecies about the complete extinction of analogue photographic papers and films have dissipated,

and outside photography's commercial industries of fashion, advertising and journalism, where there were economic and other practical imperatives for embracing new technologies, the late 1990s and 2000s saw a period of hybridization between traditional analogue photography and the promise of digital techniques.

Sherrie Levine (b. 1947) and James Welling (see Chapter 4) are two pioneering artists who, in the early 1980s, drew particular attention to the role of materiality in photography. Each played a part in laying the groundwork for current trends in contemporary art photography. Levine's appropriation of classic photographs by Walker Evans (1930–1975), Edward Weston (1886–1958) and Eliot Porter (1901–1990) serves as a starting point for the ideas outlined in this chapter. There is an enduring audaciousness in the way that Levine rephotographed images by canonical photographers from the printed pages of exhibition catalogues, mounting, framing and presenting them in contemporary art galleries. A work such as *After Walker Evans* (1981) [220] was neither an attempt at

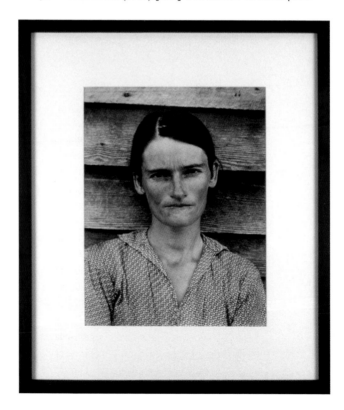

220. **Sherrie Levine,**
After Walker Evans, 1981.

forgery nor an especially ironic gesture. Instead, Levine's direct appropriation of an object – in this instance, a strikingly intimate photograph of a woman in abject poverty taken in 1936 during the Great Depression – calls forth as its subject the elucidatory power of a photograph to convey emotions and the investigative curiosity of the photographer. Levine's treatment of Evans's photographs was, in some ways, no different from the motivation of any photographer to explore a subject that intrigues them, nor dissimilar from Marcel Duchamp's granting of iconic status to found objects – the readymades – that begins Chapter 1. Her photographic work was provocative, in part, because Evans's photographs were not anonymous or vernacular, nor the conventional raw image material for new artistic thinking. Levine's project foregrounds her (and perhaps our own) responses to Walker Evans's images – responses that are led, if not determined, by his intentions and authorship. The proposition of Levine's own authorship is contentious. It is not located in an overlay of a 'signature' photographic style nor a radical shifting in the meaning of Evans's photograph by Levine's recontextualization. Rather, it is sited in her role as editor, curator, interpreter and art historian.

James Welling was associated in the 1980s with Levine and other postmodernist appropriation artists, but he has always created work on a somewhat different plane from that of his generation of critical photographic thinkers. In the early 1980s, he made a series of over fifty small, elegant, black-and-white photographs of creased aluminium foil [219]. The photographs were displayed in a modernist style with mounts and black frames, and hung in a linear sequence on white walls, in a provocative gesture that made the viewer aware both of the unreconstructed pleasure in enjoying the prints' formal qualities and of the conscious modernist conventions that operate within them. As an artist, Welling has knowingly straddled two positions with his practice: he is both a photographer who explores the medium through experimentation and the crafting of prints in an age-old fashion, and a postmodernist with an understanding of what he appropriates and the manner in which he cites.

One of the predominant strands of contemporary art photography concerns the rejection of a continuous, recognizable technique or style to declare the 'voice' of the individual photographer. Instead, many photographers now

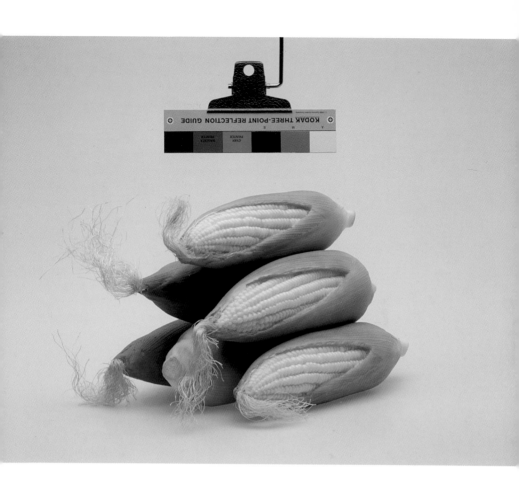

221. Christopher Williams,
*Kodak Three Point Reflection Guide,
© 1968 Eastman Kodak Company,
1968. (Corn) Douglas M. Parker
Studio, Glendale, California, April 17,
2003,* 2003.

rely on the use of a range of photographic conventions and languages. American artist Christopher Williams's (b. 1956) photographs seem, at first glance, to be of disparate subject matters and styles. At the same time, however, there is a palpable, if uneasy, sense of a coherent visual language being set up by the dynamic between his photographs. Rather than primarily appreciating the virtuosity of the artist's aesthetics or exploring a narrative of personal expression, we are encouraged to attempt to break the code of each photograph and the relationships between the images. Behind the seamless surface of Williams's photographs lies much research and a layering of meaning that is distilled down to its simplest form. In one often discussed example [221], Williams was taken with how corn byproducts figure in virtually every aspect of our daily lives and even, surprisingly, in photography

itself (a byproduct of corn is included in the lubricant used to polish photographic lenses, and also in the chemicals used for fine art photographic prints, including Williams's own). Corn byproducts were even used to make the artificial corncobs that Williams photographed. Corn and photography are therefore both the subject and the material of this photograph. Williams's decision to use the style and production values of a commercial still life photographer in this instance serves as a way to direct the viewer away from searching for a signature and personalized narrative of the subject. This trend has become an established feature of much recent contemporary art photography as artists including Mark Wyse (b. 1970), Roe Ethridge (see Chapter 4), and Elad Lassry (b. 1977) inspired practitioners in the mid-2000s to reject a single photographic language in favour of a varied lexicon of signs, conventions and clichés.

Photography's mediation, dissemination and materiality are intrinsic narratives in German artist Florian Maier-Aichen's (b. 1973) *The Best General View* [218]. The image shows the iconic Yosemite Half Dome monolith from the perfect vantage point, realized as a large, lush, colour photograph. Yet this is not a simple photograph of a mountain, but Maier-Aichen's photograph of a photomechanical print of a photograph of a mountain. In his work, photography is both the mediator and the subject; the grand production values of his large prints, moreover, render photography itself an object of desire.

The re-animation of existing photographic imagery is used to full imaginative effect by artist Daniel Gordon (b. 1980) [2]. Using photographic imagery culled from online sources, Gordon constructs elaborate scenes and three-dimensional collages, which he then photographs; the interplay of two-dimensional photographic depth and actual three-dimensional space is mesmerizing. Matt Lipps (b. 1975) similarly makes meticulous and laborious constructions, akin to paper theatres, which he dramatically lights and then photographs. He takes imagery principally from mid-twentieth-century magazines and books, from which he creates sculptural photomontages that feature groups of historical and fictional characters.

Sara VanDerBeek's (b. 1976) photographs from the mid-2000s each show a sculptural form made by the artist that creates a physical framework for photographic images drawn mainly from the pages of magazines and books [222]. The sculptural structures are strange and idiosyncratic, and clearly handcrafted. By setting the found photographs in a three-

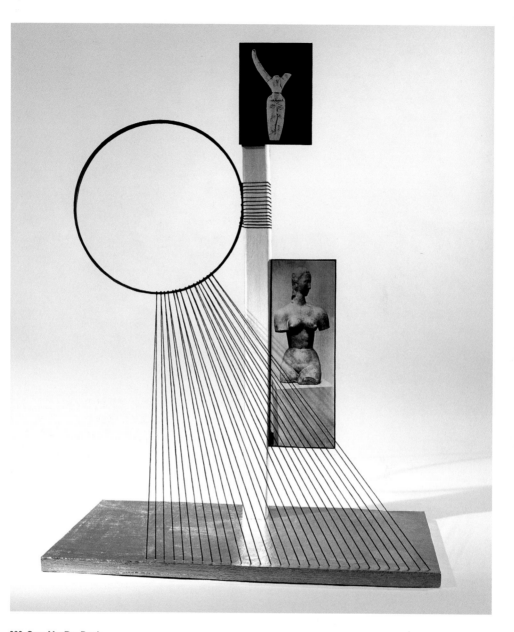

222. Sara VanDerBeek,
Eclipse 1, 2008.
VanDerBeek constructs small
sculptural pieces that emphasize
the material qualities of the
photographic images she assembles
as well as the personal connections
that they constitute for her.

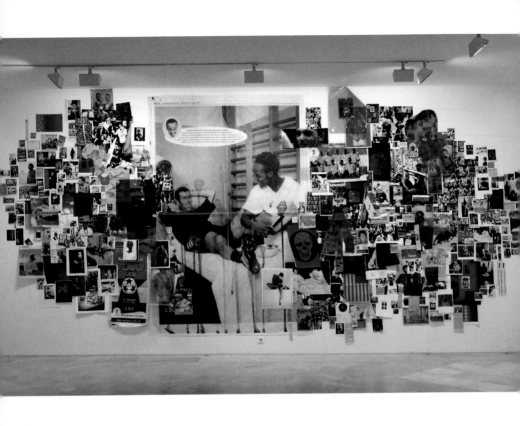

223. **Lyle Ashton Harris,**
Blow up IV (Sevilla), 2006.

dimensional space, dramatically lighting the scene, and then taking the image (VanDerBeek does not exhibit the sculptures, just the final photographs), she creates a magical interplay between photography as a personal language of imagery and as a physical and material form.

Lyle Ashton Harris's (b. 1965) *Blow up IV (Sevilla)* [223] is a wall collage made up of his own and found photographic images. The composition's central, largest picture, one that is replicated many times in the piece, shows the famous French footballer Zinedine Zidane reclining as his legs are massaged before or after a match. In both formal composition and implied racial dynamics the image resembles Édouard Manet's (1832–1883) painting *Olympia* (1863), a photocopy of which also appears in *Blow up IV (Sevilla)*. Harris makes a map of visual and ideological connections stemming from the central image. He avoids a hierarchy that privileges his own images (which include commissioned photojournalism) over those he has collected. Instead, he makes an interesting restatement of a postmodernist

idea (see Chapter 7), blending high criticality and personal narrative to suggest that all photography inherently carries representational meaning beyond the making or intent of the photographer. Harris's work pays homage to the contributions of artists such as Martha Rosler (b. 1943), Lutz Bacher (b. 1941) and Sylvia Kolbowski (b. 1953).

A number of contemporary artists have explored the versatile and ubiquitous nature of photography by using it as just one component in their mixed-media practice. One of the leading practitioners in this field is the German artist Isa Genzken (b. 1948). Since the late 1990s, Genzken has used her own and found photographs as a substantial element within her sculptural installations, with no special privilege accorded to the medium, nor, significantly, any barriers to its equal place within the scheme of her art [224]. Genzken also challenges the slick production values of so much contemporary art, including photography, with her willfully handcrafted, broken and non-functioning objects. Among these are photographs embedded in and roughly taped onto the surfaces of the sculptures, their cheap materiality purposefully evident.

224. **Isa Genzken,**
Untitled, 2006.

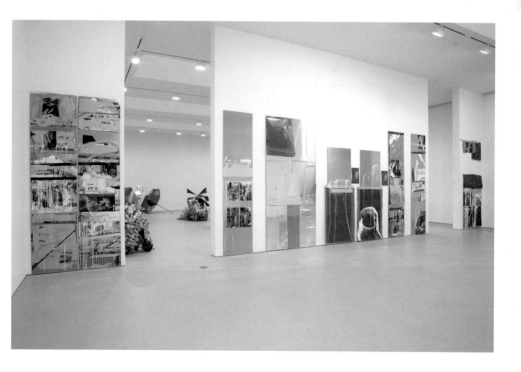

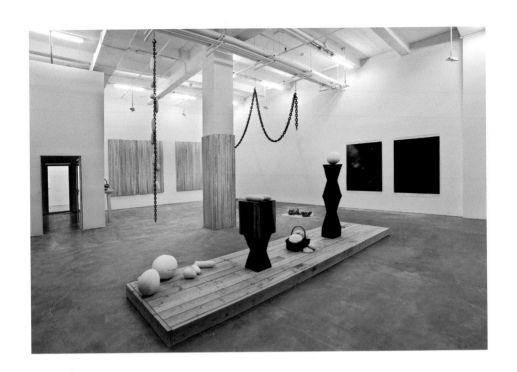

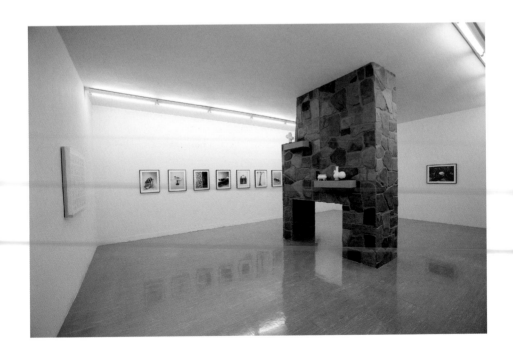

Within pan-media practice, photography is used in various ways, as an ingredient that can either intentionally disrupt or consolidate the overall narrative of an installation or artwork. In American artist Michael Queenland's (b. 1970) practice of the mid-2000s, photography is explored along with other art materials as a transformative tool of quotidian objects and experiences [225]. He has cast balloons in plaster and bronze, made loaves of bread in porcelain, and constructed totem-like wooden structures that combine modern sculptures and their display plinths in single rough and organic forms. To these playful subversions of art's formal language he adds his photographs. In combination with other media, photography becomes just one phrase in an overall statement, subjected to a consciously ambiguous but highly specified treatment. Emmeline de Mooij's (b. 1978) exhibitions bring together photography, printmaking, sculpture and textile works in gallery installations that dramatize the physical properties of the different media and collectively emphasize the beautiful idiosyncrasy of human mark-making and the ordering of things.

Taiwanese-born artist Arthur Ou's (b. 1974) installation for the 2006 Taipei Biennial [226] is dominated by the fabrication of a fireplace designed by modernist architect Marcel Breuer (1902–1981), copies of which are found in countless suburban homes. On the shelves of the fireplace are curious 'twin' Asian urns or vases melded into a single mantelpiece object. Ou's ceramic works, manufactured in the Chinese industrial capital of Shenzhen, coupled with the non-functioning fireplace façade, carry an eerie, funereal charge. On the walls of the installation are framed photographs, stylistically neutral depictions of observed and assembled subjects. A photograph of a cabinet containing fancy china makes an obvious contrast between the legacy of Eastern exports to the West and Ou's subversion of it in his own ceramic pieces. His installation also characterizes photography as one of the industrial (or industrializing) processes that ushered in modernity in the mid-nineteenth century. The use of the installation format to create enveloping, layered experiences of photographic imagery is an extremely rich area of contemporary art practice. The finely crafted gallery environments created by artists including Erin Shirreff (b. 1975), Will Rogan (b. 1975), Lorna Macintyre (b. 1977) and Lisa Oppenheim (b. 1975) stand out as exemplary works in this vein.

227. Walead Beshty,
3 Sided Picture (Magenta/Red/Blue),
December 23, 2006, Los Angeles, CA,
Kodak, Supra, 2007.

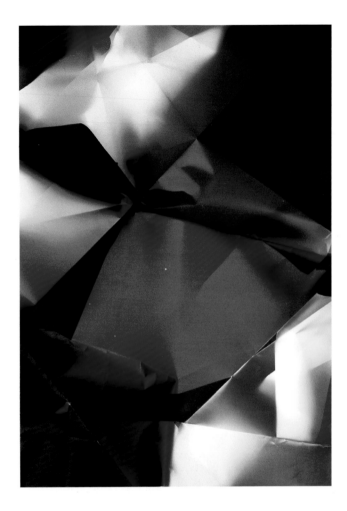

Walead Beshty (b. 1976) is perhaps best known for his photograms [227], which are made by folding large sheets of photographic paper into three-dimensional shapes while in the pitch black of a darkroom, and then exposing the temporary structures to light. The tears and creases left in the paper, as well as the shapes of colour made by the folded paper's irregular exposure to light, create strong declarations of the unique materiality of photography. Beshty treads a fine line between presenting works of overwhelming beauty and making the conditions of the work's production explicit. This is also true in the context of his more obviously sculptural works, such as his series of double-laminated safety-glass sculptures, made to the copyrighted proportions of the FedEx

228. **Zoe Leonard,**
TV Wheelbarrow, from the series
Analogue, 2001/2006.
Leonard's pointedly titled series
Analogue consists of street
photographs made in various cities
around the world which she has
either lived in or visited. The series
captures the enduring possibilities
of the camera to reflect and
document what surrounds us and
the still-relevant language of pre-
digital photography.

boxes in which they are shipped from one exhibition location
to the next. As their global tour via air freight ensues, the glass
sculptures are damaged and even lost, the evidence of their
process of distribution becoming part of the work.

Many of the most thoughtful contemporary art photographers
since 2000 have, in fact, made the rich history of photographic
materials and processes the explicit subject of their work.
Beginning in 1998, Zoe Leonard (see Chapter 7) made a ten-
year photographic project called *Analogue* documenting shop
displays of modest goods, and homemade advertising signs
[228]. Her photographs were made in towns and cities,
starting in New York and expanding around the world,
mapping a disappearing, human-scaled form of international
commerce. Leonard used an iconic vintage camera – a Rolleiflex
– and her project powerfully elides the shifting (and declining)
currencies of both local commerce and analogue photography.
It is not entirely a eulogy for two fading traditions, however,
as Leonard follows existing trade routes that, while diminutive
in comparison to multinational conglomerated trade, do still
exist. Equally, her photography explicitly declares the continuing
and meaningful status of the wandering, observant street
photographer in the contemporary era while acknowledging

229. An-My Lê,
29 Palms: Infantry Platoon Retreat,
2003–04.

its own historicized gesture. Leonard's *Analogue* project is sensitized to photography's twentieth-century heritage but it also makes for a poetic reminder of the still-resonant and intelligent ways that photography can abstract and make our experiences meaningful.

The calculated use of historical photographic technique and iconographic convention is brilliantly deployed in An-My Lê's (b. 1960) *29 Palms* (2003–04). In this series her subject is a US Marine Corps training zone in the Mojave Desert where soldiers prepare for combat in Iraq and Afghanistan [229]. Lê's decision to photograph the behind-the-scenes 'rehearsals of war' in black and white with a large-format camera calls forth the history of war photography since the mid-nineteenth century, to which her choice of technique also alludes. Additionally, her work makes reference, via stark aesthetic contrast, to the unofficial and now ubiquitous visualizations of the ongoing conflicts that soldiers and civilians have captured digitally. Lê's scenes are not staged for her camera, but by adopting a laboured and archaic form of photography she makes them speak of both contemporary and age-old enactments of imperial power, as well as the role that photography has played in such conflicts.

Trevor Paglen is creating art projects that are of equal importance in their proposals for how the covert forces that govern militarization can be visualized. In his 2008 series *Other Night Sky*, for instance, Paglen created telescopic long-exposure photographs of the night sky in Nevada, and mapped the movement of classified American military aircraft.

230. Anne Collier,
8 x 10 (Blue Sky), 2008, and *8 x 10 (Grey Sky)*, 2008. This photographic diptych, like much of Collier's work, can be read in a specific and descriptive way – as documents of somewhat anachronistic analogue photographic clichés, 'framed' within the images by Kodak photographic paper boxes. The title of the work is a literal description but also an invitation to affix binary emotional values to the optimism of the colour skyscape and the nostalgia of its black-and-white counterpart.

231. Liz Deschenes,
Moiré #2, 2007.
Deschenes's projects centre on the physicality of photography. In the *Moiré* series she mimics the moiré effect of digital screens by means of basic analogue photography. She created the photographic negative by pin-pricking a sheet of foil held up to a window with negative film exposed to the sunlight behind it. The prints were created by double exposing the photographic paper, with the inevitable misalignment of the dots of light coming into play in the handcrafted process.

The photographs are consciously disturbing in the way in which they encourage the viewer to contemplate the significance of covert military surveillance through beautiful imagery that recalls the history of exploratory astrology and also the spiritual connotations of twentieth-century amateur night photography.

American Anne Collier (b. 1970) uses photography to create often witty and linguistic propositions. Collier's *Blue Sky, Grey Sky* (2008) [230] loses some of its potency when described because it intentionally appears as an effortless observation. There is an intelligent flat-footedness in the way she strips an image down to its leanest visual economy that, in part, pays homage to conceptually driven photography of the 1960s and early 1970s. This photographic diptych, like much of Collier's work, can be read in a specific and descriptive way – as documenting somewhat anachronistic analogue photographic clichés, 'framed' within the

232. **Eileen Quinlan,**
Yellow Goya, 2007.

images by Kodak photographic paper boxes. The title of the work is a literal description but also an invitation to affix binary emotional values to the optimism of the colour skyscape and the melancholy of its black-and-white counterpart.

Liz Deschenes's (b. 1966) work explores the idea of visual perception and its intersection with the technologies and experiences of photography and film. The *Transfer* series (1997–2003) consists of a suite of bold, pure sheets of colour made with the soon-to-be extinct dye-transfer process. Using printing pigments and extremely accurate printing matrices, the dye-transfer process has legendary status in photographic history, principally because of William Eggleston's use of its rich colour saturation for his iconic photographs (see Introduction). By creating pure- and single-colour versions of dye transfers, Deschenes calls attention to the process itself. Similarly, her *Black and White* series (2003) presents a set of monochrome analogue photographs, printed with different height and width ratios commensurate with now defunct film stock. Her seven-piece series *Moiré* (2007) makes obvious allusions to Bridget Riley's (b. 1931) Op Art paintings, but equally refers to the moiré effect of the interference of pixels and raster lines on digital television screens [231]. Significantly, Deschenes created the *Moiré* series using an analogue camera: she photographed a perforated piece of paper with a large format 8 x 10 camera, producing two copies of the negative which she misaligned in the enlarger to create the pulsating optical illusion. Her use of analogue processes to simulate digital technologies in *Moiré* is typical of her continuing investigation into the nature of image making.

Eileen Quinlan's (b. 1972) series *Smoke & Mirrors* [232] is a highly self-conscious proposition about making photographs. Each of the images is unmanipulated, with an emphasis upon the imperfections and mistakes inherent in analogue photographic processes. Quinlan offers a meditation upon photography's enduring qualities of luck and happenstance. She cites historical references, ranging from early twentieth-century paranormal photography to the formal imperatives of modernism and photographic abstraction, via the seductive qualities of commercial still-life photography.

An exciting rejuvenation of experimental photographic practices is happening within the sphere of contemporary art photography. In her ongoing series *Cubes for Albers and LeWitt*, Canadian artist Jessica Eaton (b. 1977) [233] creates multiple

233. **Jessica Eaton**, *cfaal 109*, from the series *Cubes for Albers and Lewitt*, 2011.

exposures (calibrated to primary colours) of a simple white cube. As Eaton points out in her series title, the project intersects with Minimalist art practices of the mid-twentieth-century to create a timely reminder of photography's innate capacity for visual economy in an experimental mode. The Swiss collaborative duo Taiyo Onorato (b. 1979) and Nico Krebs (b.1979) have developed a studio-based practice that involves constructing kinetic objects that they then explore photographically. Their work is a commentary on photography's alchemic and mistake-prone qualities, which they approach with visual humour.

This reinvigorated experimentalism is also apparent in both the intentional use of old analogue photographic technologies and the application of analogue thinking to new digital modes of capture and post-production. The working practices of American artist Carter Mull (b. 1977) [234] epitomize this creative challenge for contemporary art photographers. In his

234. **Carter Mull,**
Connection, 2011 (detail),
installation view, 'The Day's
Specific Dreams', May 6 – June 11,
2011.

most recent work, which includes both framed wall pieces and installations, the hybridity of media as a subject within contemporary art is played out. Mull's work connects the history of image-making with present. His images give symbolic meaning to the present by emphasizing the material ways in which technologies of mark-making (from print-making and painting to pigment printing and photo-chemicals) are overlayed. The viewer is asked to trace the everyday digital image-making that characterizes modern life back to Pop Art of the 1960s, the readymade of early twentieth-century avant-garde practice and finally the eighteenth-century roots of both photography and computing. In doing so, Mull's work animates our symbolic and visceral knowledge of the modern-day media environment.

Shannon Ebner's (b. 1971) photographic and sculptural work is concerned with language – both in her deployment of the spoken and written languages of politics, protest and experimental literature, as well as in her use of photography as a language of visual signs [235]. Often working with black-and-white photography and monochromatic sculptural forms, Ebner creates a diverse scheme of iterations that explore how language embodies political and social structures. There is a

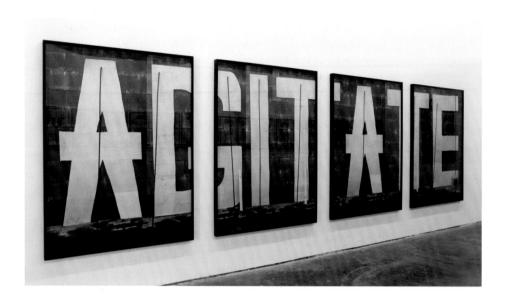

235. **Shannon Ebner,**
Agitate, 2010.

strong sense in her work of photography as a metaphor for things breaking down or functioning through false claims and rhetoric. Similarly, the work of Clunie Read (b. 1971), Tris Vonna Michell (b. 1982) and Sarah Conaway (b. 1972) has an almost performative sense of photographic language, expressing how an artist crafts images within a certain intellectual discipline and from individual viewpoint while remaining attuned to the instinctive and unpredictable nature of the photographic process.

Since the mid-2000s, a wave of creativity has come from contemporary art photographers who are repositioning the cultural value of black-and-white photography. With the current dominance of colour photography in contemporary art, commercial images and everyday life, any young artist using black-and-white photography is doing so as a conscious counter-argument to the default aesthetic of photography at large. For instance, Sharon Ya'ari's (b. 1966) photographic book *500m Radius* (2006) [236] is a sequence of forty unspectacular black-and-white photographs made in the eponymous 500m radius of his former studio in Tel Aviv, Israel. The nod to photography's conceptual past, as well as the current rupture between that past and the medium's future, is heightened by Ya'ari's choice of the worn-out modernist utopianism of the Bauhaus as his subject, represented in the modernist buildings

near his studio. Contemporary artists' deployment of black-and-white photography creates an important and challenging resistance to the tendency for contemporary art photography to be dictated by commercially available technologies and fashionable trends in the affordable art market. At the same time, it realigns contemporary practice with an intelligent and diverse history that includes avant-garde photography of the early twentieth century, conceptual art of the 1960s and the spirit of New Topographics (see introduction) that emerged in the 1970s.

There are two facets to Jason Evans's (b. 1968) *NYLPT* project [237]. Eighty of his double-exposure, black-and-white street photographs are sequenced in a duotone printed book, stylistically referencing the conventions of photobooks of the 1980s. *NYLPT* is also available as an app that allows it to be read on a tablet computer or smartphone. Using a randomization algorithm more typically used for generating online security codes, the app displays a randomized sequence of 600 double-exposure images from the project fixed into a landscape format. When each unique sequence is played, it is accompanied by a sound element, which is generated from scratch each time the

236. **Sharon Ya'ari,**
Untitled from *500m Radius*, 2006.

237. **Jason Evans**,
Untitled from *NYLPT*,
2005–12.

app is started, using sixteen inbuilt synthesizers whose range of frequency and duration have been set by Evans (who listened to drone music as he was making the photographs). The experience of the *NYLPT* app is deeply meditative, and evokes the infinite possibilities of the photographic act. At the heart of the project is the enduring quality of photography, and in particular street photography, as an activity that is governed by chance. It celebrates the randomness of both lived experience and photographic observation. Evans's project represents an exciting period for photography, in which the essentialist and symbolic notions of the photographic are creatively and imaginatively played out in new and profound ways in the digital environment.

We are also seeing a shift away from the traditional emphasis on artistic authorship as expressed through a consistent photographic style, and a new focus on elaborate acts of sequencing and editing images for gallery exhibitions and artists' books. Through the sophisticated editorial approaches of photographers such as Marie Angeletti (b. 1984) and Hannah Whitaker (b. 1980), authorship of the individual photographic

images per se becomes almost secondary to the cumulative meaning of assembled and manipulated imagery.

Photography publishing in the twenty-first century is a diverse and extremely active area of photographic creativity. New digital technologies for image capture, design, printing, and distribution have transformed traditional trade publishing and increased the potential for self-publishing and distribution by artists themselves. The creative energy around photography publishing is reflected in its increased presence at photography and art fairs worldwide, and photobooks (including rare and out-of-print volumes) are the focus of a developing collectors' market. In 2005, photographer, publisher and curator Tim Barber (b. 1979) [238] set up his website Tiny Vices (www.tinyvices.com). The site, which consists of portfolios of work by a range of established and emerging artists, also features a place to purchase and be informed about books from small, independent photobook publishers and collectives. Barber's project reflects how the internet has become embedded in photographic thinking by practitioners and how it functions as the primary vehicle for contemporary photography outside the institutional and gallery system. It highlights how the hidden realities of being a photographer – such as sequencing, editing, curating and being engaged with other photographers' work – can be made a visible part of photographic community discourse.

In this vibrant publishing climate, many contemporary art photographers are creating books, often self-published and with modest print runs, as a primary creative form. Rather than waiting for rare opportunities to create a book with an established trade publisher and adhere to the conventional formats, there is a resurgence of artists self-publishing books in the spirit of practitioners of the 1960s and 1970s. The artist books published by Ed Ruscha (b. 1937) since 1963 continue to be important models. Among the contemporary art photographers who have become known internationally via their artist books are Charlotte Dumas (b. 1977), Cuny Janssen (b. 1975), and Anouk Kruithof (b. 1981). Viviane Sassen (b. 1972) [239] creates dazzling and optically surprising photographs across the photographic genres of contemporary art, documentary and fashion. Her books, self-published in small print runs, have brought her acclaim within the contemporary art sphere, not only for the innovative design concept she brings to each publication but because

238. Tim Barber,
Untitled (Cloud), 2003.

her aesthetic style is brilliantly exaggerated by the materiality of the printed page. Sassen's photographic images confound expectations of two- and three-dimensional space, image orientation, vantage point and positive and negative space. There is also something very much of the photographic moment in the way that she works with her human subjects, providing the necessary happenstance to disrupt the images.

Rinko Kawauchi's (b. 1972) books – *Utatane* [Nap] (2001), *Hanabi* [Fireworks] (2001) and *AILA* [Family] (2004) – shape subtle, elegiac narratives without the aid of interpretative text. *Utatane* interweaves Kawauchi's ways of perceiving the world around her with fleeting conflations of forms. The title is lyrical, even musical, in the sounds it evokes: the whirr of a sewing machine or the sizzle of frying eggs. In *AILA* [240], the staccato image sequence includes photographs of animals and humans being born, hives of insects and matrices of fish eggs, dewdrops, waterfalls, rainbows and tree canopies. Kawauchi's finely edited and accumulated observations leave the reader fully nourished by the exquisite and intriguing sights she actively seeks. Kawauchi is far from alone in the orb of contemporary art photography in not overcomplicating photographic strategies and in remaining true to

the notion that all around us are pictures waiting to happen. Photographers such as Mikiko Hara (b. 1967), Anders Edström (b. 1966), Anne Daems (b. 1966) and Jason Fulford (b. 1973) similarly create subtle photographic forms out of incidental, everyday observations while reinforcing the enduring idea that a camera gives its carrier the actual and psychological permission to scrutinize life for beauty, wonder and humour.

The emerging talents who are defining the field of photography as contemporary art began their creative lives within the haptic and social era of digital photography. They make works that explore how new technologies feed into the analogue-framed discourses of photography as contemporary art. Invariably these digital-native photographers experiment across platforms. For them the gallery is only one of several contexts for presenting work; there are also online formats, as well as both traditional and electronic publishing. This latest generation of practitioners are distinctly agnostic in thinking about 'high' versus 'low' culture, yet meticulous in how they approach photographic language in its

239. **Viviane Sassen,**
Mimosa, from the series *Flamboya*,
2007.

240. Rinko Kawauchi,
Untitled, from the series *AILA,* 2004.
Kawauchi's *AILA* is an exemplary
book that highlights the roles that
editing and sequencing play in
constructing the narrative of a
photographic body of work.
Kawauchi narrates a lyrical eulogy
to the creativity and profundity of
daily life.

different contexts, cognizant of the variance in the types
of engagement that these contexts create with an audience.
Lucas Blalock's (b. 1978) [241] photographs knowingly draw the
default visual settings of digital photography and post-production
into the ongoing trajectory of contemporary art photography.
Blalock's photographs can be read as offering homage to the
enduring capacity of photography to give visual charge and
meaning to its ostensible subjects, yet at the same time his work
toys critically with that very notion. His images bring the language
of Photoshop into the principally American story of classic art
photography and its history of appropriating vernacular style.
Blalock meaningfully revives modernist photographic conventions
in the digital epoch.

There is an almost Baroque quality in the degree to which
contemporary art photographers including Sam Falls (b. 1984)
and Joshua Citarella (b. 1987) compound layer upon layer of
image-making in their work. Painterly Photoshop techniques,
analogue photographic conventions, physical mark-making and
construction combine to demonstrate how overly worked the
medium of photography can now become. Kate Steciw (b. 1979)
[242] uniquely combines photography with sculptural elements
in her gallery installations. By assembling visual elements from

241. **Lucas Blalock,**
Both Chairs in CW's Living Room,
2012.

242. Kate Steciw,
Apply, Applications, Auto, Automotive, Burn, Cancer, Copper, Diameter, Fire, Flame, Frame, Metal, Mayhem, Pipe, Red, Roiling, Rolling, Safe, Safety, Solid, Strip, Tape, Trap, Trappings, 2012.

243. Artie Vierkant,
Image Objects, 2011–.
Vierkant's *Image Objects* have a hybrid character. Vierkant selects documentation images of his gallery exhibitions that circulate online and overlays them with Photoshop manipulation to create new images that build on, rather than merely derive from, their original sources.

vernacular photography – such as generic, commercial product images that Steciw renders into exaggerated forms using Photoshop – with cheap, seemingly mass-produced sculptural elements made using industrial commercial processes, Steciw's projects draw a parallel between sculpture and photography as both physical objects and cultural ciphers. Artie Vierkant's (b. 1986) [243] series of 'image objects' transfer the dynamics and aesthetics of digital photography and graphics tools into seductive but disarming wall-based gallery experiences. His approach is provocative in the way that he monumentalizes the visual language of our screen-based everyday lives into formal objects. Anne de Vries (b. 1977) [244] works with photography, sculpture and new media. He brilliantly combines the modernist conventions of sculpture and installation art with visual motifs that reference advertising and amateur photography. His work distills contemporary visual culture into into sculptural

experiences that operate as philosophical abstractions of technological experience.

The photographers who conclude this chapter offer a fitting end to this book, encouraging us to engage with the wonders of life and to recognize the beauty and magic that are still to be found photographically. The enduring capacity of photography to abstract and give form to our experiences is continuously reworked and revived, both through reference to the traditions of analogue photography and through the tools of digital photography. In an era in which we receive, take and disseminate as well as tag, browse and edit photographic imagery, we are all more invested, and more expert, in the language of photography than ever before, and we have a greater appreciation for how photography can be a far from neutral or transparent vehicle for bridged and framed moments of real time. The contemporary art photographers described in these pages rephrase our material and physical understanding of photography's past, while continuing to expand the vocabulary of photography as contemporary art. They show us ways of working and thinking that have real substance and direction in an increasingly digitized sphere, with its constantly shifting values and evolving sense of what it truly means to make photographs.

Further Reading

Essential reading on photography as contemporary art:

Batchen, Geoffrey, *Each Wild Idea: Writing, Photography, History* (Cambridge, MA, 2001)

Bourdieu, Pierre, *Photography: A Middle-Brow Art* (Cambridge, 1990)

Campany, David, *Art and Photography* (London, 2003)

Crow, Thomas, *Modern Art in Common Culture* (New Haven and London, 1996)

Salvesen, Britt, *New Topographics* (Göttingen, 2009)

Tagg, John, *The Burden of Representation: Essays on Photographies and Histories* (Basingstoke, 1988)

Wells, Liz, *Photography: A Critical Introduction* (London, 1997)

Selected photographers' monographs:

Araki, Nobuyoshi, *Araki By Araki* (Tokyo, 2003)
—, *Self Life Death* (London, 2011)

Bacher, Lutz, *Do You Love Me* (New York, 2011)
Ballen, Roger, *Shadow Chamber* (London, 2006)
—, *Boarding House* (London, 2009)
Baltz, Lewis, *The New Industrial Parks Near Irvine, California* (Göttingen and Los Angeles, 2001)
—, *The Tract Houses* (Göttingen and Los Angeles, 2005)
—, *Nevada 1977* (Göttingen, 2009)
—, *Texts* (Göttingen, 2011)
Barney, Tina, *Friends and Relations: Photographs* (Washington DC, 1991)
Barth, Uta, *Uta Barth – To Draw with Light* (New York, 2012)
Basilico, Gabriele, *Cityscapes* (Milan, 2008)
Beban, Breda, *Still* (Sheffield, 2000)
Becher, Bernd and Hilla, *Bernd and Hilla Becher: Life and Work* (Cambridge, MA, 2006)
Billingham, Richard, *Ray's a Laugh* (Zurich, 1996)
Broomberg, Adam and Oliver Chanarin, *Ghetto* (Göttingen, 2004)
—, *Fig.* (Brighton, 2008)
—, *People in Trouble Laughing Pushed to the Ground* (London, 2011)
Brotherus, Elina, *Elina Brotherus: The New Painting* (London, 2005)
Burtynsky, Edward, *Manufactured Landscapes: The Photographs of Edward Burtynsky* (New Haven, 2009)
Bustamante, Jean-Marc, *Something is Missing* (Salamanca, 1999)
—, *Jean-Marc Bustamante* (Paris, 2003)

Calle, Sophie, *M'as tu vue – Did you see me?* (New York, 2003)
Carucci, Elinor, *Closer* (San Francisco, 2002)
Casebere, James, *James Casebere: The Spatial Uncanny* (Milan, 2001)
Clark, Larry, *Tulsa* (New York, 2000)
Collins, Hannah, *Hannah Collins: In the Course of Time* (San Sebastian, 1996)
Crewdson, Gregory, *Twilight* (New York, 2002)
—, *Gregory Crewdson: 1985–2005* (Ostfildern, 2005)

Daems, Anne, *72 Girls and Some Boys Who Could Be Models* (New York, 2007)
Davey, Moyra, *Long Life Cool White* (Cambridge, MA, 2008)
Day, Corinne, *Diary* (London, 2000)
Dean, Tacita, *FLOH* (Göttingen, 2002)
—, *Analogue* (Göttingen, 2006)
Delahaye, Luc, *History* (New York, 2003)
Delvoye, Wim, *Skatalog* (Düsseldorf, 2001)
Demand, Thomas, *Thomas Demand* (London, 2000)
—, *Thomas Demand* (New York 2005)
Derges, Susan, *Susan Derges: Elemental* (Göttingen, 2010)
diCorcia, Philip-Lorca, *Streetwork 1993–1997* (Salamanca, 1998)
—, *Heads* (Göttingen, 2001)
—, *A Story Book Life* (Santa Fe, 2003)
—, *Thousand* (Göttingen, 2007)
Dijkstra, Rineke, *A Retrospective* (New York, 2012)
Divola, John, *Three Acts* (New York, 2006)
Doherty, Willie, *False Memory* (London, 2002)
Dolron, Desiree, *Desiree Dolron* (The Hague, 2005)
Dunning, Jeanne, *Bodies of Work* (Chicago, 1991)

Edström, Anders, *waiting some birds a bus a woman and spidernets places a crew* (Göttingen, 2004)
Eggleston, William, *William Eggleston's Guide* (facsimile edition), (New York, 2002)
—, *Los Alamos* (Zurich, 2003)
Epstein, Mitch, *Mitch Epstein: Work* (Göttingen, 2006)
—, *Mitch Epstein: American Power* (Göttingen, 2009)
Erdt, Ruth, *The Gang* (Baden, 2000)
Ethridge, Roe, *Rockaway, NY* (Göttingen, 2007)
—, *Le Luxe* (London, 2011)
Evans, Jason, *NYPLT* (London, 2012)

Feldmann, Hans-Peter, *272 Pages* (Barcelona, 2002)
—, *Zeitungsphotos* (Cologne, 2007)
Fischli, Peter and David Weiss, *Fischli and Weiss* (London, 2005)
—, *Equilibres* (Cologne, 2007)
Fontcuberta, Joan, *Contranatura* (Alicante, 2001)
—, *Joan Fontcuberta* (Paris, 2008)
Fox, Anna, *Anna Fox* (Göttingen, 2008)
Fraser, Peter, *Peter Fraser* (Portland, OR, 2006)
Fulford, Jason, *Crushed*, (New York, 2007)
—, *Raising Frogs for $$$* (Los Angeles, 2006)
—, *The Mushroom Collection* (Minneapolis, 2012)
Fuss, Adam, *Adam Fuss* (Santa Fe, 1997)
—, *Less of a Test than Earth* (Winterthur, 1999)

Genzken, Isa, *I Love New York, Crazy City* (Zurich, 2006)
—, *Isa Genzken* (London, 2006)
Gersht, Ori, *Ori Gersht: History Repeating* (Boston, 2012)
Goldin, Nan, *The Devil's Playground* (London, 2003)
—, *The Ballad of Sexual Dependency* (New York, 2012)
Gonzalez-Torres, Felix, *Felix Gonzales-Torres* (Göttingen, 2007)
Graham, Paul, *American Night* (Göttingen, 2003)
—, *A Shimmer of Possibility* (London, 2009)

—, *The Present* (London, 2012)
Grannan, Katy, *Be Zany Poised Harpists/Be Blue Little Sparrows* (New York, 2002)
—, *Westerns: Katy Grannan* (San Francisco, 2007)
Gray, Colin, *The Parents* (Edinburgh, 1995)
Gursky, Andreas, *Andreas Gursky: Photographs from 1984 to the Present* (Munich, 1998)
—, *Andreas Gursky* (New York, 2001)

Haifeng, Ni, *Ni Haifeng: No-Man's-Land* (New York, 2004)
Hanzlová, Jitka, *Female* (Munich, 2000)
—, *Jitka Hanzlová* (Madrid, 2012)
Harris, Lyle Ashton, *Lyle Ashton Harris: Blow Up* (New York, 2008)
Harrison, Rachel, *Rachel Harrison: Current 30* (Milwaukee, 2003)
Hassink, Jacqueline, *The Power Book* (London, 2007)
—, *The Table of Power 2* (Ostfildern, 2012)
Hatakeyama, Naoya, *Naoya Hatakeyama* (Ostfildern, 2002)
—, *Atmos* (Portland, OR, 2004)
Hernandez, Anthony, *Rodeo Drive 1984* (London, 2012)
Hoch, Matthias, *Matthias Hoch: Photographs* (Ostfildern, 2005)
Höfer, Candida, *Candida Höfer* (New York, 2004)
Homma, Takashi, *Stars and Stripes* (Tokyo, 2000)
—, *Tokyo Suburbia* (Tokyo, 2000)
—, *Tokyo* (New York, 2008)
Horn, Roni, *Another Water: The River Thames, for Example* (London, 2000)
—, *Roni Horn* (London, 2000)
Huan, Zhang, *Zhang Huan* (Ostfildern, 2003)
Hubbard, Teresa and Alexander Birchler, *Wild Walls* (Belefeld, 2001)
Hunter, Tom, *Tom Hunter* (Ostfildern, 2003)
Hütte, Axel, *After Midnight* (Munich, 2007)

Jasansky, Lukas and Martin Polak, *Pragensie 1985–1990* (Prague, 1998)
Jones, Sarah, *Sarah Jones* (Salamanca, 1999)

Kaoru, Izima, *Izima Kaoru 2000–2001* (London, 2000)
Kawauchi, Rinko, *Hanabi* (Tokyo, 2001)
—, *Utatane* (Tokyo, 2001)
—, *Aila* (Tokyo, 2004)
—, *Cui Cui* (Tokyo, 2005)
Kolbowksi, Silvia, *Imadequate...Like...Power* (Cologne, 2005)
Kulik, Oleg, *Selected Projects, Moscow 1991–1993* (London, 1997)

Lamsweerde, Inez van, and Vinoodh Matadin, *Inez van Lamsweerde and Vinoodh Matadin: Pretty Much Everything* (Göttingen, 2007)
Lassry, Elad, *Elad Lassry* (Zurich, 2010)
Lê, An-My, *Small Wars* (New York, 2005)
Lee, Nicki S., *Nikki S. Lee: Projects* (Ostfildern, 2001)
Leonard, Zoe, *The Fae Richards Photo Archive* (New York, 1997)
—, *Analogue* (Minneapolis, 2007)
—, *Zoe Leonard* (Göttingen, 2008)
Letinsky, Laura, *Now Again* (Antwerp, 2006)
Levine, Sherrie, *Sherrie Levine* (London and New York, 2007)
Li, Dinu, *As If I Were a River* (Manchester, 2003)

Lipper, Susan, *Trip* (Stockport, 2000)
Lockhart, Sharon, *Teatro Amazonas* (Rotterdam, 1999)
Lucas, Sarah, *Sarah Lucas* (London, 2002)
Lum, Ken, *Four Boats Stranded: Red and Yellow, Black and White, 2001* (Vancouver, 2001)
Luxemburg, Rut Blees, *Commonsensual: The Works of Rut Blees Luxemburg* (London, 2009)

Maier-Aichen, Florian, *Florian Maier-Aichen* (Los Angeles, 2007)
Manchot, Melanie, *Love is a Stranger: Photographs, 1998–2001* (Munich, 2001)
Mannikko, Esko, *Esko Mannikko* (Stuttgart, 1996)
McGinley, Ryan, *Ryan McGinley* (New York, 2002)
—, *Whistle for the Wind* (New York, 2012)
McMurdo, Wendy, *Wendy McMurdo* (Salamanca, 1999)
Meene, Hellen van, *Hellen van Meene* (London, 1999)
Meiselas, Susan, *Kurdistan: In the Shadow of History* (New York, 1997)
—, *Encounters with the Dani* (Göttingen, 2003)
—, *In History* (Göttingen and New York, 2008)
Mesa-Pelly, Deborah, *Deborah Mesa-Pelly* (Salamanca, 2000)
Mikhailov, Boris, *Boris Mikhailov: A Retrospective* (Zurich, 2003)
—, *Time is Out of Joint* (Berlin, 2012)
Misrach, Richard, *Desert Cantos* (Albuqerque, 1987)
—, *Petrochemical America* (New York, 2012)
Moffatt, Tracey, *Tracey Moffatt* (Ostfildern, 1998)
—, *Laudanum* (Ostfildern, 1999)
Moon, Boo, *Boo Moon* (Tucson, 1999)
Mori, Mariko, *Mariko Mori* (Chicago, 1998)
Morimura, Yasumasa, *Daughter of Art History: Photographs* (New York, 2003)
Mthethwa, Zwelethu, *Zwelethu Mthethwa* (New York, 2010)
Muniz, Vik, *Reflex: A Vik Muniz Primer* (New York, 2005)

Niedermayr, Walter, *The Aspen Series* (Ostfildern, 2013)
Nieweg, Simone, *Landschaften und Gartenstücke* (Amsterdam, 2002)
Norfolk, Simon, *Afghanistan* (Stockport, 2002)

O'Callaghan, Deirde, *Hide That Can* (London, 2002)
Orozco, Gabriel, *Photogravity* (Philadelphia, 1999)
—, *Trabajo* (Cologne, 2003)

Paglen, Trevor, *Invisible: Covert Operations and Classified Landscapes* (New York, 2010)
—, *The Last Pictures* (Berkeley, 2012)
Parker, Cornelia, *Cornelia Parker* (Turin, 2001)
Parr, Martin, *Martin Parr* (London, 2004)
—, *Small World* (Stockport, 2007)
—, *The Last Resort* (Stockport, 2009)
Prince, Richard, *Richard Prince: Paintings – Photographs* (Ostfildern, 2002)
—, *Richard Prince* (New York, 2002)

Richardson, Clare, *Harlemville* (Göttingen, 2003)
—, *Clare Richardson: Beyond the Forest* (Göttingen, 2007)
Riddy, John, *Praeterita* (Oxford, 2000)

Ristelhueber, Sophie, *Fait* (New York, 2009)
—, *Details of the World* (Boston, 2001)
Robbins, Andrea and Max Becher, *Andrea Robbins and Max Becher: Portraits* (New York, 2008)
Rousse, Georges, *Georges Rousse: 1981–2000* (Geneva, 2000)
Ruff, Thomas, *Thomas Ruff: 1979 to the Present* (Cologne, 2001)
—, *Thomas Ruff: 1979–2010* (Munich, 2012)
Ruscha, Ed, *Then and Now* (Göttingen, 2005)
—, *Ed Ruscha: Photographer* (Göttingen, 2007)

Sanguinetti, Alessandra, *On the Sixth Day* (Portland, OR 2005)
Schmid, Joachim, *Photoworks 1982–2007* (Göttingen, 2007)
Schorr, Collier, *Jens F.* (Göttingen, 2005)
—, *Forest and Fields: Neighbors* (Göttingen, 2006)
—, *Forest and Fields: Blumen* (Göttingen, 2009)
Seino, Yoshiko, *The Sign of Life* (Tokyo, 2003)
Sekula, Allan, *Dismal Science: Photoworks 1972–1996* (Normal, IL, 1999)
Shafran, Nigel, *Nigel Shafran* (Göttingen, 2004)
—, *Nigel Shafran: Flowers For __* (Göttingen, 2009)
Shahbazi, Shirana, *Shirana Shahbazi: Meanwhile* (Zurich, 2008)
Sheihk, Fazal, *A Camel For the Son* (Göttingen, 2001)
—, *Fazal Sheihk: Ladli* (Göttingen, 2007)
Sherman, Cindy, *Cindy Sherman: The Complete Untitled Film Stills* (New York, 2003)
—, *Cindy Sherman* (Paris, 2007)
—, *Cindy Sherman* (New York, 2012)
Shonibare, Yinka, *Yinka Shonibare, MBE* (Munich, 2008)
Shore, Stephen, *American Surfaces, 1972* (Munich, 1999)
—, *Uncommon Places: The Complete Works* (London, 2004)
Shrigley, David, *Do Not Bend* (London, 2001)
Smith, Bridget, *Bridget Smith* (Salamanca, 2002)
Søndergaard, Trine, *Now That You Are Mine* (Göttingen, 2002)
Soth, Alec, *Sleeping by the Mississippi* (Göttingen, 2004)
—, *Niagara* (Göttingen, 2006)
—, *Dog Days, Bogotá* (Göttingen, 2007)
Southam, Jem, *The Shape of Time: Rockfalls, Rivermouths, Ponds* (Eastbourne, 2000)
—, *The Painter's Pool* (Portland, OR, 2007)
Starkey, Hannah, *Hannah Starkey: Photographs 1997–2007* (Göttingen, 2008)
Stehli, Jemima, *Jemima Stehli* (London, 2002)
Sternfeld, Joel, *American Prospects* (Göttingen, 2004)
—, *Stranger Passing* (San Francisco, 2001)
Stewart, Christopher, *Christopher Stewart* (Salamanca, 2004)
Strba, Annelies, *Shades of Time* (Ennetbaden, 1997)
Sugimoto, Hiroshi, *Portraits* (New York, 2000)
—, *Architecture* (Chicago, 2003)
—, *Hiroshi Sugimoto* (Munich, 2005)
Sultan, Larry, *Pictures from Home* (New York, 1992)
—, *The Valley* (Zurich, 2004)
Sultan, Larry, and Mike Mandel, *Evidence* (New York, 2004)
—, *Larry Sultan & Mike Mandel* (New York, 2012)

Tandberg, Vibeke, *Vibeke Tandberg: Kunstmuseum Thun* (Thun, 2000)
Taylor-Wood, Sam, *Sam Taylor-Wood* (Göttingen, 2002)
Teller, Juergen, *Märchenstüberl* (Göttingen, 2002)
—, *The Master* (Göttingen, 2005)
Teller, Juergen, and Cindy Sherman, *Juergen Teller, Cindy Sherman, Marc Jacobs* (New York, 2006)
Tillmans, Wolfgang, *If One Thing Matters, Everything Matters* (London, 2003)
—, *Wolfgang Tillmans: Lighter* (Munich, 2008)
—, *Neue Welt/New World* (Cologne, 2012)
Tronvoll, Mette, *Mette Tronvoll: Isortoq Unartoq* (Cologne, 2000)

Wall, Jeff, *Jeff Wall Catalogue Raisonné 1978–2004* (Göttingen, 2005)
—, *Jeff Wall* (London, 2009)
Waplington, Nick, *Safety in Numbers* (London, 1997)
—, *Learn How to Die the Easy Way* (London, 2002)
Wearing, Gillian, *Signs That Say What You Want Them To Say And Not Signs That Say What Someone Else Wants You To Say 1992–1993* (London, 1997)
Welling, James, *James Welling: Flowers* (New York, 2005)
—, *Light Sources 1992–2004* (Göttingen, 2009)
—, *James Welling: Monograph* (New York, 2013)
Wenders, Wim, *Pictures from the Surface of the Earth* (Munich, 2001)
Wentworth, Richard, *Richard Wentworth–Eugène Atget: Faux Amis* (London, 2001)
White, Charlie, *Charlie White: American Minor* (Zurich, 2009)
Willmann, Manfred, *Das Land* (Salzburg, 2000)
Wurm, Erwin, *Erwin Wurm* (Ostfildern, 2002)
—, *Erwin Wurm: One Minute Sculptures – Catalogue Raisonné 1988–1998* (Ostfildern, 1999)
Wyse, Mark, *18 Landscapes* (Portland, OR, 2005)

Ya'ari, Sharon, *500m Radius* (Tel Aviv, 2006)
Yang Yong, *Yang Yong* (Beijing, 2003)

Illustration List

Dimensions of works are given in centimetres and inches, height before width.

1. Sarah Jones, *The Bedroom (I)*, 2002. C-print mounted on aluminium, 150 × 150 (59 × 59). © the artist, courtesy Maureen Paley Interim Art, London. 2. Daniel Gordon, *Anemone Flowers and Avocado*, 2012. C-print, 114.3 × 91.4 (45 × 36). Courtesy the artist and Wallspace, New York. 3. William Eggleston, *Untitled*, 1970. Vintage dye transfer print, 40.6 × 50.8 (16 × 20). From the series *Memphis*. Courtesy Cheim & Reid, New York. © Eggleston Artistic Trust. 4. Stephen Shore, *Untitled (28a)*, 1972. C-print, 10.2 × 15.2 (4 × 6). From the series *American Surfaces*. Courtesy Sprüth Magers Lee, London. Copyright the artist. 5. Alec Soth, *Sugar's, Davenport, IA*, 2002. C-print, 101.6 × 81.3 (40 × 32). From the series

Sleeping by the Mississippi. Courtesy Yossi Milo Gallery, New York. **6.** Bernd and Hilla Becher, *Twelve Water-towers*, 1978–85. Black-and-white photograph, 165 x 180 (65 x 70¾). Collection F.R.A.C. Lorraine. Courtesy Sonnabend Gallery, New York. **7.** Lewis Baltz, *Southwest Wall,Vollrath, 2424 McGaw, Irvine, from The New Industrial Parks near Irvine, California*, 1974, gelatin silver print 15.2 x 22.9 (6 x 9) © Lewis Baltz, courtesy Galerie Thomas Zander, Cologne. **8.** László Moholy-Nagy, *Lightplay: Black/White/Gray, Museum of Modern Art (MoMA)*, c. 1926. Gelatin silver print, 37.4 x 27.4 (14¾ x 10¾). Gift of the photographer. Acc. n.: 296.1937. Digital image: The Museum of Modern Art, New York/Scala, Florence. © Hattula Moholy-Nagy/DACS 2014 **9.** Man Ray/Marcel Duchamp, *Dust Breeding*, 1920. Gelatin silver print. 23.9 x 30.4 cm (9⁷⁄₁₆ x 12 in.). Purchase, Photography in the Fine Arts Gift, 1969 (69.521). Image © The Metropolitan Museum of Art/Art Resource/Scala, Florence. © Man Ray Trust/ADAGP, Paris and DACS, London 2014/ © Succession Marcel Duchamp/ADAGP, Paris and DACS, London 2014 **10.** Philip-Lorca diCorcia, *Head #7*, 2000. Fuji Crystal Archive print, 121.9 x 152.4 (48 x 60). © Philip-Lorca diCorcia. Courtesy Pace/MacGill Gallery, New York. **11.** Alfred Stieglitz, *Fountain, 1917, by Marcel Duchamp*, 1917. Gelatin silver print, 23.5 x 17.8 (9½ x 7). Private collection, France. Duchamp: © ADAGP, Paris and DACS, London 2004. **12.** Sophie Calle, *The Chromatic Diet*, 1998. Extract from a series of 7 photographs and menus. Photograph, 48 x 72 (18⅞ x 28⅜). Courtesy Galerie Emmanuel Perrotin, Paris. © ADAGP, Paris and DACS, London 2004. **13.** Zhang Huan, *To Raise the Water Level in a Fishpond*, 1997. C-print, 101.6 x 152.4 (40 x 60). Courtesy the artist. **14.** Rong Rong, *Number 46: Fen. Maliuming's Lunch, East Village Beijing*, 1994. Gelatin silver print, 120 x 180 (47¼ x 70¾). With thanks to Chinese Contemporary (Gallery), London. **15.** Joseph Beuys, *I Like America and America Likes Me*, 1974. Rene Block Gallery, New York, 1974. Courtesy Ronald Feldman Fine Arts, New York. Photo © Caroline Tisdall. © DACS 2004. **16.** Oleg Kulik, *Family of the Future*, 1992–97. C-type print, 50 x 50 (19⅝ x 19⅝). Courtesy White Space Gallery, London. **17.** Melanie Manchot, *Gestures of Demarcation VI*, 2001. C-print, 80 x 150 (31½ x 59). Courtesy Rhodes + Mann Gallery, London. **18.** Jeanne Dunning, *The Blob 4*, 1999. Ilfochrome mounted to plexiglas and frame, 94 x 123.8 (37 x 48¾). Courtesy Feigen Contemporary, New York. **19.** Tatsumi Orimoto, *Bread Man Son and Alzheimer Mama,Tokyo*, 1996. From the series *Art Mama*. C-print, 200 x 160 (78¾ x 63). Courtesy DNA Gallery, Berlin. **20.** Erwin Wurm, *The bank manager in front of his bank*, 1999. C-print, 186 x 126.5 (73¼ x 49¾). Edition of 3 and 2 AP. From the series *Cahors*. Galerie ARS FUTURA, Zurich, Galerie Anne de Villepoix, Paris. **21.** Erwin Wurm, *Outdoor Sculpture*, 1999. C-print, 186 x 126.5 (73¼ x 49¾). Edition of 3 and 2 AP. From the series *Cahors*. Galerie ARS FUTURA, Zurich, Galerie Anne de Villepoix, Paris. **22.** Gillian Wearing, *Signs that say what you want them to say and not signs that say what someone else wants you to say*, 1992–93. C-print, 122 x 92 (48 x 36¼). Courtesy Maureen Paley Interim Art, London. **23.** Bettina von Zwehl, *#2*, 1998. C-print

mounted on aluminium, 80 x 100 (31½ x 39⅜). From the series *Untitled I*. Courtesy Lombard-Freid Fine Arts, New York. **24.** Shizuka Yokomizo, *Stranger (10)*, 1999. C-print, 127 x 108 (50 x 42½). Courtesy The Approach, London. **25.** Hellen van Meene, *Untitled #99*, 2000. C-print, 39 x 39 (15⅜ x 15⅜). From the series *Japan*. © the artist, courtesy Sadie Coles HQ, London. **26.** Ni Haifeng, *Self-portrait as a Part of Porcelain Export History (no. 1)*, 1999–2001. C-print, 100 x 127 (39⅜ x 50). Courtesy Gate Foundation/Lumen Travo Gallery, Amsterdam. **27.** Kenneth Lum, *Don't Be Silly,You're Not Ugly*, 1993. C-print, aluminium, lacquer paint, pvc, 182.9 x 243.8 x 5.1 (72 x 96 x 2). Courtesy Collection of Vancouver Art Gallery, Canada; Private Collection, Cologne. **28.** Roy Villevoye, *Presents (3 Asmat men, 3 T-shirts, 3 presents)*, 1994. C-print from slide, 100 x 150 (39⅜ x 59). Courtesy Fons Welters Gallery, Amsterdam. **29.** Nina Katchadourian, *Mended Spiderweb #19 (Laundry Line)*, 1998. C-print, 50.8 x 76.2 (20 x 30). Courtesy the artist and Debs & Co., New York. **30.** Wim Delvoye, *OutWalking the Dog*, 2000. C-print on aluminium, 100 x 125 (39⅜ x 49¼). Courtesy the artist. **31.** David Shrigley, *Ignore This Building*, 1998. C-print, 39 x 49 (15⅜ x 19¼). Courtesy Stephen Friedman Gallery, London. **32.** Sarah Lucas, *Get Off Your Horse and Drink Your Milk*, 1994. Cibachrome on aluminium, 84 x 84 each photograph (33⅛ x 33⅛). © the artist, courtesy Sadie Coles HQ, London. **33.** Annika von Hausswolff, *Everything is connected, he, he, he*, 1999. C-print, 106.7 x 137.2 (42 x 54). Courtesy the artist and Casey Kaplan, New York. **34.** Mona Hatoum, *Van Gogh's Back*, 1995. C-print, 50 x 38 (19¾ x 15). © the artist. Courtesy Jay Jopling/White Cube, London. **35.** Georges Rousse, *Mairet*, 2000. Lamdachrome print, variable dimensions. Courtesy Robert Mann Gallery, New York. © ADAGP, Paris, and DACS, London 2004. **36.** David Spero, *Lafayette Street, New York*, 2003. C-print, 108 x 138 (42½ x 54¾). From the series *Ball Photographs*. Courtesy the artist. **37.** Tim Davis, *McDonalds 2, Blue Fence*, 2001. C-print, 152.4 x 121.9 (60 x 48). Edition of 7. Courtesy Brent Sikkema, New York. **38.** Olga Chernysheva, *Anabiosis (Fisherman; Plants)*, 2000. C-print, 104 x 72 (41 x 28¾). Courtesy White Space Gallery, London. **39.** Rachel Harrison, *Untitled (Perth Amboy)*, 2001. C-print, 66 x 50.8 (26 x 20). Courtesy the artist and Greene Naftali, New York. **40.** Philip-Lorca diCorcia, *Head #23*, 2000. Fuji Crystal Archive print, 121.9 x 152.4 (48 x 60). © Philip-Lorca diCorcia. Courtesy Pace/MacGill Gallery, New York. **41.** Roni Horn, *You Are the Weather* (installation shot), 1994–96. 100 colour photographs and gelatin silver prints, 26.5 x 21.4 each (10⅜ x 8⅜). Courtesy the artist and Matthew Marks Gallery, New York. **42.** Jeff Wall, *Passerby*, 1996. Black-and-white print, 229 x 335 (90⅛ x 131⅞). Courtesy Jeff Wall Studio. **43.** Jeff Wall, *Insomnia*, 1994. Transparency in lightbox, 172 x 214 (67¾ x 84¼). Courtesy Jeff Wall Studio. **44.** Philip-Lorca diCorcia, *Eddie Anderson; 21 years old; Houston,TX; $20*, 1990–92. Ektacolour print, image 65.7 x 96.4 (25⅞ x 38), paper 76.2 x 101.6 (30 x 40). Edition of 20. © Philip-Lorca diCorcia. Courtesy Pace/MacGill Gallery, New York. **45.** Teresa Hubbard and Alexander Birchler, *Untitled*, 1998. C-print, 145 x 180 (57⅛ x 70¾). From the series *Stripping*. Edition of 5. Courtesy

the artists and Tanya Bonakdar Gallery, New York. **46.** Sam Taylor-Wood, *Soliloquy I*, 1998. C-print (framed), 211 x 257 (83⅛ x 101⅛). © the artist. Courtesy Jay Jopling/White Cube, London. **47.** Tom Hunter, *The Way Home*, 2000. Cibachrome print, 121.9 x 152.4 (48 x 60). © the artist. Courtesy Jay Jopling/White Cube, London. **48.** Yinka Shonibare, *Diary of a Victorian Dandy 19:00 hours*, 1998. C-print, 183 x 228.6 (72 x 90). Courtesy Stephen Friedman Gallery, London. **49.** Sarah Dobai, *Red Room*, 2001. Lambdachrome, 127 x 150 (50 x 59). Courtesy Entwistle, London. **50.** Liza May Post, *Shadow*, 1996. Colour photograph mounted on aluminium, 166 x 147 (65⅜ x 57⅞). Courtesy Annet Gelink Gallery, Amsterdam. **51.** Sharon Lockhart, *Group #4: Ayako Sano*, 1997. Chromogenic print, 114.3 x 96.5 (45 x 38). 12 framed prints, overall dimensions 82 x 249.5 (32¼ x 98¼). From the series *Goshogaoka Girls Basketball Team*. Edition of 8. Courtesy neugerriemschneider, Berlin, Barbara Gladstone Gallery, New York, and Blum and Poe, Santa Monica. **52.** Frances Kearney, *Five People Thinking the Same Thing, III*, 1998. C-print, 152.4 x 121.9 (48 x 60). Courtesy the artist. **53.** Hannah Starkey, *March 2002*, 2002. C-print, 122 x 183 (48 x 72). Courtesy Maureen Paley Interim Art, London. **54.** Justine Kurland, *Buses on the Farm*, 2003. C-print framed, 64 x 75 (25¼ x 29½). From the series *Golden Dawn*. Courtesy Emily Tsingou Gallery, London, and Gorney Bravin + Lee, New York. **55.** Sarah Jones, *The Guest Room (bed) I*, 2003. C-print mounted on aluminium, 130 x 170 (51⅛ x 66¾). © the artist, courtesy Maureen Paley Interim Art, London. **56.** Sergey Bratkov, *#1*, 2001. C-print, 120 x 90 (47¼ x 35⅜). From the series *Italian School*. Courtesy Regina Gallery, Moscow. **57.** Wendy McMurdo, *Helen, Backstage, Merlin Theatre (the glance)*, 1996. C-print, 120 x 120 (47¼ x 47¼). © Wendy McMurdo. **58.** Deborah Mesa-Pelly, *Legs*, 1999. C-print, 50.8 x 61 (20 x 24). Courtesy the artist and Lombard-Freid Fine Arts, New York. **59.** Anna Gaskell, *Untitled #59 (by proxy)*, 1999. C-print, 101.6 x 76.2 (40 x 30). © the artist. Courtesy Jay Jopling/White Cube, London. **60.** Inez van Lamsweerde and Vinoodh Matadin, *The Widow (Black)*, 1997. C-print on plexiglas, 119.4 x 119.4 (47 x 47). Courtesy the artist and Matthew Marks Gallery, New York. **61.** Mariko Mori, *Burning Desire*, 1996–98. Glass with photo interlayer, 305 x 610 x 2.2 (120⅛ x 240¼ x ⅞). From the series *Esoteric Cosmos*. Courtesy Mariko Mori. **62.** Gregory Crewdson, *Untitled (Ophelia)*, 2001. Digital C-print, 121.9 x 152.4 (48 x 60). From the series *Twilight*. © the artist. Courtesy Jay Jopling/White Cube, London. **63.** Charlie White, *Ken's Basement*, 2000. Chromogenic print on Fuji Crystal Archive paper mounted on plexiglas, 91.4 x 152.4 (36 x 60). From the series *Understanding Joshua*. Courtesy the artist and Andrea Rosen Gallery, New York. © Charlie White. **64.** Izima Kaoru, *#302, Aure Wears Paul & Joe*, 2001. From the series *Landscape with a Corpse*. C-print, 124 x 156 (48⅞ x 61⅜). Courtesy Von Lintel Gallery, New York, (gallery@vonlintel.com). **65.** Christopher Stewart, *United States of America*, 2002. C-print, 150 x 120.5 (59 x 47½). From the series *Insecurity*. Courtesy the artist. **66.** Katharina Bosse, *Classroom*, 1998. Colour negative print, 101 x 76 (39¾ x 28⅞). From the series

Realms of signs, realms of senses. Courtesy Galerie Reckermann, Cologne. **67.** Miriam Bäckström, *Museums, Collections and Reconstructions, IKEA Corporate Museum, 'IKEA throughout the Ages'. Älmhult, Sweden, 1999*, 1999. Cibachrome on glass, 120 x 150 (47¼ x 59). Courtesy Nils Stærk Contemporary Art, Copenhagen. **68.** Miles Coolidge, *Police Station, Insurance Building, Gas Station*, 1996. C-print, 111.8 x 76.2 (44 x 30). From the series *Safetyville*. Courtesy Casey Kaplan, New York, and ACME, Los Angeles. **69.** Thomas Demand, *Salon (Parlour)*, 1997. Chromogenic print on photographic paper and diasec, 183.5 x 141 (72¼ x 55½). Courtesy the artist and Victoria Miro Gallery, London, and 303 Gallery, New York. © DACS 2004. **70.** Anne Hardy, *Lumber*, 2003–04. C-print, 152 x 121 (59¾ x 47¾). From the series *Interior Landscapes*. Courtesy the artist. **71.** James Casebere, *Pink Hallway #3*, 2000. Cibachrome mounted on plexiglas, 152.4 x 121.9 (60 x 48). Courtesy Sean Kelly Gallery, New York. **72.** Rut Blees Luxemburg, *Nach Innen/In Deeper*, 1999. C-print, 150 x 180 (59 x 70½). From the series *Liebeslied*. © Rut Blees Luxemburg. **73.** Desiree Dolron, *Cerca Paseo de Marti*, 2002. Di bonded cibachrome print, 125 x 155 (49¼ x 61). From the series *Te Dí Todos Mis Sueños*. © Desiree Dolron, courtesy Michael Hoppen Gallery, London. **74.** Hannah Collins, *In the Course of Time, 6 (Factory Krakow)*, 1996. Gelatin silver print mounted on cotton, 233 x 525 (91¾ x 206¾). Collection Reina Sofia Museum, Madrid. © the artist. **75.** Celine van Balen, *Muazez*, 1998. C-print mounted on aluminium and matt laminate, 50 x 62 (19⅝ x 24⅜). From the series *Muslim girls*. Courtesy Van Zoetendaal, Amsterdam. **76.** Andreas Gursky, *Chicago, Board of Trade II*, 1999. C-print, 207 x 336.9 (81½ x 132¾). Courtesy Matthew Marks Gallery, New York and Monika Sprüth Gallery/Philomene Magers, © DACS 2004. **77.** Andreas Gursky, *Prada I*, 1996. C-print, 145 x 220 (57⅛ x 86⅝). Courtesy Matthew Marks Gallery, New York and Monika Sprüth Gallery/Philomene Magers, © DACS 2004. **78.** Walter Niedermayr, *ValThorens II*, 1997. Colour photograph, 103 x 130 (40½ x 51⅛) each photograph. Courtesy Galerie Anne de Villepoix, Paris. **79.** Bridget Smith, *Airport, Las Vegas*, 1999. C-print, 119 x 162.5 (46⅞ x 64). Courtesy the artist and Frith Street Gallery, London. **80.** Ed Burtynsky, *Oil Fields #13, Taft, California*, 2002. Chromogenic colour print, 101.6 x 127 (40 x 50). From the series *Oil Fields*. © Edward Burtynsky, Toronto. **81.** Takashi Homma, *Shonan InternationalVillage, Kanagawa, 1995–98*. C-print, variable dimensions. From the series *Tokyo Suburbia*. Courtesy Taka Ishii Gallery, Tokyo. **82.** Lewis Baltz, *Power Supply No. 1*, 1989–92. C-print, 114 x 146 (44⅞ x 57½). From the series *Sites of Technology*. Courtesy Galerie Thomas Zander, Cologne. © Lewis Baltz. **83.** Matthias Hoch, *Leipzig #47*, 1998. C-print, 100 x 120 (39⅜ x 47¼). Courtesy Galerie Akinci, Amsterdam and Dogenhaus Galerie, Leipzig. **84.** Jacqueline Hassink, *Mr. Robert Benmosche, Chief Executive Officer, Metropolitan Life Insurance, New York, NY, April 20, 2000*, 2000. C-print, 130 x 160 (59⅛ x 63). Courtesy the artist. **85.** Candida Höfer, *Bibliotheca PHE Madrid I*, 2000. C-print, framed, 154.9 x 154.9 (61 x 61). Courtesy Candida Höfer/VG Bild-Kunst © 2004. **86.** Naoya Hatakeyama, *Untitled, Osaka 1998–99*. C-print,

two photographs, 89 x 180 each (35 x 70⅞). Courtesy Taka Ishii Gallery, Tokyo. **87.** Axel Hütte, *The Dogs' Home, Battersea*, 2001. Duratrans print, 135 x 165 (53⅛ x 65). From the series *As Dark as Light*. Courtesy Galeria Helga de Alvear, Madrid. **88.** Dan Holdsworth, *Untitled (A machine for living)*, 1999. C-print, 92.5 x 114.5 (36⅜ x 45⅛). Courtesy Entwistle, London. **89.** Richard Misrach, *Battleground Point #21*, 1999. Chromogenic print, 50.8 x 61 (20 x 24) edition of 25, 121.9 x 152.4 (48 x 60) edition of 5. Courtesy artist and Catherine Edelman Gallery, Chicago. **90.** Thomas Struth, *Pergamon Museum 1, Berlin*, 2001. C-print, 197.5 x 248.6 (77¾ x 97⅞). Courtesy the artist and Marian Goodman Gallery, New York. **91.** John Riddy, *Maputo (Train) 2002*, 2002. C-print, 46 x 60 (18¼ x 23⅝). Courtesy the artist and Frith Street Gallery, London. **92.** Gabriele Basilico, *Beirut*, 1991. C-print, 18 x 24 (7⅛ x 9⅜). © Gabriele Basilico. **93.** Simone Nieweg, *Grünkohlfeld, Düsseldorf – Kaarst*, 1999. C-print, 36 x 49 (14⅛ x 19¼). © Simone Nieweg, courtesy Gallery Luisotti, Los Angeles. **94.** Yoshiko Seino, *Tokyo*, 1997. C-print, 50.8 x 61 (20 x 24). From the series *Emotional Imprintings*. © Yoshiko Seino. Courtesy Osiris, Tokyo. **95.** Gerhard Stromberg, *Coppice (King's Wood)*, 1994–99. C-print, 132 x 167 (52 x 65¾). Courtesy Entwistle, London. **96 and 97.** Jem Southam, *Painter's Pool*, 2003. C-print, 91.5 x 117 (36 x 46). © Jem Southam, courtesy Hirschl Contemporary Art, London. **98.** Boo Moon, *Untitled (East China Sea)*, 1996. C-print, variable dimensions. © boomoon. **99.** Clare Richardson, *Untitled IX*, 2002. C-print, 107.5 x 127 (42⅜ x 50). From the series *Sylvan*. © the artist. Courtesy Jay Jopling/ White Cube, London. **100.** Lukas Jasansky and Martin Polak, *Untitled*, 1999–2000. Black and white photograph, 80 x 115 (31½ x 45¼). From the series *Czech Landscape*. Courtesy Lukas Jasansky, Martin Polak and Galerie Jirisvestka, Prague. **101.** Thomas Struth, *Paradise 9 (Xi Shuang Banna Provinz Yunnan), China*, 1999. C-print, 275 x 346 (108¼ x 136¼). Courtesy the artist and Marian Goodman Gallery, New York. **102.** Thomas Ruff, *Portrait (A.Volkmann)*, 1998. C-print, 210 x 165 (82⅝ x 65). Galerie Nelson, Paris/Ruff. © DACS 2004. **103.** Hiroshi Sugimoto, *Anne Boleyn*, 1999. Gelatin silver print, unframed, 149.2 x 119.4 (58¾ x 47). © the artist. Courtesy Jay Jopling/White Cube, London. **104.** Joel Sternfeld, *A Woman with a Wreath, New York, New York, December 1998*, 1998. C-print, 91.4 x 109.2 (36 x 43). Courtesy the artist and Luhring Augustine, New York. **105.** Jitka Hanzlová, *Indian Woman, NY Chelsea*, 1999. C-print, 29 x 19.3 (11⅜ x 7⅝). From the series *Female*. Courtesy Jitka Hanzlová. **106.** Mette Tronvoll, *Stella and Katsue, Maiden Lane*, 2001. C-print, 141 x 111 (55¼ x 43¾), frame, 154 x 124 (60⅝ x 48¾). From the series *New Portraits*. Galerie Max Hetzler, Berlin. **107.** Albrecht Tübke, *Celebration*, 2003. C-print, 24 x 30 (9½ x 11¾). Courtesy the artist. **108.** Rineke Dijkstra, *Julie, Den Haag, Netherlands, February 29, 1994*, 1994. C-print, 153 x 129 (60¼ x 50¾). From the series *Mothers*. Courtesy the artist and Marian Goodman Gallery, New York. **109.** Rineke Dijkstra, *Tecla, Amsterdam, Netherlands, May 16, 1994*, 1994. C-print, 153 x 129 (60¼ x 50¾). From the series *Mothers*. Courtesy the artist and Marian Goodman Gallery, New York.

110. Rineke Dijkstra, *Saskia, Harderwijk, Netherlands, March 16, 1994*, 1994. C-print, 153 x 129 (60¼ x 50¾). From the series *Mothers*. Courtesy the artist and Marian Goodman Gallery, New York. **111.** Peter Fischli and David Weiss, *Quiet Afternoon*, 1984–85. Colour and black-and-white photographs, dimensions ranging from 23.3 x 30.5 (9⅛ x 12) to 40.6 x 30.5 (16 x 12). Courtesy the artists and Matthew Marks Gallery, New York. **112.** Gabriel Orozco, *Breath and Piano*, 1993. C-print, 40.6 x 50.8 (16 x 20). Edition of 5. Courtesy the artist and Marion Goodman Gallery, New York. **113.** Felix Gonzalez-Torres, *'Untitled'*, 1991. Billboard, dimensions vary with installation. As installed for The Museum of Modern Art, New York "Projects 34: Felix Gonzalez-Torres" May 16–June 30, 1992, in twenty-four locations throughout New York City. © The Felix Gonzalez-Torres Foundation. Courtesy Andrea Rosen Gallery, New York. Photograph by Peter Muscato. **114.** Richard Wentworth, *Kings Cross, London*, 1999. Unique colour photograph, 28.8 x 19 (11⅜ x 7½). From the series *Making Do and Getting By*. Courtesy Lisson Gallery, London, and the artist. **115.** Jason Evans, *New Scent*, 2000–03. Resin coated black-and-white print, 30.5 x 25.4 (12 x 10). Courtesy the artist. **116.** Nigel Shafran, *Sewing kit (on plastic table) Alma Place*, 2002. C-print, 58.4 x 74 (23 x 29¼). Courtesy the artist. **117.** Jennifer Bolande, *Globe, St Marks Place, NYC*, 2001. Digital C-print mounted on plexiglas, 98 x 82.5 (38⅝ x 32½). Edition of 3. Courtesy Alexander and Bonin, New York. **118.** Jean-Marc Bustamante, *Something is Missing (S.I.M 13.97 B)*, 1997. C-print, image, 40 x 60 (15¾ x 23½), sheet, 51 x 61 (20 x 24). Edition of 6. Courtesy the artist and Matthew Marks Gallery, New York. © ADAGP, Paris, and DACS, London 2004. **119.** WimWenders, *Wall in Paris,Texas*, 2001. C-print, 160 x 125 (63 x 49¼). Courtesy Haunch of Venison. **120.** Anthony Hernandez, *Aliso Village #3*, 2000. C-print, 101.6 x 101.6 (40 x 40). Courtesy the artist and Anthony Grant, Inc., New York. **121.** Tracey Baran, *Dewy*, 2000. C-print, 76.2 x 101.6 (30 x 40). From the series *Still*. © Tracey Baran. Courtesy Leslie Tonkonow Artworks + Projects, New York. **122.** Peter Fraser, *Untitled 2002*, 2002. Fuji Crystal Archive C-print, 50.8 x 61 (20 x 24). From the series *Material*. Courtesy the artist. **123.** Manfred Willmann, *Untitled*, 1988. C-print, 70 x 70 (27½ x 27½). From the series *Das Land*, 1981–93. Courtesy the artist. **124.** Roe Ethridge, *The Pink Bow*, 2001–02. C-print, 76.2 x 61 (30 x 24). Courtesy the artist and Andrew Kreps Gallery, New York. **125.** Wolfgang Tillmans, *Suit*, 1997. C-print, variable dimensions. Courtesy Maureen Paley Interim Art, London. **126.** James Welling, *Ravenstein 6*, 2001. Vegetable dye on rag paper, framed, 97 x 156 (38¼ x 61⅜). Edition of 6. From the series *Light Sources*. Courtesy Donald Young Gallery, Chicago. **127.** Jeff Wall, *Diagonal Composition no. 3*, 2000. Transparency in a lightbox, 74.6 x 94.2 (29¾ x 37⅛). Courtesy Jeff Wall Studio. **128.** Laura Letinsky, *Untitled #40, Rome*, 2001. Chromogenic print, 59.7 x 43.2 (23½ x 17). From the series *Morning and Melancholia*. © Laura Letinsky, courtesy Michael Hoppen Gallery. **129.** Uta Barth, *Untitled (nw 6)*, 1999. Colour photograph, framed, 88.9 x 111.8 (35 x 44). From the series *Nowhere Near*. Courtesy the artist, Tanya

Bonakdar Gallery, New York, and ACME, Los Angeles. **130.** Sabine Hornig, *Window with Door*, 2002. C-print mounted behind perspex, 168 x 149.5 (66⅛ x 58⅞). Edition of 6. Courtesy the artist and Tanya Bonakdar Gallery, New York. **131.** Nan Goldin, *Gilles and Gotscho Embracing*, *Paris*, 1992. Cibachrome print, 76.2 x 101.6 (30 x 40).© Nan Goldin, courtesy Matthew Marks Gallery, New York. **132.** Nan Goldin, *Siobhan at the A House #1, Provincetown, MA*, 1990. Cibachrome print, 101.6 x 76.2 (40 x 30). © Nan Goldin, courtesy Matthew Marks Gallery, New York. **133.** Nobuyoshi Araki, *Shikijyo Sexual Desire*, 1994–96. C-print, variable dimensions. Courtesy Taka Ishii Gallery, Tokyo. **134.** Larry Clark, *Untitled*, 1972. 10 gelatin silver prints, 20.5 x 25.4 (8 x 10) each. From the series *Tulsa*. Courtesy the artist and Luhring Augustine, New York. **135.** Juergen Teller, *Selbstportrait: Sauna*, 2000. Black and white bromide print, variable dimensions. Courtesy Juergen Teller. **136.** Corinne Day, *Tara sitting on the loo*, 1995. C-print, 140 x 60 (15¼ x 23⅝). From the series *Diary*. Courtesy the artist and Gimpel Fils, London. **137.** Wolfgang Tillmans, *Lutz & Alex holding each other*, 1992. C-print, variable dimensions. Courtesy Maureen Paley Interim Art, London. **138.** Wolfgang Tillmans, 'If one thing matters, everything matters', installation view, Tate Britain, 2003. Courtesy Maureen Paley, Interim Art, London. **139.** Jack Pierson, *Reclining Neapolitan Boy*, 1995. C-print, 101.6 x 76.2 (40 x 30). Edition of 10. Courtesy the artist and Cheim & Reid, New York. **140.** Richard Billingham, *Untitled*, 1994. Fuji Longlife colour photograph mounted on aluminium, 80 x 120 (31½ x 47¼). © the artist, courtesy Anthony Reynolds Gallery, London. **141.** Nick Waplington, *Untitled*, 1996. C-print, variable dimensions. From the series *Safety in Numbers*. Courtesy the artist. **142.** Anna Fox, *From the series Rise and Fall of Father Christmas, November/December 2002*, 2002. Archival Inkjet print, 50.8 x 61 (20 x 24). Courtesy the artist. **143.** Ryan McGinley, *Gloria*, 2003. C-print, 76.2 x 101.6 (30 x 40). Courtesy the artist. **144.** Hiromix, from *Hiromix*, 1998. Edited by Patrick Remy Studio. © Hiromix 1998 and © 1998 Steidl Publishers, Göttingen. **145.** Yang Yong, *Fancy in Tunnel*, 2003. Gelatin silver print, 180 x 120 (70⅞ x 47¼). Courtesy the artist. **146.** Alessandra Sanguinetti, *Vida mia*, 2002. Ilfochrome, 76.2 x 76.2 (30 x 30). Courtesy Alessandra Sanguinetti. **147.** Annelies Strba, *In the Mirror*, 1997. 35 mm slide. From the installation *Shades of Time*. Courtesy the artist and Frith Street Gallery, London. **148.** Ruth Erdt, *Pablo*, 2001. C-print, variable dimensions. From the series *The Gang*. © Ruth Erdt. **149.** Elinor Carucci, *My Mother and I*, 2000. C-print, 76.2 x 101.6 (30 x 40). From the book *Closer*. Courtesy Ricco/Maresca Gallery. **150.** Tina Barney, *Philip & Philip*, 1996. Chromogenic colour print, 101.6 x 76.2 (40 x 30). Courtesy Janet Borden, Inc., New York. **151.** Larry Sultan, *Argument at the Kitchen Table*, 1986. C-print, 76.2 x 101.6 (30 x 40). From the series *Pictures From Home*. Courtesy the artist and Janet Borden, Inc., New York. **152.** Mitch Epstein, *Dad IV*, 2002. C-print, 76.2 x 101.6 (30 x 40). From the series *Family Business*. Courtesy Brent Sikkema, New York, © Mitch Epstein. **153.** Colin Gray, *Untitled*, 2002. C-print, variable dimensions. Courtesy the artist. **154.** Elina

Brotherus, *Le Nez de Monsieur Cheval*, 1999. Chromogenic colour print on Fujicolor Crystal Archive paper, mounted on anodized aluminium, framed, 80 x 102 (31½ x 40⅛). From the series *Suite Françaises 2*. Courtesy the artist and &:gb agency, Paris. **155.** Breda Beban, *The Miracle of Death*, 2000. C-print, 152 x 102 (59⅞ x 40⅛). Courtesy the artist. **156.** Sophie Ristelhueber, *Iraq*, 2001. Triptych of chromogenic prints mounted on aluminium and framed, 120 x 180 each (47⅜ x 70⅞). Courtesy the artist. **157.** Willie Doherty, *Dark Stains*, 1997. Cibachrome mounted on aluminium, 122 x 183 (48 x 72). Edition of 3. Courtesy Alexander and Bonin, New York. **158.** Zarina Bhimji, *Memories Were Trapped Inside the Asphalt*, 1998–2003. Transparency in lightbox, 130 x 170 x 12.5 (51⅛ x 66⅞ x 4⅞). © The artist, Courtesy Lisson Gallery, London and Luhring Augustine, New York. © Zarina Bhimji 2004. All rights reserved, DACS. **159.** Anthony Haughey, *Minefield, Bosnia*, 1999. Lambdachrome, 75 x 75 (29½ x 29½). From the series *Dispute Territory*. © Anthony Haughey 1999. **160.** Ori Gersht, *Untitled Space 3*, 2001. C-print, 120 x 150 (47¼ x 59). Courtesy the artist and Mummery+Schnelle, London. **161.** Paul Seawright, *Valley*, 2002. Fuji Crystal Archive C-print on aluminium, 122 x 148 (48 x 59⅜). Courtesy Maureen Paley Interim Art, London. **162.** Simon Norfolk, *Destroyed Radio Installations, Kabul, December 2001*, 2001. Digital C-print, 101.6 x 127 (40 x 50). From the series *Afghanistan: Chronotopia*. Simon Norfolk, courtesy Galerie Martin Kudler, Cologne, Germany. **163.** Fazal Sheikh, *Halima Abdullai Hassan and her grandson Mohammed, eight years after Mohammed was treated at the Mandera feeding centre, Somali refugee camp, Dagahaley, Kenya*, 2000. Gelatin silver print, variable dimensions. © Fazal Sheikh. Courtesy Pace/MacGill Gallery, New York. **164.** Chan Chao, *Young Buddhist Monk, June 1997*, 2000. C-print, 88.9 x 73.7 (35 x 29).From the series *Burma: Something Went Wrong*. Courtesy the artist, and Numark Gallery, Washington. **165.** Zwelethu Mthethwa, *Untitled*, 2003. C-print, 179.1 x 241.3 (70½ x 95). Courtesy Jack Shainman Gallery, New York. **166.** Adam Broomberg and Oliver Chanarin, *Timmy, Peter and Frederick, Pollsmoor Prison*, 2002. C-print, 40 x 30 (15¾ x 11¼). From the series *Pollsmoor Prison*. © 2002, Adam Broomberg and Oliver Chanarin. **167.** Deidre O'Callaghan, *BBC 1*, March 2001. High resolution scan (SCITE x CT file), 36.53 x 29.6 (14⅜ x 11⅝), 300 dpi, 59.4 MB. From the series 'Hide That Can'. © Deidre O'Callaghan, from the book *Hide That Can*, Trolley 2002. **168.** Trine Søndergaard, *Untitled, image #24*, 1997. From the series *Now that you are mine*. C-print, 100 x 100, (39¾ x 39¾). Trine Søndergaard/Now that you are mine/Steidl 2002. **169.** Dinu Li, *Untitled*, May 2001. C-print, 50.8 x 60.9 (20 x 24). From the series *Secret Shadows*. Courtesy Open Eye Gallery, Liverpool. **170.** Margareta Klingberg, *Lövsjöhöjden*, 2000–01. C-print, 70 x 100 (27½ x 39¾). Courtesy the artist. © DACS, 2004. **171.** Allan Sekula, *Conclusion of Search for the Disabled and Drifting Sailboat 'Happy Ending'*, 1993–2000. Cibachrome triptych (framed together), 183.5 x 96.5 (72¼ x 38). From the series *Fish Story*. Courtesy the artist and Christopher Grimes Gallery, Santa Monica. **172.** Paul Graham, *Untitled 2002*

(Augusta) #60, 2002. Lightjet Endura C-print, Diasec, 189.5 x 238.5 (74⅝ x 93⅜). From the series *American Night*. © the artist, courtesy Anthony Reynolds Gallery, London. **173.** Paul Graham, *Untitled 2001 (California)*, 2001. Lightjet Endura C-print, Diasec, 189.5 x 238.5 (74⅝ x 93⅜). From the series *American Night*. © the artist, courtesy Anthony Reynolds Gallery, London. **174.** Martin Parr, *Budapest, Hungary*, 1998. Xerox laser prints, 42 x 59.2 (16½ x 23¼). From the series *Common Sense*. © Martin Parr/Magnum Photos. **175.** Martin Parr, *Weston-Super-Mare, United Kingdom*, 1998. Xerox laser prints, 42 x 59.2 (16½ x 23¼). From the series *Common Sense*. © Martin Parr/Magnum Photos. **176.** Martin Parr, *Bristol, United Kingdom*, 1998. Xerox laser prints, 42 x 59.2 (16½ x 23¼). From the series *Common Sense*. © Martin Parr/Magnum Photos. **177.** Martin Parr, *Venice Beach, California, USA*, 1998. Xerox laser prints, 42 x 59.2 (16½ x 23¼). From the series *Common Sense*. © Martin Parr/Magnum Photos. **178.** Luc Delahaye, *Kabul Road*, 2001. C-print, framed, 110 x 245 (43¼ x 96½). © Luc Delahaye/Magnum Photos/Ricci Maresca, New York. **179.** Ziyah Gafic, *Quest for ID*, 2001. C-print, 40 x 40 (15¾ x 15¾). Ziyah Gafic/Grazia Neri Agency, Milan. **180.** Andrea Robbins and Max Becher, *German Indians Meeting*, 1997–98. Chromogenic print, 77.4 cm x 89.4 cm (30⅜ x 35¼). © Andrea Robbins and Max Becher. **181.** Shirana Shahbazi, *Shadi-01-2000*, 2000. C-print, 68 x 56 (26¾ x 22). Courtesy Galerie Bob van Orsouw, Zurich. **182.** Esko Mannikko, *Savukoski*, 1994. C-print, variable dimensions. Courtesy the artist. **183.** Roger Ballen, *Eugene on the phone*, 2000. Silver print, 40 x 40 (15¾ x 15¾). © Roger Ballen courtesy Michael Hoppen Gallery, London. **184.** Boris Mikhailov, *Untitled*, 1997–98. C-print, 127 x 187 (50 x 73⅝), edition of 5. 40 x 60 (15¾ x 23⅝), edition of 10. From the series *Case History*. Courtesy Boris and Victoria Mikhailov. **185.** Vik Muniz, *Action Photo 1*, 1997. Cibachrome, 152.4 x 114.3 (60 x 45), edition of 3. 101.6 x 76.2 (40 x 30), edition of 3. From the series *Pictures of Chocolate*. Courtesy Brent Sikkema, New York. **186.** Cindy Sherman, *Untitled #400*, 2000. Colour photograph, 116.2 x 88.9 (45¾ x 35). Courtesy the artist and Metro Pictures Gallery. **187.** Cindy Sherman, *Untitled #48*, 1979. Black and white print, 20.3 x 25.4 (8 x 10). Courtesy the artist and Metro Pictures Gallery. **188.** Yasumasa Morimura, *Self-portrait (Actress) after Vivien Leigh 4*, 1996. Ilfochrome, framed, acrylic sheet, 120 x 94.6 (47¼ x 37¼). Courtesy the artist and Luhring Augustine Gallery, New York. **189.** Nikki S. Lee, *The Hispanic Project (2)*, 1998. Fujiflex print, 54 x 71.8 (21 ¾ x 28 ⅜). © Nikki S Lee. Courtesy Leslie Tonkonow Artworks + Projects, New York. **190.** Trish Morrissey, *July 22nd, 1972*, 2003. C-print, 76.2 x 101.6 (30 x 40). From the series *Seven Years*. Courtesy the artist. © Trish Morrissey. **191.** Gillian Wearing, *Self-Portrait as my father Brian Wearing*, 2003. Black-and-white print, framed, 164 x 130.5 (64⅝ x 51¾). Courtesy Maureen Paley Interim Art, London. **192.** and **193.** Jemima Stehli, *After Helmut Newton's 'Here They Come'*, 1999. Black-and-white photographs on foamex, 200 x 200 (78¾ x 78¾). Courtesy Lisson Gallery, London, and the artist. **194.** **195** and **196.** Zoe Leonard and Cheryl Dunye, *The Fae

Richards Photo Archive, 1993–96. Created for Cheryl Dunye's film The Watermelon Woman (1996), 78 black-and-white photographs, 4 colour photographs and notebook of seven pages of typed text on typewriter paper, photos from 8.6 x 8.6 (3¾ x 3¾) to 35.2 x 25.1 (13⅞ x 9⅞), notebook (11½ x 9) Edition of 3. Courtesy Paula Cooper Gallery, New York. **197.** Collier Schorr, Jens F (114, 115), 2002. Photo collage, 27.9 x 48.3 (11 x 19). Courtesy 303 Gallery, New York. **198.** The Atlas Group/Walid Ra'ad, Civilizationally We Do Not Dig Holes to Bury Ourselves (CDH: A876), 1958–2003. Black-and-white photograph, 12 x 9 (4¾ x 3½). © The artist, courtesy Anthony Reynolds Gallery, London. **199.** Joan Fontcuberta, Hydropithecus, 2001. C-print, 120 x 120 (47¼ x 47¼). From the series Digne Sirens. Courtesy Musée de Digne, France. Joan Fontcuberta, 2004 **200.** Aleksandra Mir, First Woman on the Moon, 1999. C-print 91.4 x 91.4 (36 x 36). Event produced by Casco Projects, Utrecht, on location in Wijk aan Zee, Netherlands. **201.** Tracey Moffatt, Laudanum, 1998. Toned photogravure on rag paper, 76 x 57 (29⅞ x 22½). Series of 19 images, edition of 60. Courtesy the artist and Roslyn Oxley9 Gallery, Sydney, Australia. **202.** Cornelia Parker, Grooves in a Record that belonged to Hitler (Nutcracker Suite), 1996. Transparency, 33 x 22.5 (13 x 8¾). Courtesy the artist and Frith Street Gallery, London. **203.** Vera Lutter, Frankfurt Airport, V: April 19, 2001. Unique gelatin silver print, 206 x 425 (81¼ x 167⅜). Courtesy Robert McKeever/Gagosian Gallery, New York. **204.** Susan Derges, River, 23 November, 1998, 1998. Ilfochrome, 105.4 x 236.9 (41½ x 93¼). From the series River Taw. Collection Charles Heilbronn, New York. **205.** Adam Fuss, From the series 'My Ghost', 2000. Daguerrotype, 20.3 x 25.4 (8 x 10). Courtesy the artist and Cheim & Reid, New York. **206.** John Divola, Installation: 'Chairs', 2002. Image: 'Heir Chaser (Jimmy the Gent), 1934/2002. From the series Chairs. Installation: approximately 373.4 x 81.3 (147 x 32), image: gelatin silver print, 20.3 x 25.4 (8 x 10). © John Divola. Centro de Arte de Salamanca, Salamanca, Spain. **207.** Richard Prince, Untitled (Girlfriend), 1993. Ektacolour photograph, (11.8 x 162.6 (44 x 64). Courtesy Barbara Gladstone, New York. **208.** Hans-Peter Feldmann, page from Voyeur, 1997. Voyeur produced by Hans-Peter Feldmann in collaboration with Stefan Schneider, under the direction of Dennis Ruggieri, for Ofac Art Contemporain, La Flèche, France. © 1997 the Authors, © 1997 Verlag der Buchhandlung Walther König, Cologne, in cooperation with 3 Möven Verlag. © DACS 2004 (Feldmann). **209.** Nadir Nadirov in collaboration with Susan Meiselas, Family Narrative, 1996. Gelatin silver print on paper, 20.3 x 25.4 (8 x 10). © Nadir Nadirov in collaboration with Susan Meiselas, published in Kurdistan In the Shadow of History (Random House, 1997). **210.** Tacita Dean, Ein Sklave des Kapitals, 2000. Photogravure, 54 x 79 (21¼ x 31⅛). From the series The Russian Ending. Courtesy the artist and Frith Street Gallery, London and Marian Goodman Gallery, New York/Paris. **211.** Joachim Schmid, No. 460, Rio de Janeiro, December 1996, 1996. C-print mounted on board, 10.1 x 15 on 21 x 29.7 (4 x 5⅞ on 8⅜ x 11⅝). From the series Pictures from the Street. Courtesy the artist. **212.** Thomas Ruff, Nudes pf07, 2001. Laserchrome and

Diasec, 155 x 110 (61 x 43¼). Edition of 5. From the series Nudes. Galerie Nelson, Paris/Ruff. © DACS 2004. **213.** Susan Lipper, untitled, 1993–98. Gelatin silver print, 25.4 x 25.4 (10 x 10) From the series trip. Courtesy the artist. **214.** Markéta Othová, Something I Can't Remember, 2000. Black-and-white photograph, 110 x 160 (43¼ x 63), edition of 5. Courtesy Markéta Othová. **215.** Torbjørn Rødland, Island, 2000. C-print, 110 x 140 (43¼ x 55¼). Courtesy Galleri Wang, Oslo, Norway. **216.** Katy Grannan, Joshi, Mystic Lake, Medford, MA, 2004. C-print, 121.9 x 152.4 (48 x 60). From the series Sugar Camp Road. Courtesy Artemis, Greenberg, Van Doren Gallery, New York and Salon 94, New York. **217.** Vibeke Tandberg, Line #1 – 5, 1999. C-print, digital montage, 132 x 100 (52 x 39⅜). Courtesy c/o Atle Gerhardsen, Berlin. © DACS 2004. **218.** Florian Maier-Aichen, The Best General View, 2007. C-print, 213.4 x 178.4 (84 x 70 ¼). Courtesy the artist and Blum & Poe, Los Angeles. **219.** James Welling, Crescendo B89, 1980. Gelatin silver print mounted on archival paper, 12.1 x 9.8 (4 ¾ x 3 ⅞₆), mounted 35.6 x 27.9 (14 x 11). Courtesy David Zwirner, New York. **220.** Sherrie Levine, After Walker Evans, 1981. Gelatin silver print, 15.9 x 12.7 (6 ¼ x 5), framed 37.8 x 29.5 (14 ⅞ x 11 ⅜). © Sherrie Levine. Courtesy Paula Cooper Gallery, New York. © Walker Evans Archive. The Metropolitan Museum of Art, New York. **221.** Christopher Williams, Kodak Three Point Reflection Guide, © 1968 Eastman Kodak Company, 1968. (Corn) Douglas M. Parker Studio, Glendale, California, April 17, 2003, 2003. Dye transfer print, 40.6 x 50.8 (16 x 20), framed 74 x 81.6 x 3.8 (29 ⅛ x 32 ⅛ x 1 ½). © Christopher Williams. Courtesy David Zwirner, New York. **222.** Sara VanDerBeek, Eclipse I, 2008. Digital C-print, 50.8 x 40.6 (20 x 16), edition of 3, and 2 artist proofs. Courtesy the artist and D'Amelio Terras, New York. **223.** Lyle Ashton Harris, Blow up IV (Sevilla), 2006. Mixed media installation, variable dimensions. MUSAC Collection, Contemporary Art Museum of Castilla and León. Courtesy the artist and CRG Gallery, New York. **224.** Isa Genzken, Untitled, 2006. Mixed media installation, 9 panels consisting of 28 parts, variable dimensions. Courtesy David Zwirner, New York and Galerie Daniel Bucholz, Cologne. **225.** Michael Queenland, Bread and Balloons, 2007. Mixed media installation, variable dimensions. Courtesy the artist and Harris Lieberman, New York. **226.** Arthur Ou, To Preserve, To Elevate, To Cancel, 2006. Mixed media installation, variable dimensions. Courtesy the artist and Hudson Franklin, New York. **227.** Walead Beshty, 3 Sided Picture (Magenta/Red/Blue), December 23, 2006, Los Angeles, CA, Kodak, Supra, 2007. Colour photographic paper, 198.1 x 127 (78 x 50). Collection of FRAC Nord - Pas de Calais, Dunkirk. **228.** Zoe Leonard, TV Wheelbarrow, from the series Analogue, 2001/2006. Dye transfer print, 50 x 40 (19 ¹¹⁄₁₆ x 15 ¾), edition of 6. Courtesy Galerie Gisela Capitain, Cologne. **229.** An-My Lê, 29 Palms: Infantry Platoon Retreat, 2003–04. Gelatin silver print, 67.3 x 96.5 (26 ½ x 38). Courtesy Murray Guy, New York **230.** Anne Collier, 8 x 10 (Blue Sky), 2008. C-print, 75.6 x 88.3 (29 ¾ x 34 ¾), edition of 5, and 2 artist proofs. Courtesy the artist and Marc Foxx, Los Angeles. Anne Collier,

8 x 10 (Grey Sky), 2008. C-print, 75.6 x 88.3 (29 ¾ x 34 ¾), edition of 5, and 2 artist proofs. Courtesy the artist and Marc Foxx, Los Angeles **231.** Liz Deschenes, Moiré #2, 2007. UV-laminated chromogenic print, 137.2 x 101.6 (54 x 40), framed 152.4 x 116.8 (60 x 46). Courtesy Miguel Abreu Gallery, New York. **232.** Eileen Quinlan, Yellow Goya, 2007. UV-laminated chromogenic print mounted on Sintra, 101.6 x 76.2 (40 x 30), edition of 5. Courtesy the artist and Miguel Abreu Gallery, New York. **233.** Jessica Eaton, cfaal 109, from the series Cubes for Albers and Lewitt, 2011. Pigment print, 101.6 x 127 (40 x 50). Courtesy the artist **234.** Carter Mull, Connection, 2011 (detail). Offset ink, mylar, 1800 unique stills, 40.6 x 22.9 (16 x 9) each. Installation view, 'The Day's Specific Dreams', May 6–June 11, 2011. Courtesy the artist. **235.** Shannon Ebner, Agitate, 2010. Installation, 4 C-prints, each 160 x 121.9 (63 x 48). Courtesy the artist and LAXART. **236.** Sharon Ya'ari, Untitled from 500m Radius, 2006. Archival pigment print, 42 x 34 (16 ⁹⁄₁₆ x 13 ¾). Courtesy the artist and Sommer Contemporary Art, Tel Aviv. **237.** Jason Evans, Untitled from NYLPT, 2005–12. APP, music CD and multiple print formats; various dimensions. Courtesy the artist. **238.** Tim Barber, Untitled (Cloud), 2003. Colour photograph, variable dimensions. Courtesy Tim Barber. **239.** Viviane Sassen, Mimosa, from the series Flamboya, 2007. C-print, 150 x 120 (59⁷⁄₁₆ x 47¼), edition of 3 and 2 AP; and 125 x 100 (49³⁄₁₆ x 39⅜), edition of 5 and 2 AP. Courtesy the artist and Stevenson, Cape Town and Johannesburg. **240.** Rinko Kawauchi, Untitled, from the series AILA, 2004. C-print, variable dimensions. © Rinko Kawauchi. Courtesy the artist and FOIL Gallery, Tokyo. **241.** Lucas Blalock, Both Chairs in CW's Living Room, 2012. C-print, 134.3 x 106.4 (52⅞ x 41¾). Courtesy the artist and Ramiken Crucible, New York. **242.** Kate Steciw, Apply, Applications, Auto, Automotive, Burn, Cancer, Copper, Diameter, Fire, Flame, Frame, Metal, Mayhem, Pipe, Red, Roiling, Rolling, Safe, Safety, Solid, Strip, Tape, Trap, Trappings, 2012. C-print, custom oak frame, chrome decorative vents, self-adhesive safety tread, frame decals, 152.4 x 111.8 (60 x 44). Courtesy the artist; photograph Mark Woods. **243.** Artie Vierkant, Image Objects, 2011–. UV prints on sintra, altered documentation images, dimensions not fixed. Courtesy the artist. **244.** Anne de Vries, Steps of Recursion, 2011. Documentation photo sculpture, 130 x 30 (51¼ x 11¾). Courtesy the artist.

Index